ARNOLD SCHOENBERG
WASSILY KANDINSKY
Letters, Pictures and Documents

Arnold Schoenberg
Wassily Kandinsky

LETTERS, PICTURES
AND DOCUMENTS

edited by
JELENA HAHL-KOCH

translated by
JOHN C. CRAWFORD

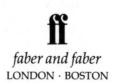

faber and faber
LONDON · BOSTON

This translation first published in 1984
by Faber and Faber Limited
3 Queen Square London WC1N 3AU
Printed in Great Britain by
Ebenezer Baylis & Son Limited
The Trinity Press, Worcester and London
Typeset by Goodfellow & Egan, Cambridge
All rights reserved

Original German edition, *Arnold Schönberg – Wassily Kandinsky:*
Briefe, Bilder und Dokumente einer aussergewöhnlichen Begegnung,
first published by Residenz Verlag 1980

British Library Cataloguing in Publication Data
Schoenberg, Arnold
Arnold Schoenberg/Wassily Kandinsky
1. Schoenberg, Arnold 2. Kandinsky, Wassily
I. Title II. Kandinsky, Wassily III. Hahl-Koch, Jelena
780'.092'4 ML410.S2
ISBN 0–571–13060–7
ISBN 0–571–13194–8 (Pbk)

Library of Congress Cataloging in Publication Data
Schoenberg, Arnold, 1874–1951
Arnold Schoenberg, Wassily Kandinsky, letters, pictures, and documents
1. Schoenberg, Arnold, 1874–1951
2. Kandinsky, Wassily, 1866–1944 3. Composers—Correspondence
4. Painters—Soviet Union—Correspondence
I. Kandinsky, Wassily, 1866–1944 Correspondence English 1984
II. Hahl-Koch, Jelena III. Title
ML410.S283A44 1984 780'.92'4 [B] 83–8956
ISBN 0–571–13060–7
ISBN 0–571–13194–8 (Pbk)

CONTENTS

CONTENTS

8

ILLUSTRATIONS

Schoenberg's music introduces us into a new realm, where musical experiences are not acoustical, but *purely spiritual*. This is where the 'Music of the Future' begins.

KANDINSKY: *On the Spiritual in Art*, 1911

You are such a full man that the least vibration always causes you to overflow. . . I am very proud to have found your respect, and tremendously glad of your friendship.

SCHOENBERG: letter to Kandinsky 8 March 1912

EDITOR'S FOREWORD

The friendship between two leading artistic personalities of the early twentieth century, the founders of abstract painting and atonal music, has already been the subject of several studies. Now their correspondence has become available, furnishing many new insights into their creative processes and personalities, for neither man, in the decisive period between 1911 and 1914, had another correspondent with whom he could so thoroughly discuss and share his creative problems, going beyond the merely technical. When their correspondence began early in 1911, both stood in the midst of the most difficult and momentous phase of radical change in their artistic development, which was preceded by years of searching, of disparagement by critics and public, and thus also of a certain loneliness. Amazed not only by their intellectual affinity, but also at the similarities in their specific musical and artistic goals, they wrote to each other from then on about everything which affected them as artists.

In this edition, all existing letters addressed by one correspondent to the other have been included, even those which are of minor significance. Thus the postcards exchanged almost daily in the late summer of 1911 regarding their planned first meeting show how busy both artists were, and the almost anecdotal exchanges about Schoenberg's vacation cottage for the summer of 1914 express something about the difficulties of a composer who was as poor as he was exacting, but probably say just as much about the patience of his friend.

The most important letters concentrate on the following topics:

1. *The theater experiments.* Attempts at a 'total work of art for the stage,' on which Schoenberg and Kandinsky had been working independently of one another, but with similar aims, since 1909/10, in particular Kandinsky's *Der gelbe Klang* and Schoenberg's *Die glückliche Hand*, the texts of which were finished at the same time. It has seemed sensible to reprint these short stage pieces together with the commentaries of their authors.

2. *The principal theoretical works.* Kandinsky's *On the Spiritual in Art* and Schoenberg's *Theory of Harmony*, which also were written about the same time and were printed in 1911. Kandinsky's commentaries on the *Theory of*

11

Harmony are published here for the first time in English, as a complement to his remarks in the letters. Even before the printing of Schoenberg's work he had translated excerpts from it into Russian and published them in an exhibition catalog in Odessa in 1911, along with his own detailed commentaries.

3. *Painting and music.* Their points of contact and the possibility of a 'common denominator,' also Schoenberg's painting, to which he devoted himself as a dilettante, but with great zeal. Though otherwise not very successful, his paintings were shown in Kandinsky and Marc's group exhibition Der Blaue Reiter and reproduced in the almanac of the same name. In addition, Kandinsky's article on Schoenberg's painting, written for the Schoenberg 1912 Festschrift, is reprinted.

In the editor's essay (pp. 135–70) topics raised in the letters are discussed, partly on the basis of new materials. An additional essay by John C. Crawford (pp. 173–86), translator of this edition, traces Schoenberg's development as a creative artist up to the time when his friendship with Kandinsky began. In the notes, well-known persons are briefly identified along with their most important particulars and their relationship to Kandinsky or Schoenberg, but the less well-known are discussed in greater detail, according to their relevance.

With a few exceptions, the letters are published here for the first time. Schoenberg's letters are to be found in the Gabriele Münter and Johannes Eichner Bequest in Munich. They were hitherto inaccessible, and none has been published. Kandinsky's letters, as well as Schoenberg's own letter-copies of 1922, are preserved at the Library of Congress in Washington. Of these, Schoenberg's letters of 1922–3, which are so politically and personally significant, have already been edited by Erwin Stein (1958, English translation in 1964). Other partial publications are indicated in the notes. Of the letters of Gabriele Münter (also in the Library of Congress), only those are included which are relevant and which complete or replace letters by Kandinsky.

Editor's markings are placed in brackets: for example, three dots for the omission of Münter's personal news, or completed abbreviations. Other punctuation marks, such as parentheses, three dots and underlining (here rendered in italics) are original. Russian names are rendered in scholarly transcription; the exceptions to this are persons who themselves customarily wrote their names otherwise in the West.

JELENA HAHL-KOCH

ACKNOWLEDGEMENTS

I would like to thank the following very warmly for their assistance and sympathetic interest: Nina Kandinsky, Lawrence Schoenberg, Lette Valeska, the administrator of the Scheyer Legacy, Professor Leonard Stein and Clara Steuermann of the Schoenberg Institute in Los Angeles, Dr Hans Konrad Röthel, who is in charge of the Gabriele Münter and Johannes Eichner Bequest in Munich, Wayne Shirley of the Library of Congress in Washington, Universal Edition in Vienna, as well as many other individuals, libraries and museums. I would also like to express my thanks to Residenz Verlag, publishers of the original German edition of this book.

JELENA HAHL-KOCH

TRANSLATOR'S ACKNOWLEDGEMENTS

I am grateful to the following for permission to reproduce copyright material: Lawrence Schoenberg and Columbia Masterworks for use of the English translation of Arnold Schoenberg's *Die glückliche Hand* by David Johnson which appeared in the booklet distributed with *The Music of Arnold Schoenberg*, 1963, Vol. I; Faber & Faber, London, and G.K. Hall, New York, for use of the English translations of Kandinsky's 'Über Bühnenkomposition', *Der gelbe Klang*, 'Die Bilder' and commentaries on Schoenberg's *Harmonielehre* which appeared in Kenneth C. Lindsay and Peter Vergo (eds), *Kandinsky: Complete Writing on Art*, Vol. I. I would also like to thank Dr Jorun Johns for her generous help with various difficult problems of translation, and my wife, Dorothy Lamb Crawford, and daughter, Susan, for their kind assistance and encouragement.

JOHN C. CRAWFORD

13

CHRONOLOGICAL TABLE

ARNOLD SCHOENBERG		WASSILY KANDINSKY	
		1866	born in Moscow on 4 December
		1871 on,	in Odessa
1874	born in Vienna on 13 September		
1882	studies the violin		
1883	first attempts at composition		
		1886 on,	studies law and political economy at the University of Moscow
1891	bank trainee (until 1895)		
		1892	marries his cousin Anna Tschimiakin
		1895	after completing his studies, works for a fine art printer
		1896	declines a position at the University of Dorpat and goes to Munich, in order to become a painter
		1897–8	studies at the art school of Anton Ažbè in Munich
1899	composes the String Sextet, Op. 4 ('Verklärte Nacht' ['Transfigured Night'])		
1900	composes the *Gurre-Lieder*, which he orchestrates in 1911	1900	studies with Franz von Stuck at the Munich Academy of Art

CHRONOLOGICAL TABLE

1901	marries Mathilde von Zemlinsky; moves to Berlin where he is conductor at Ernst von Wolzogen's literary cabaret, Überbrettl	1901	founds own art school and Phalanx exhibition gallery
1902	meets Richard Strauss; obtains a lectureship at the Stern Conservatory		
1903	returns to Vienna; meets Gustav Mahler, composes *Pelleas und Melisande*, Op. 5	1903/4	dissolves Phalanx and undertakes extended journeys, mostly together with Gabriele Münter
1904	Alban Berg and Anton von Webern become his pupils		
		1906/7	extended stay in Paris
1907/8	composes his Second String Quartet, Op. 10	1908/9	works on his first stage compositions
1909	Three Piano Pieces, Op. 11 and the monodrama *Erwartung* ('Expectation'), Op. 17	1909	with A. Jawlensky, G. Münter and others, founds the Neue Künstlervereinigung of Munich
1910	teaches (unofficially) at the Vienna Academy; begins work on the drama with music *Die glückliche Hand*, Op. 18; first exhibition of pictures in Vienna	1910	paints his first abstract watercolor, finishes writing *Über das Geistige in der Kunst* ('On the Spiritual in Art')
1911	finishes *Harmonielehre* ('Theory of Harmony') and has it published by Universal Edition, Vienna. In autumn moves to Berlin; lectureship there at Stern Conservatory	1911	withdraws from Neue Künstlervereinigung and founds the Blaue Reiter, together with Franz Marc. 'On the Spiritual in Art' is published by Piper. In December first exhibition of the Blaue Reiter, with pictures by Schoenberg, among others. Divorce from first wife
		1911/12	four paintings by Kandinsky are exhibited at the Neue Secession Berlin. Schoenberg sees these
1912	composes *Pierrot Lunaire*,	1912	second Blaue Reiter exhibition;

Op. 21; the Schoenberg Festschrift appears. Four of his pictures are shown in the Blaue Reiter collective exhibition. In the almanac of the same name, his essay 'Das Verhältnis zum Text' ('The Relationship to the Text') and the score of 'Herzgewächse' ('Foliage of the Heart'), Op. 20, are published

the almanac of the same name is published by Piper. In March six of Kandinsky's woodcuts are exhibited at the Neue Secession Berlin. March–May first Blaue Reiter exhibition at the Sturm in Berlin; Kandinsky's first one-man show takes place there in October

1913	premiere of *Gurre-Lieder* in Vienna	1913	his prose poems *Klänge* ('Sounds') are published by Piper and an album *Kandinsky 1903–1913* (including his 'Rückblicke' ['Reminiscences']) by H. Walden's Sturm in Berlin; exhibits in Erste Deutsche Herbstsalon there
1914	conducts own works in England and Netherlands; spends the summer with his family near Kandinsky in Upper Bavaria	1914	last exhibition of the Blaue Reiter held at the Sturm in Berlin. Writes the stage work *Violetter Vorhang* ('Violet Curtain'). After the outbreak of war, returns to Russia via Switzerland and the Balkans
1915	military service; works on the oratorio *Die Jakobsleiter* ('Jacob's Ladder')		
		1916	separation from Gabriele Münter
		1917	marries Nina Andreevskii, daughter of a Russian general
1918	founds the *Verein für musikalische Privataufführungen* ('Association for Private Musical Performances')	1918	member of the art section of the commissariat for mass education. Teaches at the Academy of Art; publishes his 'Reminiscences' in Moscow
		1919	director of the Museum for Pictorial Culture; organizes twenty-two provincial museums

CHRONOLOGICAL TABLE

1921	new edition of the *Theory of Harmony*	1921	founds the Academy of Arts and Sciences in Moscow. Departs for Berlin in December
		1922	Called to the Bauhaus as professor
1923	makes public his 'twelve-tone method' of composition. Death of his wife Mathilde		
1924	premiere of *Die glückliche Hand* in Vienna, and, before that, of *Erwartung* in Prague. Marries Gertrud Kolisch		
1925	takes over the master class for composition at the Berlin Academy of Arts	1925	moves with Bauhaus to Dessau
1926	third move to Berlin		
1928	German premiere of *Die glückliche Hand* in Breslau	1928	stages Mussorgsky's *Pictures at an Exhibition* at the Dessau Theater with the abstract play of color-forms and light
1930	his opera *Von Heute auf Morgen* ('From Today Till Tomorrow'), Op. 32, comedy of marriage with libretto by his wife Gertrud, premiered in Berlin		
1931	works on *Moses und Aron*		
		1932	the Bauhaus is closed
1933	is dismissed in Berlin, emigrates to New York via Paris	1933	goes to Neuilly-sur-Seine, near Paris
1934	Los Angeles	1934	fifty-seven Kandinsky works in German museums are seized as 'degenerate' and sold
1936	teaches at the University of California (until 1944)		
		1944	Kandinsky dies on 13 December in Neuilly-sur-Seine
1951	Schoenberg dies on 13 July in Los Angeles		

18

The Schoenberg – Kandinsky Correspondence

W. KANDINSKY
AINMILLERSTR. 36,I
MÜNCHEN.

18 I 11.

Sehr geehrter Herr Professor!

Entschuldigen Sie bitte, dass ich ohne das Vergnügen zu haben Sie persönlich zu kennen einfach an Sie schreibe. Ich habe eben Ihr Concert hier gehört und habe viel wirkliche Freude daran gehabt. Sie kennen mich, d.h. meine Arbeiten natürlich nicht, da ich überhaupt nicht viel ausstelle und in Wien auch flüchtig und schon vor Jahren ein Mal ausgestellt habe (Secession). Unsere Bestrebungen aber und die ganze Denk- u. Fühlweise haben so viel Gemeinsames, dass ich mich ganz berechtigt fühle, Ihnen meine Sympathie auszusprechen.

Sie haben in Ihren Werken das verwirklicht, wonach ich in freilich unbestimter Form in der Musik so eine grosse Sehnsucht

W. Kandinsky
Ainmillerstrasse 36, I
Munich 18 January 1911

Dear Professor,
Please excuse me for simply writing to you without having the pleasure of
knowing you personally. I have just heard your concert here and it has given
me real pleasure. You do not know me, of course—that is, my works—since I
do not exhibit much in general, and have exhibited in Vienna only briefly
once and that was years ago (at the Secession). However, what we are striving
for and our whole manner of thought and feeling have so much in common
that I feel completely justified in expressing my empathy.

In your works, you have realized what I, albeit in uncertain form, have so
greatly longed for in music. The independent progress through their own
destinies, the independent life of the individual voices in your compositions,
is exactly what I am trying to find in my paintings. At the moment there is a
great tendency in painting to discover the 'new' harmony by constructive
means, whereby the rhythmic is built on an almost geometric form. My own
instinct and striving can support these tendencies only half-way. *Construction*
is what has been so woefully lacking in the painting of recent times, and it is
good that it is now being sought. But I think differently about the *type* of
construction.

I am certain that our own modern harmony is not to be found in the
'geometric' way, but rather in the anti-geometric, antilogical [antilogischen]
way. And this way is that of 'dissonances in *art* ['], in painting, therefore, just
as much as in music. And 'today's' dissonance in painting and music is
merely the consonance of 'tomorrow.' (What I might call the academic-
'harmonic' is of course not to be excluded by this: one takes what one needs
without worrying from *where* one takes it. And particularly 'today,' in the
time of the coming 'Liberalism,' there are so many possibilities!)

It has given me immense joy to find that you have the same ideas. I am only
sorry about one thing: I did not understand the last two sentences on your
program announcement (poster).* In spite of repeated efforts I could not
arrive at an exact interpretation.

I am taking the liberty of sending you a portfolio of my work (the woodcuts
are nearly three years old), and I enclose in this letter a couple of photographs
of my fairly recent pictures. I have no photographs of my most recent ones. I
would be very happy if these works interested you.

With feelings of real affinity and sincere respect,

 Kandinsky

* Trans. note: see postscript to next letter.

ARNOLD SCHÖNBERG
WIEN, XIII.
HIETZINGER HAUPTSTRASSE 113

24/1. 1911

Arnold Schoenberg
Vienna XIII
Hietzinger Hauptstrasse 13

24 January 1911

Dear Sir,
I thank you most warmly for your letter. It gave me extraordinary pleasure.
For the present, there is no question of my works winning over the masses.

All the more surely do they win the hearts of individuals—those really worthwhile individuals who alone matter to me. And I am particularly happy when it is an artist creating in another art from mine who finds points of contact with me. Certainly there are such unknown relationships and common ground among the best artists who are striving today, and I dare say they are not accidental. I am proud that I have most often met with such evidence of solidarity from the best artists.

First of all, my heartfelt thanks for the pictures. I liked the portfolio very much indeed. I understand it completely, and I am sure that our work has much in common—and indeed in the most important respects: In what you call the 'unlogical' [Sic: Unlogische] and I call the 'elimination of the conscious will in art.' I also agree with what you write about the constructive element. Every formal procedure which aspires to traditional effects is not completely free from conscious motivation. But art belongs to the *unconscious*! One must express *oneself*! Express oneself *directly*! Not one's taste, or one's upbringing, or one's intelligence, knowledge or skill. Not all these *acquired* characteristics, but that which is *inborn, instinctive*. And all form-making, all *conscious* form-making, is connected with some kind of mathematics, or geometry, or with the golden section or suchlike. But only unconscious form-making, which sets up the equation 'form = outward shape,' really creates forms; that alone brings forth prototypes which are imitated by unoriginal people and become 'formulas.' But whoever is capable of listening to himself, recognizing his own instincts, and also engrossing himself reflectively in every problem, will not need such crutches. One does not need to be a pioneer to create in this way, only a man who takes himself seriously—and thereby takes seriously that which is the true task of humanity in every intellectual or artistic field: to recognize, and to express what one has recognized!!! This is my belief!

Again, many thanks for the pictures. As I said, the portfolio pleased me *very, very* much. I understand the photographs [of the other pictures] less well, for the moment. One would have to see such things in color. For that reason, I hesitate whether to send you some photographs of my pictures. Perhaps you do not know that I also paint. But color is so important to me (not 'beautiful' color, but color which is expressive in its relationships), that I am not sure whether a person would get anything out of looking at the reproductions. Friends of mine think so, but I have my doubts. However, if you are interested, I will send you some. Although I paint completely differently, you will nevertheless find points of contact—at least I find such points in the photographs; most of all, in that you seem to be objective only to a very small degree. I myself don't believe that painting must necessarily be objective. Indeed, I firmly believe the contrary. Nevertheless, when imagination suggests objective things to us, then, well and good—perhaps

23

this is because our eyes perceive only objective things. The ear has an advantage in this regard! But when the artist reaches the point at which he desires only the expression of inner events and inner scenes in his rhythms and tones, then the 'object in painting' has ceased to belong to the reproducing eye.

I am sorry that I was not in Munich. Perhaps then we could have got to know each other. In any case that will happen one day, either when I come to Munich or you to Vienna. I think we would have a lot to say to each other. This thought gives me pleasure, and I hope to hear from you soon. Until then, warmest regards,

Arnold Schoenberg

Quite right: I do not have the [concert] poster at hand, and can't find it. Thus I myself don't know which sentences you mean—these sentences were put on the poster by the Gutman concert agency *without my knowledge*. To me, such advertising is unwanted and distasteful, but I could do nothing about it except complain to the agency. I didn't even have the right to do that, since the concert was arranged by this agency at its own risk (for which I am otherwise *very* grateful). Thus I had no influence at all [on the wording of the announcement].

The sentences [reproduced below] are taken from an article entitled 'A Chapter from my Theory of Harmony,' which appeared in the October issue of *Die Musik*.[1]

Sch.

„In einem Sinne soll man nie unzeitgemäss sein — nach rückwärts!
Dissonanzen sind nur graduell verschieden von den Konsonanzen; sie sind nichts anderes als entfernter liegende Konsonanzen. Wir sind heute schon so weit, zwischen Konsonanzen und Dissonanzen keinen Unterschied mehr zu machen. Oder höchstens den, dass wir Konsonanzen weniger gern verwenden.
Ich glaube, man wird in der Harmonie von uns Allermodernsten schliesslich dieselben Gesetze erkennen können, wie in der Harmonie der Alten. Nur entsprechend ausgeweitet, allgemeiner gelasst.
Unsere Lehre führt dahin, auch Hervorbringungen Jüngerer, die das Ohr der Aelteren verpönt, als notwendige Ergebnisse der Schönheitsentwicklung anzusehen. Niemals aber sollte man wünschen, Dinge zu schreiben, deren Verantwortung man nur mit dem Einsatz einer vollen Persönlichkeit zu übernehmen vermag. Dinge, die Künstler fast widerwillig im Zwange ihrer Entwicklung geschrieben haben, aber nicht aus dem hemmungsarmen Mutwillen formunsicherer Voraussetzungslosigkeit".
Aus der „Harmonielehre" von Arnold Schönberg.

This extract from Schoenberg's *Theory of Harmony* was included in the poster for the 1 January 1911 concert in Munich

In one sense one should never be untimely—in a backward direction!

Dissonances are only different from consonances in degree; they are nothing more than remoter consonances. Today we have already reached the point where we no longer make the distinction between consonances and dissonances. Or at most, we make the distinction that we are less willing to use consonances.

24

I believe that it will eventually be possible to recognize the same laws in the harmony of those of us who are the most modern as in the harmony of the classics; but suitably expanded, more generally understood.

Our teaching persuades us to regard even the productions of the young, which the ears of their elders despise, as necessary steps in the development of beauty. However, one should never wish to write things for which one can take responsibility only by staking a complete personality; things which artists have written almost against their will, compelled by their development, but not out of the unrestrained wantonness of an absolutism unsure of form.

W. Kandinsky
Murnau
Oberbayern 26 January 1911

Dear Professor,
Your letter has given me a lot of pleasure. I thank you warmly, and look forward very much to knowing you personally. I have often turned several of these ideas over in my mind (for instance, conscious vs. unconscious work). Fundamentally, I agree with you. That is, when one is actually at work, then there should be no thought, but the 'inner voice' alone should speak and control. But up to now the painter has thought too little in general. He has conceived his work as a kind of coloristic balancing act. But the painter (and precisely so that he will be able to express *himself*) should learn his whole material so well and develop his sensitivity to the point where he recognizes and vibrates spiritually at the difference between = and \wedge ! Inner knowledge is just that. Then there can be building and construction which results not in

geometry, but art. I am very pleased that you speak of self-perception. That is the root of the 'new' art, of art in general, which is never new, but which must only enter into a new phase—'Today!'

I would be *very* happy to receive some photos from you. Actually, I can get along even without colors. Such a photo is a kind of piano reduction. Thank you in advance for sending them.

Now for another question which is very important to me. The second touring-'Salon' will soon begin in Russia. This is an international art exhibition which will be taken to the principal cities of Russia and which is devoted to the 'new' art. The organizer, the sculptor Mr V. v. Izdebskii, is a good friend of mine.[2] As usual, he has asked me to help him organize the exhibition and also to recommend to him particularly good and interesting articles on art (all the arts, thus also music), or to name suitable authors. Yesterday I got his letter and immediately wrote to him about you. Since this matter is very urgent, I took the liberty of ordering a couple of copies of *Die Musik* in order to send one immediately to Izdebskii. If you are opposed to this use of your article, please write to me by return mail, so that I can cancel the translation. But I hope *very* much that you will not deprive us of permission! The catalog is to be a kind of art periodical, and will be read by many people with great interest. The whole enterprise really deserves every support. It is always a great joy to me when artists of different countries work together on a cause. Such a disregard for political boundaries is of great consequence and will bring a rich future harvest.

With feelings of affinity and esteem,

Kandinsky

At the moment I am in the country, but in two weeks again in Munich.

W. Kandinsky
Ainmillerstr. 36, I
Munich 6 February 1911

Dear Professor,
Many thanks for the package. I am very sorry that I have to return the album. Would you permit me to keep it another ten to fourteen days? I am really enthusiastic about your pictures: their sources are a natural necessity and a fine sensitivity. I have long felt that our period—which is after all a great one—will bring forth not one, but many possibilities. In a work which many like well, but which has not yet been accepted by a publisher,[3] I speak among other things of the fact that in painting the possibilities can become so rich that it will not only reach both extreme limits, but well-nigh go beyond them. And these very widely separated limits (= two poles) are complete

26

abstraction and purest realism. For my own part, I incline more and more to the first. But the second is *just* as welcome to me and I await its appearance with impatience. I believe it will come tomorrow! Now, particularly in your pictures I perceive the real especially strongly. Naturally, this realism is in no way like that which we have already gone through. And *inwardly*, the opposite: there, *res*—the goal; here— the means. And isn't one means as good as another, as long as it leads to the goal? Here I think again of your 'forbidden' parallel octaves. Among us painters, it is the *res* which is forbidden. And therefore I am glad when it appears. This human tendency toward the fossilizing of form is shocking, even tragic. Yesterday, the man who exhibited a new form was ruined. Today, this same form is immovable law for all time. This is tragic, because it shows over and over again that human beings depend mostly on externals. I have considered this question at length, and have even found some comfort. But at times my patience is ready to explode.

Do you exhibit your pictures? Would you perhaps furnish something for the Russian 'Salon' of which I have written you, and for which I asked you for the article? I have translated it myself, because I wanted to familiarize myself properly with it, in spite of lack of time. It pleases me *extraordinarily*. And I am very glad that I have got to know you, if only by correspondence. In the same way, my wife, Gabriele Münter,[4] takes great pleasure in your pictures and letters. In her pictures she has decided points of contact with you. I will send you some one day. They also show something of a healthy realism, though very different from yours.

With many cordial greetings and feelings of real affinity,

Kandinsky

Munich 9 April 1911

Dear Professor,

It gives me very special pleasure to send you a photo of myself. Would you like to give me the same pleasure by sending me a photo of yourself?

I envy you very much! You have your *Theory of Harmony* already in print. How immensely fortunate (though only relatively!) musicians are in their highly advanced art, truly an *art* which has already had the good fortune to forgo completely all purely practical aims. How long will painting have to wait for this? And painting also has the right (= duty) to it: color and line for their own sake—what infinite beauty and power these artistic means possess! And yet today the beginning of this path is already more clearly

visible. In this field as well one may now dream of a 'Theory of Harmony'. I already dream and hope that I will write at least the first sentences of this great future book. Perhaps another will do the same. All the better! Just as many as possible. I am also taking the time to look into musical theory somewhat (naturally only very superficially: my powers are not sufficient for a deeper look), so that I know approximately how this theory is constructed. When one has understood to some extent how St Stephan's in Vienna is built, perhaps one will be in a position to stick together a rough little hut.

I warmly wish you much success in your work. I will wait patiently for the detailed answer which you promise.

With many friendly greetings, Yours,

Kandinsky

Since there was a *great* rush, I took the liberty of translating your article from *Die Musik* without permission from 'Universal Edition' and sending it for publication. Otherwise this highly important matter might have been postponed for a whole year.

Murnau 25 August 1911

Dear Mr Schoenberg,
I am glad that I will after all get a chance to see you. I have just arrived from Munich and found your letter here. Could you perhaps come to us on Sunday? You go from Berg—steamer—at 2.10 (runs Sundays and holidays), are in Tutzing at 2.45, board the express train there (leaves Tutzing at 3.00), and are in Murnau at 3.46, where I will pick you up at the station. We spend the day together, you stay the night here, and the next morning (naturally!! if you are so inclined) we go on foot to Sindelsdorf in the vicinity of Lake Kochel, where my good friend Franz Marc (painter) and his wife live, who are *very* interested in you.[5] It would be a great joy for them to get to know you. If you wish, you can be home again by Monday evening. Otherwise, we could all stay overnight in Sindelsdorf. Next week, I could come to you: I would like it if we could meet at least twice.

If my plan suits you, I will be at the station Sunday. If not, perhaps you could telegraph me: the time is too short for a letter. If you are not yet acquainted with Murnau, it will give you great pleasure.

With warmest greetings, also from Miss Münter.

Kandinsky

Berg on the Starnberger See
c/o Frau Widl 26 August 1911

Dear Mr Kandinsky,
I thank you heartily for your invitation. Unfortunately, I cannot come to you
this Sunday, because I cannot be away from my work for such a long time
right at the moment. Also, my wife is not really well, and on that account
alone I did not think I could be away. Therefore I would be glad if you would
visit us, as you suggested, in the coming week. In about a week I will be
finished with my work and then I will certainly return your visit. But please:
let me know which day as soon as possible so that I can make arrangements. I
should also go to Munich once during that week and if I know in plenty of
time when you are coming, then I can easily arrange my schedule. I already
look forward to the pleasure of meeting you, and greet you cordially.

Your Arnold Schoenberg

Murnau Sunday [*probably 29 August 1911*]

Dear Professor,
I received the telegram yesterday, the letter today. Many thanks! After long
deliberation I have decided to come to you the day after tomorrow (Tuesday).
It is very difficult for me to find another day this week and to postpone it to
next week would be too long for me. Actually, it was already arranged with
the Marcs that we would go there on Monday, so I can leave from there on
Tuesday and arrive at Schloss Berg by boat about 11.40. I would be able to stay
until 5.35.
 If this is in any way inconvenient for you, please cancel by telegraph.
Address: Marc, Sindelsdorf. If I do not receive a telegram there tomorrow, I
will set off the day after tomorrow.
 With kindest regards,

Your Kandinsky

Murnau 7 September 1911

Dear Mr Schoenberg,
Many thanks for the letter. I also got a letter from Marc yesterday. He asks
when I am expecting you and requests, if possible, putting off our all meeting
to next week, since this week it would be *very* difficult for him to come. So
perhaps we should arrange it for everyone's convenience, that you come on

Wednesday of next week (as early as possible!) and, if this day suits you, the Marcs will also come to our house. As soon as I have your answer I will pass it on to Marc.—The two issues of the *Merker*[6] have just arrived. Many thanks. Now they will be studied.

With kind regards and my respects to your wife,

Your Kandinsky

Of course we expect both of you!
Depart Berg 7.50 Arrive Tutzing 8.10
Depart Tutzing 8.41 Arrive Murnau 10.00

Berg on the Starnberger See 10 September 1911

Dear Mr Kandinsky,

I hope that nothing will prevent me. I will come to you Wednesday, as you suggest. If something comes up, I would indeed have to telegraph and then come Thursday instead. But I think that it will work. My wife will probably come with me, and is looking forward, as am I, to the meeting. In the meantime, then, kind regards,

Your Arnold Schoenberg

My timetable:
Depart Leoni 7.50 Arrive Tutzing 8.10
Depart Tutzing 8.41 Arrive Murnau 10.00

I will not visit Strauss this time![7]

Berg on the Starnberger See 11 September 1911

Dear Mr Kandinsky,

I *cannot* come on Wednesday after all. I forgot something which I will tell you about.—Rather, I will come instead Thursday the 14th for certain, if you do not write to the contrary. I can also come Friday or Saturday, perhaps even Sunday.

Then I must ask you about something else. Can you recommend me a doctor (perhaps a specialist) for the following matter: my daughter has had for some time a skin ailment on her feet—open, festering sores. We think it is a constitutional problem, connected with malnutrition and anemia, and have adequate grounds for this opinion.

Now I would very much like to know of a competent doctor, who does not demand colossal sums. I am not a rich man. Quite the contrary—I am a capable musician! Therefore I can on no account pay the fees which these 'professors' demand from visitors or rich residents. I should therefore be glad if you could give me the name, and if possible recommend to me, someone from Munich who could charge me 'artists' prices' as it were.

I would be grateful if you could write to me immediately about this.

In the meantime, goodbye, with many kind regards,

Your Arnold Schoenberg

18 September 1911

Dear Mr Schoenberg,
Wednesday or Thursday I must be in Munich, for two or three days in fact. So I will telephone you about eleven on Wednesday, in order that we can make an appointment. Your visit gave us all great pleasure. I send you many hearty greetings. Give my regards to your wife.

Your Kandinsky

[*almost certainly Tuesday, 21 September 1911*]

Dear Mr Schoenberg,
Our Munich address is Ainmillerstrasse 36, I, Gh [garden house]. I promised to inform you of it, and now it suddenly occurs to me. We travel to Munich tomorrow evening and will be staying there until about Monday or Tuesday.

I will telephone you tomorrow about eleven.

Kind regards from both of us.

Your Kandinsky

Murnau [*probably end of September 1911*]

Dear Mr Schoenberg,
On the third day of the work on *Der blaue Reiter*, we think again how fine it would be if we could all be together once more—if only for a short time. And kindest regards from

Maria Marc Aug. Macke
Elisabeth Macke[8]

31

[*Münter's handwriting*] If we just could be [together] for a short time—or better, for a long time!

Kind regards, G. Münter
Kandinsky

[*Münter's handwriting*] Munich, 27 September 1911

Dear Mr Schoenberg,
Here is the reminder. Please be so good as to see to it that the article which was mentioned from the *Pocketbook** in question reaches Kandinsky's hands as soon as possible—and also other good things which you have written.[9] You would also do a very good turn if you would have sent to us directly good reproductions (photographs or plates) of pictures by Kokoschka,[10] who as you know is also in Berlin. If not, may we ask for Kokoschka's address, so we may apply to him ourselves? Work on *Der blaue Reiter* is forging ahead. A mass of work. The printing should be started, so help us! Forge with us, so that the goal is reached.

We are anxiously awaiting articles and material for illustrations.

And how are you and your family getting along in Berlin? You will surely excuse Kandinsky for not being able to write himself today. I must also write to Mr Berg immediately about your pictures.

And now—I too must hurry. Kindest regards and best wishes from both of us, in which the Marcs also join.
Yours truly,

Gabriele Münter

Munich 7 October 1911

Dear Mr Schoenberg,
Did you feel today (that is, *particularly* today) that here among us your music and yourself were *much* spoken of?

Many thanks for the *Pocketbook*. (Today I received the second copy directly from the publisher.)

Will you send something more for *Der blaue Reiter*? The beginning of 'Teaching'[†] is unbelievably fine: every sentence like a pistol shot. Bang! Bang!

* *Musikalisches Taschenbuch*, vol. II.

† Schoenberg's 'Problems in Teaching Art' ('Probleme des Kunstunterrichts') in *Musikalisches Taschenbuch*, vol. II (see note 9).

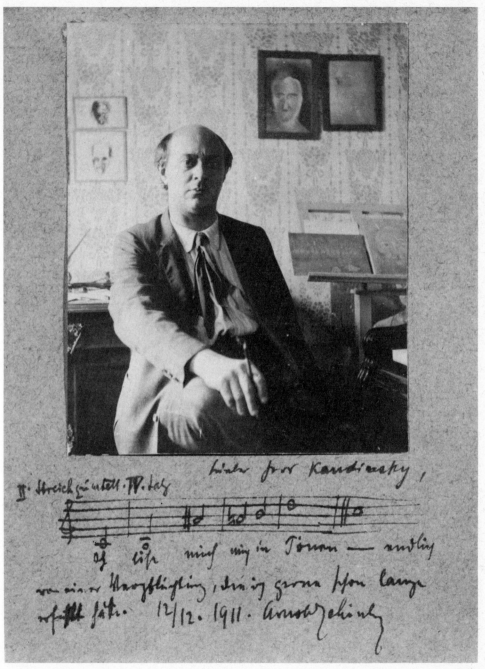

1. Arnold Schoenberg, before 1911, with dedication to Kandinsky:
Dear Mr Kandinsky, I am discharging in musical tones an obligation I have long wished to fulfill.
12 December 1911 Arnold Schoenberg

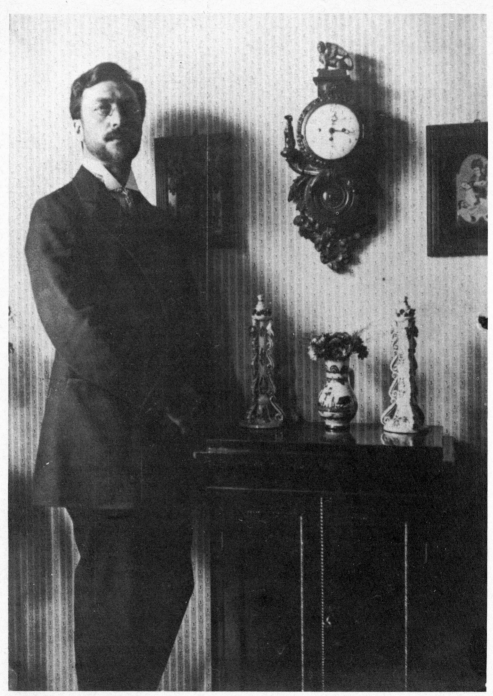

2. Wassily Kandinsky, sent to Schoenberg with a dedication in 1911

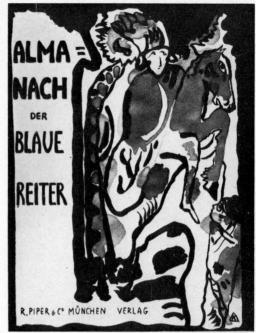

3. Kandinsky's dedication on the back of his photograph (plate 2):
To Arnold Schoenberg, with feelings of profound affinity Kandinsky Munich, 9 April 1911

4. *Der Blaue Reiter*, 1912 almanac edited by Kandinsky and Marc

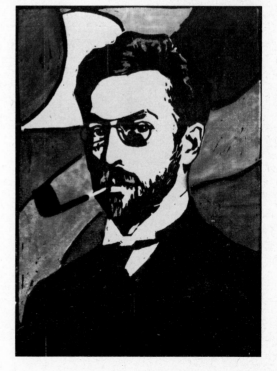

5. Wassily Kandinsky, woodcut by Gabriele Münter, 1906

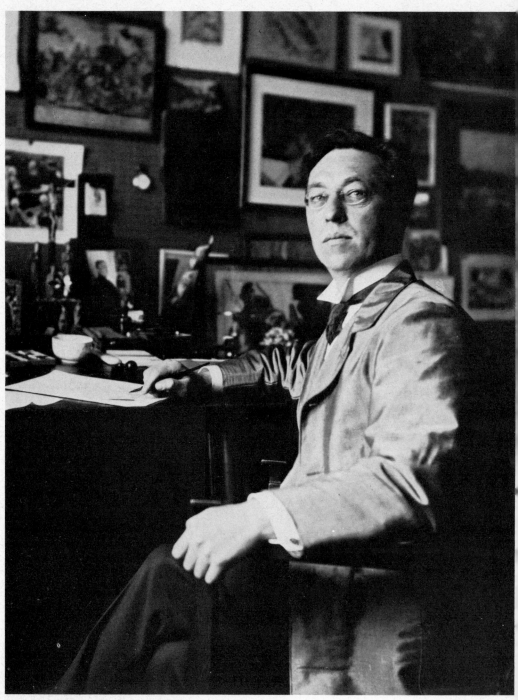

6. Wassily Kandinsky at his writing desk, 1912

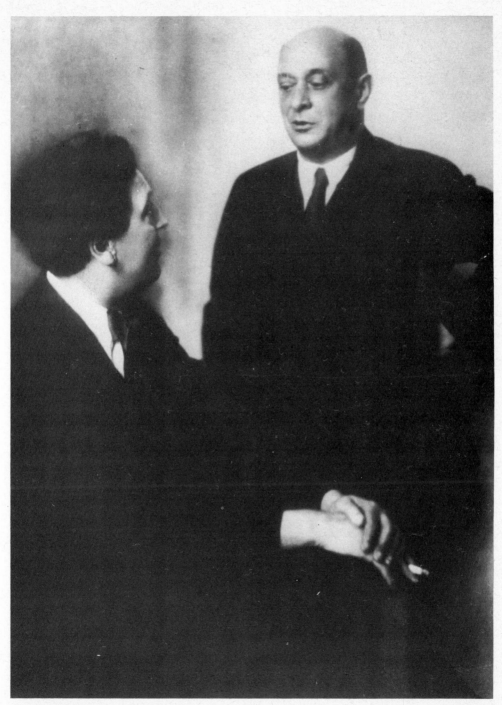

7. Arnold Schoenberg with his pupil Alban Berg, about 1911

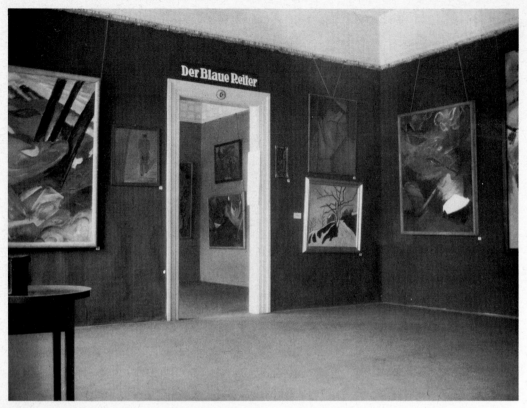

8. A room of the first Blaue Reiter exhibition, 1911–12, photographed by Gabriele Münter. Schoenberg's self-portrait at left, near the door

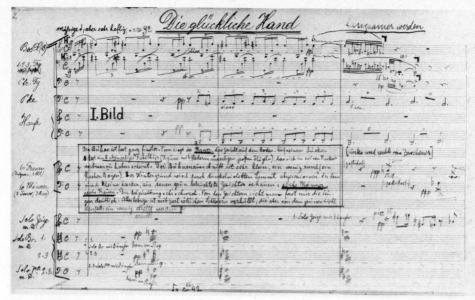

9. Page from the full score of Schoenberg's music drama *Die glückliche Hand* with textual additions

ARNOLD SCHÖNBERG
Nach einer Amateur-Aufnahme

ARNOLD SCHÖNBERG

MIT BEITRÄGEN VON ALBAN BERG
PARIS VON GÜTERSLOH · K. HORWITZ
HEINRICH JALOWETZ · W. KANDINSKY
PAUL KÖNIGER · KARL LINKE
ROBERT NEUMANN · ERWIN STEIN
ANT. V. WEBERN · EGON WELLESZ

R. PIPER & CO · MÜNCHEN 1912

10. The Festschrift for Schoenberg by his pupils and friends. Kandinsky's essay on Schoenberg's paintings is printed in this volume

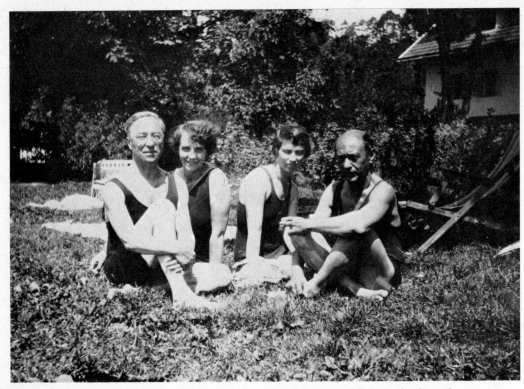

11. Kandinsky and Schoenberg with their wives Nina and Gertrud at Pörtschach on the Wörthersee, 1927

MUSIKALISCHES
TASCHENBUCH

❀ 1911 ❀
ZWEITER JAHRGANG.

ILLUSTRIERTER KALENDER
Für Musikstudierende und Freunde der Tonkunst.

MIT AUFSÄTZEN

von MAX MOROLD, ARNOLD SCHÖNBERG, ALBERT ERNST, RUDOLF KAISER, Dr. THEODOR HELM, Dr. VIKTOR JOSS, Doktor KARL PREISS, KARL DÖRR, T. KOTYKIEWICZ, ANTON POLLER, DANIEL FUCHS u. a. und einem statistischen Teil von KARL BIXNER.

Hiezu ein Anhang (Kalendarium).

❖

PREIS K 2.—.

Druck und Verlag von Stern & Steiner, Wien, II/3.

Bang! One would like much more of that: it tastes too good. And the piano piece?? Mr Alban Berg[11] has written to me that he is sending your pictures, a short composition of his own (I asked him for it), and that he is taking charge of your moving arrangements. Has your move been definitely decided? Has it already been settled? Write me something about yourself and your family. How are you?

Do you see Kokoschka? Is he doing fine things? Could one obtain photos?

Don't be annoyed. You know, after all, how important it is that the first number of the *Reiter* comes out well: varied, serious. If it is *in any way* possible, give me yet another article (even if a very short one). Even if not till November!

Don't forget that you still owe me your picture, I mean your photographic portrait. I can wait still longer, but I must have it!

Many cordial greetings from us both, also to your wife.

Your Kandinsky

Arnold Schoenberg
Berlin-Zehlendorf, Wannseebahn
Machnower Chausee, Villa Lepke 11 November 1911

Dear Mr Kandinsky,
I am already very curious about *Der blaue Reiter*. When will it finally appear then? Or have you not yet reached that point?

I have still not found the time to write you an essay for the second number, but perhaps I will get to it soon. At the moment, it would hardly be possible, since from 20 November on I will have begun a series of 8 – 10 lectures on 'Aesthetics and the Theory of Composition' at the Stern Conservatory. As you can well imagine, the object is to overturn both. Perhaps I will prepare one of these lectures in written form and give it to *Der blaue Reiter*.

Besides that I cannot tell you much about my stay here yet. So far no students have been found here for me. That will probably take more time. On the other hand, Rosé[12] will play my First Quartet here in December. Other performances are also at hand. In Paris a whole evening of chamber music and Lieder. Then in Prague my Second Quartet, and a concert in which I will conduct. In Munich the Sextet. In Vienna a choral work. All that will certainly be useful.

In Berlin people must of course first get to know me, and that I expect from my lectures. I hope that I may still succeed in making Hell hot for the Berliners.

34

Now I must also tell you that your pictures made a great and lasting impression on me. Much is still before my eyes. The dreamlike nature of the impressions, that which is wild and nevertheless clearly controlled, and in particular the incredibly strong effect of the colors. I would love to see them again. And I have also reflected often on Miss Münter's pictures. The remarkable and yet womanly strength of her works touched me extraordinarily.

I would like very much to see you both again. You wanted to come to Berlin: is there some prospect of this?

I am living in great style here. Right in the woods!! Actually right in the country. Almost an hour away from Berlin proper. I wish that you could see it. The Berlin landscape has a peculiar beauty which is completely different from that of the Viennese landscape. Particularly the woods and the atmosphere. It suits me extraordinarily—although I am very, very fond of the Austrian landscape. Perhaps for that very reason.

Now I hope that you will write something to me soon. I would also like to know what you have to say about my pictures, which you now have there in the original. By the way, do you need them much longer? Have you already made photographs of them?

Many kind regards to you and your wife from me and my wife.

<div align="right">Your
Arnold Schoenberg</div>

Munich 16 November 1911

Dear Mr Schoenberg,

Your letter pleased me very much. Fine—all those concerts! When will the one in Munich be? I am tremendously happy about it. A whole evening in Paris—really splendid. There I could get something into the press through Le Fauconnier.[13] Would you like that? I am also happy that you are so nicely housed. *Perhaps* we will come to Berlin in January. Now, the *Blaue Reiter*! It will not appear before the middle of January, perhaps even at the end. And therefore you have more than a month for your article. First number without Schoenberg! No, I won't have it. We will quite certainly have 3 – 4 articles on music—France, Russia. One of these is long, is entitled 'Musicology,' comes from Moscow and will turn many things upside down.[14] Give us 10 – 15 pages! As I said, it *must* not be without Schoenberg.

In your pictures (which I received from the carrier only yesterday: we have been back in Munich two days) I see a *great* deal. And two roots: 1) 'pure'

<div align="right">35</div>

realism, that is, things as they are, and at the same time their *inner* sonority. It is that which I foretold in my book as 'fantasy in the most austere subject matter.'* It is at the opposite pole from my own art and . . . grows spiritually out of the same root: a chair lives, a line lives—and that is finally, and fundamentally, equivalent. This 'fantasy' I love very much, most particularly as it occurs in your pictures! The 'Self-Portrait', the 'Garden' (not the one I wanted, but also a very good one). 2) The second root—dematerialization, romantic-mystical sonority (thus, also that which I create) pleases me less in *this* application of the principle. And . . . yet these things are good too and interest me very much. Kokoschka also has this second sonority (= root) (seen three years ago, so 'had'), along with the element of 'strangeness!' That interests me (I am happy to see it) but does not make me vibrate spiritually. For me it is too binding, too precise. When something of the sort stirs in me, I *write* (I would never paint it). And I say merely: he had a white face and black lips. That is enough for me, or rather, it is *more*. I feel more and more strongly: in every work an empty space must remain, that is, not bind! Perhaps this is not an 'eternal' law, but a law of 'tomorrow.' I am modest, and content myself with 'tomorrow!' Yes, indeed!

Please write to me also about how my works in the 'Neue Secession' affect you.[15] I was actually always sure that *you* would understand and be sensitive to Münter. In general, very few people are sensitive to her work. Yes, these dear elephant hides! I am fortunate: I bruise the hides of the dear little beasts! Here the means of both of us match perfectly. So make Hell properly hot for these Berliners! Those fellows must be made to sweat and writhe. Naturally we don't need to provide for this *deliberately*. I have a friend who, without meaning to, squeezes your hand so hard on shaking hands that everyone says 'ouch!' Then he immediately begs your pardon. We are not that well brought up.

I have a lot of work. And many wishes as a painter. Why is there so little time? Also, I feel particularly strongly at this time that all of us will 'live' often again. I mean, in body. And this long, long path.

I shake your hand warmly and we both greet you and your wife. Has the little one completely recovered?

<div style="text-align:right">Your Kandinsky</div>

*Kandinsky, *Über das Geistige in der Kunst* ('On the Spiritual in Art'), 10th edn (Berne: Benteli, 1973), p. 127.

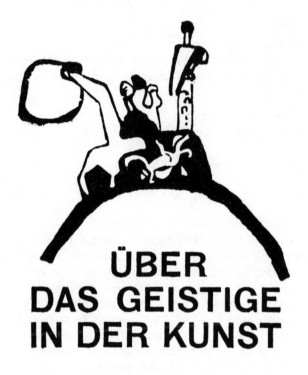

KANDINSKY

**ÜBER
DAS GEISTIGE
IN DER KUNST**

On the Spiritual in Art was published by Piper in Munich, 1912

Munich 6 December 1911

Dear Mr Schoenberg,
The three of us have read a review of your D minor Sextet in the 'M.N.M.'
[*Münchener Neueste Nachrichten*] and are very happy for you and also for our
common cause. [16]
 We shake your hand cordially and send kindest regards to your wife.

Kandinsky

Please write again!!

[*Marc's handwriting*]
At New Year I and my wife will be coming to Berlin, and I look forward very
much to seeing you again there. Naturally, I will write to you beforehand.
Kind regards, F. Marc

[*Münter's handwriting*]
Because of lack of space I will just add kind regards,
Münter

Berlin-Zehlendorf 14 December 1911

Dear Mr Kandinsky,
I have still not read all of your book, only two thirds of it. Nevertheless, I must
already write to you now that I like it extraordinarily. You are certainly right
about so many things, particularly what you say about color in comparison to
musical timbre. That is in accord with my own perceptions. Your theory of
forms is most interesting to me. I am very curious about the 'Theory' chapter.
I am not in complete agreement with some details. In particular, I do not agree
when you write, if I understand you correctly, that you would have preferred
to present an exact theory. I do not think that is necessary at present. We
search on and on (as you yourself say) with our feelings. Let us endeavor
never to lose these feelings to a theory.
 Now I must write to you about your pictures. Well: I liked them very much
indeed. I went immediately, on the day after I got your letter. 'Romantic
Landscape' [see Plate 16] pleased me the most. The other pictures
are not hung very advantageously. There is something that I cannot
reconcile myself to: the format, the size. I also have a theoretical objection:
since it is only a question of proportions, for example

 black 24: white 120
 by red 12: yellow 84

it cannot possibly depend on the format, because I can certainly say the same thing if I reduce it, for example by 12:

$$\text{black 2: white 10}$$
$$\text{by red 1: yellow 7}$$

I believe it is easier to grasp this equation if it is reduced.

Practically expressed: I feel these color-weights less, because they disappear too much from my field of vision. (A few escape me entirely.) I had to stand far away, *and then of course the picture is smaller, the equation 'reduced'.*

Perhaps I have for this reason less of an impression of the very large pictures, because I could not take them in as a whole.

Now to Miss Münter's pictures: although I did not immediately remember them, they attracted my attention at once as I entered the room: They are really extremely original and of salutary simplicity. Absolute naturalness. An austere undertone, which is certainly a characteristic feature, behind which goodness and love are hidden. I enjoyed the pictures very much.

Mr Marc's pictures also pleased me very much. There is a curious gentleness in this 'giant'. I was actually surprised by this, but I soon managed to bring it into harmony with the impression I had of Marc. Very likeable, in any event. Otherwise, not much pleased me in the exhibition. Best of all a Mr Nolde,[17] whom I then met, but I did not like him personally very much. Then from Prague: Kubišta.[18] He is affected, but has talent and courage!! The Berliners will turn their hand to anything. Especially to what is the 'latest modern,' I guessed immediately that there must be a Frenchman who painted 'Bathing Women'. These you will find five or six times in the room. Exactly like Cézanne. On the other hand, I would be glad to find out which Frenchman provided the original for the many 'circus people!'[19]

I am very sorry that you don't like my pictures very much. Also, the most important ones were not sent to you in every case. But nevertheless in large part.

Now to the *Blaue Reiter*. I believe I can after all give you some of my music for reproduction. How long may it be? May it be four to five pages? Or shorter? Write to me about this at once! On the other hand, I have still not written anything for you. My lectures at the Stern Conservatory take up so many of my thoughts. Perhaps it will still come!

Now something else:

I am to send my pictures to Budapest for an exhibition. I have been alloted a whole room for twenty-four paintings.

Now I have no idea which ones you have. Could you not notify me? And: would you be willing to send the pictures directly to Budapest? That is, those that I specify to you (charges to be collected on delivery!). The others come to

me. That is to say, I am exhibiting no portraits or such, but only those paintings which I call 'Impressions' or 'Fantasies'. I believe you have eight paintings there, but there are certainly portraits (finger exercises, scales) among them. Please write to me immediately about this. And you will be so good, won't you, as to send on the pictures as soon as I write you.

I recommended to the painter Gütersloh[20] that he get in touch with you.

Adolf Loos,[21] the *most outstanding architect*, has also written to you at my suggestion. Also concerning Kokoschka! What have you arranged with him?

I hope you can read my letters more easily than I yours.

I have sent you my *Theory of Harmony*. You will be astonished at how much I say that is closely similar to you.

Today I am at last sending you my photo.

Please greet Miss Münter most warmly for me. I will write separately to her soon. Then also Mr Marc and the others whom I found on your card.

Many kind regards to you. In sincere friendship,

Your Arnold Schoenberg

Munich 15 December 1911

Dear Mr Schoenberg,

Many thanks for your picture, your book and your letter. All that has given me *much* pleasure. I will just say that immediately. I am very tired, but cannot put off the letter till tomorrow.—I wanted to exhibit the following of your pictures (the exhibition begins Tuesday the 19th): 'Self-portrait,' 'Lady in Pink' (perhaps 'Landscape') and two or three 'Visions', which make a strong impression on everyone, just as they do on me (but I *love* the realistic ones). Our exhibition is becoming *very* interesting, with a variety of forms. With regard to Budapest, I will naturally be *very* glad to do everything.—More later! Both of us greet you warmly, and your wife as well.

Your Kandinsky

Munich 16 December 1911

Dear Mr Schoenberg,

Please let me know your prices *right away*. We will not be able to produce a real catalog: no time, but simple typewritten lists. Also printed circulars.

Kind regards!

Your Kandinsky

Munich 20 December 1911

Dear Mr Schoenberg,
Many thanks for the letters, and especially for the promised music. It would be better not to go over four pages, but one cannot set fixed limits in such a case. I will take care of your pictures. Four are already hanging in the first Blaue Reiter exhibition: 'Self-portrait,' 'Landscape,' and two 'Visions.' If you wish, I will send you these by mail on 30 December. If possible, leave them with us: we are very probably going on tour. You should not be missing. The exhibition is *ff!* [= Fortissimo *sic*.] And makes an impression. . . . In two days, five sales. In haste! Kind regards, from Miss Münter too!

 Your Kandinsky

PS I am still *swamped* with work.

Berlin-Zehlendorf 12 January 1912

Dear Mr Kandinsky,
I have heard nothing from you for a long time now, but I would like to know if you sent my pictures to Budapest promptly. Then: what did people say about them? Reviews, etc.? And finally, how is the *Blaue Reiter* coming? When should I send you my musical supplement? And: what have you to say about my *Theory of Harmony?* I still haven't heard a word from you about it. I sent it to you immediately after I got it, as I was getting 'flu.
 Please greet Miss Münter very cordially from me. When are you coming to Berlin? On 28 January there is to be (??) an evening of my compositions here (???).
 Many kind regards,

 Your Arnold Schoenberg

Munich 13 January 1912

Dear Mr Schoenberg,
I am really very ashamed. But it isn't laziness! I will just briefly list for you what I am doing: 1) the *Blaue Reiter*, that is, write, read and correct articles, etc., 2) arrange Exhibition I of the B.R., 3) prepare Exhibition II of the B.R., 4) invite Germans, Frenchmen and Swiss for the exhibition in Moscow (I have

unlimited authority, therefore also unlimited responsibility),[22] 5) help in the buying and selling of unfamiliar pictures, and as a result constantly 6) read and write letters which are always hurried, and often complicated, often very unpleasant (there are days when I get letters with each of the five mail deliveries, there are days with twenty incoming letters, and there is never a day without letters), 7) I owe letters, 8) I don't paint, 9) I neglect my *own* affairs. In two weeks I have written over eighty letters. My only hope is that it will change when the *Bl. R.* is finally printed, and the exhibitions are arranged. I am already tormented by two pictures which I would like to paint—one is finished in my mind, the other I would like to attempt—So don't be angry with me! After all, you also do not answer my letters very carefully. I asked you for the prices of your pictures a long time ago and whether we could keep some for our *B.R.* exhibition. I sent everything to Budapest long ago with the following exceptions: 1) 'Self-portrait,' 'Landscape,' and two 'Visions' were exhibited by us 2) the portrait 'Lady in Pink' you did not wish to have sent (it is still with me). Following your wish, I separated 'Landscape' from group I (it is at Thannhauser's);[23] the other three travelled with our exhibition to Cologne, and have the firm intention of travelling still further. These pictures have done very well with us. And who told you that I do not like your pictures? It is only that the origin of the 'Visions' is not clear to me, and I would be very pleased to hear something *soon* about this. It's very important to my article in the *B[laue] R[eiter]*!!

I was firmly convinced that I thanked you immediately for your book. It really gave me great pleasure. And the dedication! I had scarcely stuck my nose into it when Hartmann[24] came and grabbed the book away from me. He wanted to read it *without fail* and *immediately* and could not find it on sale here yet. I must get it back one of these days. I was annoyed with Hartmann and grateful too, because he explained to me a lot which I certainly would not have understood in your book. We spoke about it for hours, and what I have already got from it pleases me *very* much. Wouldn't you send your book to the Moscow Conservatory? It is a pity that Hartmann, who originally wanted to travel from Prague to Petersburg by way of Berlin (mainly to meet you), had to travel directly to Russia after all.

Your letter about the visit to the Neue Secession pleased us all very much, and most particularly the detailed reports on our (also Marc's) pictures. All the same, I must disagree, naturally! In mathematics 4:2 = 8:4. In art—no. In mathematics 1+1 = 2, in art 1−1 = 2 can also exist. Secondly: are you against the doubling of orchestral forces? Now, that is only enlargement (and thus complication) of the means. But thirdly: it is precisely my intention (sometimes) to prevent, by means of the dimensions, the pictures being taken in at a glance. Fourthly, size is a force, a means—such a candlestick 🕯

and such a one ⬡ are two completely different beings!

Around this time Marc and his wife will be visiting you, or have already visited you. He has become a rather enthusiastic art-Berliner. It is true that much more is going on there. Think of living there! But just between ourselves, I see no great personality emerging there as yet.

Perhaps I will travel to Russia in spring. If so, by way of Berlin. Then I will see you. One can say so little in a letter. And many of us put off writing letters, don't you think? And many of us excuse it, isn't that so?

Kind regards from both of us to you and your wife.

Your Kandinsky

PS Can you please send me your music *quickly?* And the article? Must I get along without it? Write something quickly! How can German music not be represented by an article? There will be two on Russian music.

Munich 16 January 1912

Dear Mr Schoenberg,

I am very sorry that I have inflicted something unpleasant on you. I only thought that your pictures would help the ensemble of the exhibition, and that at the same time they would be shown in various cities, and in good company, which could be helpful to you. Perhaps I wrote to you unclearly in December! So please excuse my arbitrary action! Won't you?—I scarcely believe that they are still waiting for those pictures in Budapest. In any case, I would ask you, if you do want the pictures sent, to write by return post to Miss E. Worringer—Gereonsclub, Gereonshaus, Cologne—about it. I will write to her at the same time as this letter and ask her to act according to your wishes. I will have the 'Nocturne' sent from here (by mail). I have already taken various steps about your concert—in Moscow and Petersburg. Perhaps it will be useful in the end. The new Petersburg society 'ARS'[25] also wants to put on concerts. I already wrote to them in the early autumn about

43

your music. And they showed a lot of interest in you. But the society is not yet completely organized.—So, I expect your article and am happy about it! Today I gave the last manuscripts to the printer. So send it with all speed! And the music? I have just ordered your self-portrait in Cologne to be photographed. This is for the B[laue] R[eiter], which is to be completely ready (printed, and so on) in five to six weeks. If you only knew what a job it is!— May I send you something for revision? It is an article about Scriabin, which I had to translate myself, and I am in mortal fear that I have misused various specialized terms! Oh, do help me please! The article is quite short. Would you?—Tomorrow I am going away for two or three days to settle my head more or less in the right place again—at the moment it's somewhere else! Kind regards from house to house, and don't be offended with me if I behave somewhat unclearly.

<div align="right">Your Kandinsky</div>

[Münter's handwriting] *[probably between 17 and 27 January 1912]*

Dear Mr Schoenberg,
I only want to let you know quickly that your article, 'The Relationship to the Text' has arrived, and most of all, that I am very delighted by your contribution to the B[laue] R[eiter] and by this article (which has *just* come, and which I have just glanced at) as by everything of yours. Yesterday Kandinsky went away for a few days' rest. He really needs it: these have been frantic months! Publisher, editor, article writer, arranger of several exhibitions, picture-selling agency—in this situation the painter and the human being no longer have a chance. Yesterday 'Night' went off to Budapest and 'Lady in Pink' to you. The former insured for 300 marks. The latter had already been sent off, and I hope *very* much that it arrives in good condition. I have taken up my pen so quickly because your beautiful contribution immediately filled me with enthusiasm!

I hope the Marcs will visit you soon now. They have been intending to for a long time and something has always prevented it. Kind regards to you and your wife.

<div align="right">Your G. Münter</div>

Have already read article, which is very fine! I only disagree about the 'portrait.'* Who is right? (Of course, it is only a question of words.)

*'[. . .] in all music composed to poetry, the exactitude of the reproduction to the events is as irrelevant to the artistic value as is the resemblance of the portrait to its model [. . .]' (Schoenberg, 'The Relationship to the Text', *Style and Idea*, p. 145)

[Münter's handwriting] Munich, 27 January 1912

Dear Mr Schoenberg,
Many thanks for your friendly note. So your concert is tomorrow, and by the time you get my letter, it will already be over and I hope I do not disturb you too much. [. . .]

One of these days Kandinsky will send the short article which you are kindly willing to revise. He also asks you particularly to send your music *as soon as possible*. Kandinsky does not know Koussevitsky personally.[26] However, he knows about him and also attended a concert conducted by him in Moscow last year. He is one of the most radical young conductors.

And how will your concert have gone? I wish that I could be there. What is being performed, pure Schoenberg? It would be nice if you would report a bit about it. How is the public in Berlin? The Marcs will be back any day now. Did they finally visit you?

Kind regards from our house to yours.

 Your Gabriele Münter

[undated slip of paper, probably beginning of February 1912]

Dear Mr Kandinsky,
Wouldn't you also like to ask for a contribution from Busoni?[27] He is very closely connected with us. Read the 1 February issue of *Pan* or his *New Aesthetics of Music*.

 [Unsigned]

Munich 6 February 1912

Dear Mr Schoenberg,
We are very happy that the concert went so well. We congratulate you heartily and wish you GREAT inner and outward success in Prague. Would you send us reviews? You would get them all back in good order. When is your concert here? Various acquaintances here are asking about it. And we are too.

I hope I do not startle you too much with the Scriabin revision. If you would be so good as to undertake it *after* the concert. I am afraid that we have shoved all sorts of musical nonsense into our translation. I would be very, very grateful to you.

45

To 'complete' your title was Piper's[28] doing. I have also written to him that I am curious what you will think of it. Can I take charge of the second proofs myself?

It made me very happy that you sent music after all. I had already begun to give up hope. Fortunately, it was still possible for me to mention it in the prospectus, which just today went back to the printers after the correcting of the first proofs. Very fine!

Now I hope you will not be annoyed that I have given Piper instructions to order by telegraph a photo of your 'Lady in Pink' for the *Blaue Reiter*. I *had* to have it in time! And there is a GREAT hurry.

And I am also in a *great* hurry! Many kind regards from us both to you and your wife.

<div align="right">Your Kandinsky</div>

(PS) I hope that you have already sent the photo. As I said, I must have it *very* quickly.

[Telegram from Munich to Schoenberg, c/o Zemlinsky, Prague, Hawliczekgasse 9. Probably February 1912,[29] when Schoenberg conducted his Pelleas und Melisande, *Mozart, and Bach-Mahler in Prague]*

Thinking of you warmly.

<div align="right">Münter Kandinsky</div>

Munich 4 March 1912

Dear Mr Schoenberg,
The heartiest congratulations from both of us and from Marc (he is in Munich at the moment) on your splendid success. That even our dear 'M.N.N.' *[Münchener Neueste Nachrichten]* allowed itself to be inspired to an enthusiastic review of your concert is as significant as it is unheard of![30] I am impatiently awaiting your promised letter, in which you will certainly write *fully* about your concert. I had a *very great* desire to travel to Prague for the concert, but how should I have done it—I, poor slave of the *Blaue Reiter*. Day after day passes in unceasing concern over it: the book, the exhibitions, and so on and on. I have no time for anything else. I await the book's appearance with longing. If you only knew how I yearn for my work, how I would like to draw and draw, paint, paint and paint. But enough sentiment, and let us proceed to serious business.

46

The editorial staff of *Der Sturm* is producing an exhibition which will apparently be really splendid (the French, Hodler,* Munch, Kokoschka) and has invited our first exhibition as a whole: freight, our own rooms. We have accepted. Now comes the urgent and heartfelt request: please let us have the pictures by you which are already mentioned in our catalog and—the portrait of a lady which hangs in your dining room as well! I am unfortunately not clairvoyant, and ask *especially* for this portrait, as Marc is always talking about it with great enthusiasm. Please do us this favor! The pictures must be delivered to Mr Herwarth Walden[31] (at present Berlin W. 9, Potsdamerstr. 18), with details of price and title. Please paste the slip on the back and also notify me of the price and title. Will you really be so good as to do all that— and above all to send the portrait??

We greet you warmly, and also your wife.

Your Kandinsky

[PS] *When* is your concert here? Aren't you coming in person?

Munich 4 March 1912

PS to today's letter!
Dear Mr Schoenberg,
Piper is a manuscript collector. His father began it. He has autographs of Beethoven, Liszt and so on. He is very enthusiastic about your music and asked me timidly if you would not give him the manuscript for the *Blaue Reiter*. When I told him I would ask you he was delighted. Naturally, I said that I would be glad to ask you about it, but that I had no idea whether you would be willing to do it. Please be so good as also to mention this request in your letter, which I eagerly await.

Once again, many greetings,

Your Kandinsky

Berlin-Zehlendorf 8 March 1912

Dear Mr Kandinsky,
To begin with, I must tell you that your article about my pictures gave me really enormous pleasure. Above all, the fact that you considered my pictures worth the trouble. But then also what you say. And what you say over and

*Ferdinand Hodler (1853 – 1918), Swiss painter and sculptor whose work reflects both Symbolism and Expressionism.

above that: you are such a full man that the least vibration always causes you to overflow. Hence on this occasion too you bestow an abundance of the most beautiful ideas. I am very proud to have found your respect and tremendously glad of your friendship.

Now to my Prague concert. I cannot say much about it, since I did the whole thing in a half-conscious state compounded of anxiety and fatigue. I was anxious, about the conducting, and I was tired on account of the many social evenings and nights, which completely destroyed my usual peace. Therefore I had no strong impression. Subjectively, I believe the performance was very good. The audience response was remarkably excited. More than twenty minutes of the loudest hissing and applause! It was exactly the same on 5 March in Berlin, with Rosé, who performed my First String Quartet. Here I am engaged in a violent feud with the Berlin critics, brought about by two articles which I published in *Pan* against Leopold Schmidt (on 20 and 27 February). The rest of the critics are taking revenge on me on behalf of their pope!! But perhaps the affair will go still farther![32]

Now about the exhibition, above all, I thank you very much for the invitation, which is a great honor for me, but I don't know yet whether I can take part. Mr Walden delivered himself at one time of a really coarse review of *Pelleas und Melisande* (an act of vengeance) and so I cannot very well take part unless he asks me directly.[33] Even then I believe, although I by no means take him so seriously, that I cannot take part. But moreover: I do not believe it is advantageous for me to exhibit in the company of professional painters. I am surely an 'outsider,' an amateur, a dilettante. Whether I should exhibit *at all* is already a question. Whether I should exhibit with a group of painters is almost *no longer a question.* In any case, it seems disadvantageous to me if I exhibit paintings other than the ones in which [I] believe! And I would certainly have to show at least 10 to 12, if people are to get from them what I wish.

So don't be annoyed at me—please, you already know how fond I am of you, and how unwillingly I would do anything disagreeable to you—if I do not take part in the exhibition for the time being.

Before I forget: if it is the manuscript of my article that Mr Piper would like to have, it would be a pleasure for me to let him have it. On the other hand, I should be glad if I could have a few (5 – 10) offprints or galley-proofs of this article. I can also only let him have the manuscript of the songs if I can have offprints (I need these for performances).

Up to now I have not yet been able to answer Miss Münter's letter. I have so terribly much to do. However, as soon as I can somehow find time, I will write in detail. Please give her many kindest regards from me.

At the moment I have to prepare a lecture which I am to give in Prague. On

'Gustav Mahler.'[34] I would be very happy to give it in other cities as well, because I attach great importance to it. I would like, since I feel that it is my duty as an artist, to speak up for his works everywhere. Could the *Blaue Reiter* perhaps organize this in Munich? However, I really don't want to burden you still more with arrangements. I really only say it because it has just occurred to me at the moment and I won't mind if you want to forget it again in the same moment.

Actually, I took it for granted that you and Miss Münter would visit us in Berlin! Can this perhaps still take place? Or have you given up the idea? It would be really fine! I would love to get together with you again!!!

When will the *Blaue Reiter* appear? I am already extraordinarily anxious to see it.

And now, many, many kindest regards from your

Arnold Schoenberg

[Münter's handwriting] Munich, 9 March 1912

URGENT

Dear Mr Schoenberg,

A quick business letter. Kandinsky welcomes your lecture at the Blaue Reiter with joy. He had already spoken of asking you to give a lecture at our exhibition if you come. Dr Stadler,[35] an art historian, gave a short lecture at the exhibition, which was followed by *lively* discussions—the lecture has been further developed and extended, and will be repeated today. The M.N.N. *[Münchener Neueste Nachrichten]* have refused to print the notice announcing the lecture with the excuse that as they had done it once, they did not need to do so again! So the event is only posted and people will surely come. Now Dr Stadler is speaking about the exhibition. J. A. Lux,[36] a journalist and writer whom you perhaps know, offered to Kandinsky to give a lecture on literature at the exhibition. That is to take place on the 13th. The exhibition closes on 18 March. When could you give your lecture? Naturally, it need not necessarily be during the time of the exhibition. This evening we will discuss it with Goltz,[37] who is a very capable and likeable man and will be glad to organize the event—in his rooms or elsewhere. Lux could perhaps be put off, if you wanted that particular time. We have of course been hoping that you will come to Munich for the performance of your composition. Is that indeed to be on the 14th? K[andinsky] and I were both delighted by your very kind letter. I am now reading the book *Arnold Schoenberg*[38] with great interest.

This is in haste—please let me know what you think by return mail—K. will probably shed light on anything missing in my explanation.

Kind regards,

Your G. Münter

I look forward to your answer; just give it to me frankly! Kandinsky is very sad that your pictures are not to be exhibited jointly in the B[laue] R[eiter] in Berlin, since he esteems you *very highly*, and it is after all exactly his principle of great freedom and multiformity which he is advocating in the B.R. But there is certainly nothing to be done about it now! Your reasons are clear. I am really curious as to how it will turn out there. Walden seems to value K[andinsky]'s art particularly. What attitude will he take toward the B[laue] R[eiter]? Please answer immediately, so that K. will have exact details on your lecture! He also sends many greetings.

[Münter's handwriting] Munich, 15 March 1912

Dear Mr Schoenberg,

In reading through the most recent proofs, the passage once again struck me which had already seemed peculiar to me once before and, since I believe it only came about through carelessness, I would like to ask if you really find it satisfactory that Kokoschka's name should *stand before* that of Kandinsky.* I have heard that he is *still very young*, and as far as I know he has not done much aside from extremely talented pictures and also [has] scarcely [had] time for any significant development. If you so desire and answer *immediately*, it can perhaps still be corrected, that is, *if* it is not already correct in your eyes. You no doubt are aware that the order is of importance.[39] Thank you, dear Mr Schoenberg, *very much* for your obliging, quick, answer. K. will write to you shortly.

Kind regards,

Yours truly, G. Münter

* In your article 'Text. . . .'

Munich 28 March 1912

Dear Mr Schoenberg,

I recently got the news that your piano pieces were played at the ARS Society (Petersburg), and made a 'great and strong impression'. This makes me very

happy. I have just inquired whether it would not be possible for the ARS to organize a concert by you. — You will certainly get offprints of your music and your article, and two complete copies of the *B.R.*, which is now definitively in press.

With a hearty handshake,

Your Kandinsky

Munich 25 April 1912

Dear Mr Schoenberg,

How are you? You have forgotten us completely. Were you in Prague for the lecture on Mahler? Goltz doesn't dare to present the lecture on a large scale and his large room (exhibition room) doesn't belong to him at the moment. He thinks it would be best to seek help from a concert management. — I have not been very well: I have had terrible rheumatic pains and am still feeling the consequences. For more than two weeks I was confined to the house and for a long time couldn't move my head either down or up, right or left, even so much as a millimeter. I had to drop everything. Only now have I taken up my work again. Fortunately the *Blaue Reiter* was already finished and in print. Now it is being sewn, bound, etc. In two weeks it should finally come out! I enclose two proofs for you that were wrongly placed, since the printer thought they belonged in *your* book. Perhaps you can use them. You will also receive two author's copies and offprints.

I also enclose the little book by Lux.[40] Perhaps the contents will interest you, or you can use them for your music. After all, you are not a futurist and *may* use foreign texts! What do you think of the exhibition of these 'free' Italians? In their manifesto they say much that is right and important. But at the same time there are also so many immature, obsolete, strange thoughts and for my taste too much . . . police: 'go right!' (perhaps left!), 'don't stand still!!' and so on. And what do you think (I've wanted to ask for such a long time) of Scriabin?[41] Do you know his latest, larger works?

And once again: how are things? with you? with your family? I would like so much to get together with you again. We have always seen each other only fleetingly and the topics which interest us are unlimited in number. Many kind regards from both of us to you and your family.

Your Kandinsky
Please write!

[undated—after 25 April 1912]

Dear Mr Kandinsky,
I had already sent off the proofs when this prospectus and the music arrived. But I don't need them anyway. . . .

Now I would like to ask you particularly: Would you please immediately inquire whether my pictures were sent from your traveling exhibition to Budapest—because the Budapest exhibition (which has just closed) sent my pictures back to me and four pictures are missing. Please arrange to have them sent directly to me ('Landscape', 'Self-portrait Walking', and two 'Visions').

Warmest regards,

Your Schoenberg

Berlin-Zehlendorf 22 May 1912

My dear Mr Kandinsky,
I just want quickly to entreat you and your wife not to be angry with me because of my long silence. I have a great deal to do, and will have no peace until I am finished. But in two weeks I will have reached this point, and then I will write to you in detail. In the meantime, then, accept, both you and Miss Münter, my very kindest regards.

Arnold Schoenberg

[postcard
Baltic Sea Resort
Carlshagen
Villa Concordia] postmark: 6 July *[1912]*

Dear Mr Kandinsky, esteemed Miss Münter,
Are you angry with me? I have heard no word from you for such a long time!! I myself have been working very hard, I am now probably going to work still harder, and I have various worries—that is why I have not found the time to write to you! How are you? Are you both working hard? And on what? Now I intend to finally compose my *Glückliche Hand*, if I have a lucky hand. Many kind regards to both of you, from my wife as well.

Your Arnold Schoenberg

Munich 2 August 1912

Dear Mr Schoenberg,
You should not have such ideas! It is true that one experiences such things that finally everything seems believable. But if I were to have something against you, I would certainly tell you openly of my doubts or anger. And I expect the same from you. A few weeks ago you gave notice of a substantial letter. I waited for it, and planned then to write at greater length myself. Furthermore, I have felt unwell the whole summer, and was glad to put off writing letters. Finally I had to decide on an operation (you see from my style that I am still not completely recovered), which I underwent three weeks ago. I have been home for a week and my recovery is proceeding rapidly, but I am still capable of very little work. In four or five days we plan to go back to Murnau, where I hope to recover my lost energy. We read in the 'Vosstante'[42] that you were offered a professorship at the Royal and Imperial Academy. Why have you refused it? Or is Vienna really not a [suitable] base? On the other hand, I find it most proper that you want to devote yourself completely to composition.

So don't be angry with me, and write me the long letter which you promised. We both greet you and your wife most warmly.

Your Kandinsky

19 August 1912

Dear Mr Kandinsky,
I was sorry to learn that you have been ill and had to be operated on. What actually was the matter? You don't mention that at all. Was it something dangerous? And above all, are you well now, and unlikely to have a recurrence? I imagine it was your appendix. I hope that was it. That at least is no cause for concern.

I do not have very much to report. You know that I was to go to the Vienna Academy as professor and that I declined. But not, as I would have liked, in order to 'devote myself completely to composition,' for I have unfortunately not yet reached that point. But rather, because I considered it unsuitable that I, who left Vienna for a reason of primary importance, should go back for a reason of secondary importance. A pensionable post and a steady income, to be sure, and that is something I need very much. But a relatively limited field of activity, since Schreker[43] was engaged at the same time as myself, and Novak[44] also was supposed to come.—I have been living the whole summer in Carlshagen on the Baltic. Very beautiful. For once completely without

53

thoughts, purely in tranquil mindlessness. Thus actually less beautiful than lazy. But it seems that's what I needed. I had been very irritable and tired lately. I have written a [. . .][45] Perhaps no heartfelt necessity as regards its theme, its content (Giraud's *Pierrot Lunaire*), but certainly as regards its form. In any case, remarkable for me as a preparatory study for another work, which I now wish to begin: Balzac's *Seraphita*. Do you know it? Perhaps the most glorious work in existence. I want to do it scenically. Not so much as theater, at least not in the old sense. In any case, not 'dramatic.' But rather: oratorio that becomes visible and audible. Philosophy, religion that are perceived with the artistic senses. Now I am working on my *Glückliche Hand* without making real progress. Soon it will be three years old and it is still not composed. That is very rare with me. Perhaps I shall have to lay it aside once more, although I am very content with what is finished up to the present.

I must also speak to you about your contributions to the *Blaue Reiter*—thus: your stage composition pleases me extremely. Also the preface to it. I am completely in agreement. But how does all this stand in relation to 'construction?' It seems to me to be the opposite. It seems to me that he who constructs must weigh and test. Calculate the load capacity, the relationships, etc. *Der gelbe Klang*, however, is not construction, but simply the rendering of an inner vision.

There is the following difference:

> An inner vision is a whole which has component parts, but these are linked, already integrated. Something which is constructed consists of parts which try to imitate a whole. But there is no guarantee in this case that the most important parts are not missing and that the binding agent of these missing parts is: the soul.

I am sure that this is only a quarrel over words and that we agree completely about essentials. But 'construction,' though it is only a word, is nevertheless the word of yours with which I do not agree. Even though it is the only one. But as I said, *Der gelbe Klang* pleases me extraordinarily. It is exactly the same as what I have striven for in my *Glückliche Hand*, only you go still further than I in the renunciation of any conscious thought, any conventional plot. That is naturally a great advantage. We must become conscious that there are puzzles around us. And we must find the courage to look these puzzles in the eye without timidly asking about 'the solution.' It is important that our creation of such puzzles mirror the puzzles with which we are surrounded, so that our soul may endeavor—not to solve them—but to decipher them. What we gain thereby should not be the solution, but a new method of coding or decoding. The material, worthless in itself, serves in the creation of new puzzles. For the puzzles are an image of the ungraspable. And imperfect, that

is, a human image. But if we can only learn from them to consider the ungraspable as possible, we get nearer to God, because we no longer demand to understand him. Because then we no longer measure him with our intelligence, criticize him, deny him, because we cannot reduce him to that human inadequacy which is our clarity.—Therefore I rejoice in *Der gelbe Klang*, and imagine that it would make a tremendous impression on me when performed.

I would have been glad to hear what you think of my *Theory of Harmony*. Have you read it? Then also my article in the *B[laue] R[eiter]*. There are also many things in it which are very close to what you say in your preface to *Der gelbe Klang*.

I hope to hear something from you soon. How is Miss Münter? I owe her an answer to her very delightful letter. It should follow soon. Although: in just a few days I will be having rehearsals for *Pierrot Lunaire*, which will be performed by Mrs Albertine Zehme[46] on a big tour. But after that, I will find time for it. So for today, once again: warmest regards to both of you, from my wife as well.

<div align="right">Your Arnold Schoenberg</div>

What about your visit to us in Berlin???

Dear Mr Schoenberg,

I have been wanting to write to you for weeks, but somehow could not quite get to the point of doing it. So here it is: I would like to draw your attention to a book which I think would bring pleasure and enjoyment to you as well. And also to make you aware of its author, who must certainly be a remarkable and rare person. His name is Volker and his book is entitled *Siderische Geburt* ['Siderial Birth'], Karl Schnabel Verlag, Berlin, 1910. Volker's address is Luckoffstrasse 33, Nikolaussee, near Berlin. I am only slowly plodding through it, and unfortunately with interruptions. I only take from it as much as I can absorb. I cannot accept it entirely, and in particular its ending will probably be too exalted for me. But I feel that it is like a heavy golden chain passing through my hands link by link, sentence by sentence. And I believe there is something there for you! How are you? Next Sunday we must go back to Munich again, in order that K's new publication, an album with woodcuts and texts, *can come out soon. He is gradually recovering, has in fact written

* Kandinsky, *Klänge* ('Sounds') (Munich: Piper, 1913).

to you about his illness, and the doctor is pleased with his progress. I am well, but I don't work and waste time. Please let us have a *really* long letter from you.

Kind regards to you and to your wife from both of us.

Your Münter

[PS] I got to this point yesterday evening and left off—today your splendid letter arrived. And now I am completely sure that Volker is your man! At the bottom of page 31 he describes the elements of Kandinsky's Compositions II, IV, and V and so on. Naturally not in connection with K, since he probably knew absolutely nothing of him and his work at that time. I think such men should get to know each other. (Just as I found your address that time.)

Now to your question. It was a double hernia operation, along with an operation on a new varicose vein. The doctor had spoken of it as a trifle, but later we saw everything that was added to it, and how long it will still take before Kandinsky is his old self again. He has unfortunately not reached that point yet, and wants to visit his parents in South Russia in about a month. [Kandinsky's handwriting] Your letter gave me *much* pleasure. Soon I will write to you in detail. Kind regards,

Your Kandinsky

Murnau 22 August 1912

Dear Mr Schoenberg,

What is so stupid and always irritates me, is that I cannot read works about music. The parts of your book that are generally understandable, I read with *great* pleasure and the special joy which I get from *all* your writings. As far as I understand it you do not let one 'principal,' not one 'law' of existing theory escape your sharp analysis. Everything is given a real shaking, and it is *proved* (and this is what is most important!) that everything succumbs to this shaking, and everything, taken in the abstract, is only relative *and* temporary; that only human narrow-mindedness (or 'stupidity') remains unshakeable. And against this the gods fight . . . and so on!* As I said, what irritates me is that I cannot understand the positive side of your book. How much I would like to talk to you about it one day! *Perhaps* at the end of October! Since we will *perhaps* be in Berlin then. In October my fairly large collective exhibition will be in the Sturm gallery. I myself will be in Russia, and only *hope* at the end of

* Translator's note: 'Mit der Dummheit kämpfen Götter selbst vergebens' (Schiller, *Die Jungfrau von Orleans*, III, 6).

56

October to come back by way of Berlin. Münter will probably be there before that.

The fact is that the greatest necessity for musicians today is the overthrow of the 'eternal laws of harmony,' which for painters is only a matter of secondary importance. With us, the most necessary thing is to show the *possibilities* of composition (or construction) and to set up a general (very general) principle. That is the task which I have begun in my book—in very 'free' strokes. 'Inner necessity' is just a thermometer (or yardstick), but one which leads to the greatest freedom and at the same time sets up the inner capacity to comprehend as the only limitation on this freedom. In the continuation of the work, which now is ripening in me step by step (and has been for some years), I touch in moments of illumination on the universal root of all forms of expression. Sometimes I would like to bite my elbow with rage that the work advances so slowly.—As regards your article in the *B[laue] R[eiter]*, I read it with constant pleasure. At the end, I wanted to say: or, the opposite, that is to say, when one departs from the root, every possibility of combination becomes an 'or the opposite.' But sometimes one is forced to illumine only *one* side glaringly and obtrusively, and that is how I understand your article. My preface to *Der gelbe Klang* is written in a somewhat similar vein. *Unfortunately,* only a few can grasp this 'or the opposite,' and this is the reason the Ten Commandments were also given only one-sidedly and 'positively.' This is why Christ said, 'the rest you cannot grasp today.' We stand today on the threshold of the 'rest'—which is our greatest good fortune. Finally, this is the sense in which I also understand construction, which does not, in your opinion, combine harmoniously with *Der gelbe Klang*. Surely you understand me already! Up until now the word construction has only been viewed one-sidedly. But everything has at least two sides—'or the opposite.' In this particular case: by c[onstruction] one understood up until now the obtrusively geometrical (Hodler, the Cubists, and so on). I will show, however, that construction is also to be attained by the 'principle' of dissonance, (or better) that it [construction] now offers many more possibilities which must *unquestionably* be brought to expression in the epoch which is beginning. *Thus* is *Der gelbe Klang* constructed; that is, in the same way as my pictures. This is what people call 'anarchy,' by which they understand a kind of lawlessness (since they still see only *one* side of the Ten Commandments) and by which they must come to understand order (in art, construction), but one which has its roots in another sphere.—Briefly stated, there is a law which is millions of kilometers distant from us, towards which we strive for thousands for years, of which we have a presentiment, which we guess, apparently see clearly, and therefore give various forms. Thus is the evolution of 'God,' religion, science, art. And all these forms are 'right,' since

57

they have all been seen. Except that they are all false, since they are one-sided. And *evolution* consists only of this, that everything appears many-sided, *complicated*. And always more and more so. For example, the history of music is like this: monophony, melody, and so on.

And behind this *final* law, much farther away still, is another one, since this first [law] is also only *one* side. It could drive you mad or make you sing Hosanna.

We greet you and your wife. Most warmly,

Your Kandinsky

Odessa (South Russia)
Skobelevstrasse 12

23 October 1912

Dear Mr Schoenberg,

Your letter gave me great pleasure. It's fine that you have so much to do and that you are being performed so much. But on the other hand, such successes have bad consequences. They come, chop up your time and devour it. I am very happy that you are yourself coming to Petersburg. I will write Dr Kulbin[47] about it, a pleasant, congenial, energetic doctor, military academy professor, artist, organizer, etc. He will give you the best advice, and certainly help you sincerely in every way. I know Petersburg only slightly as a city. Two years ago I stayed a few days in the Hôtel d'Angleterre. Old Pet. style, no 2000 liftboys or similar unappetizing hotel extras in the grand manner. The tone is simple elegance. Very popular with the *serious* English people, not swanky (!) Americans. Very finely situated and at the same time very quiet. I paid four r[ubles] a day for a large room with two windows on Isaac Square. Pet[ersburg] is expensive! Four rubles are about 9 marks. If you let Kulbin know your time of arrival, he will certainly pick you up at the station and assist you. His address is St Petersburg, Glavny Stab, Dr N. J. Kulbin.

K. knows everything, that is, he also knows all the artists of importance. My relations with liberal (not radical) Pet[ersburg] are bad. I believe K. knows these circles as well. Not much is going on in Pet. in our sense. Moscow takes first place in this as well, though of course the Petersburgers don't want to admit it. Hartmann also lives in Moscow as a rule (at the moment he's in Naples) but perhaps will be in Pet. during November and December.

In two weeks I travel to Moscow in order to stay 3 or 4 weeks there. Then perhaps a few days in Petersburg and back to Munich by way of Berlin (?) where I will arrive in the middle or second half of December. How are you

58

dividing up your time? Please write to me about this *by return mail*, even if very briefly.

My exhibition is—Königin-Augustestr. 51 (Der Sturm) and remains in Berlin until the end of Oct. Then Holland. January— Munich, and so on.

In haste!

Many kind regards to you and your wife.

<div align="right">Your Kandinsky</div>

I await your prompt answer, then. Your letter to me I sent on to Münter.

St Petersburg <div align="right">18 December 1912</div>

Dear Mr Kandinsky,

I certainly hoped to see you in Petersburg or Berlin. I wrote to you in Odessa, but you didn't answer me. Now today I am here with Mr Kulbin and very happy to find him as you led me to expect.—Kind regards to you and Miss Münter. (When I get to Berlin, I will write to Miss Münter.)

<div align="right">Your Arnold Schoenberg</div>

[In Russian]

Greetings and good wishes <div align="right">N. Kul'bin</div>

Although we do not know each other, I have heard a lot about you, and even written to you, unfortunately without receiving an answer. I take the liberty of sending you my regards.

<div align="right">N. Dobyčina[48]</div>

Arnold Schoenberg
Berlin-Südende
Berlinerstr. 17a <div align="right">28 September 1913</div>

Dear Mr Kandinsky,

I am perpetually having to do unpleasant things and struggle with weariness afterwards. It is sad that one has no time to catch one's breath. When I am tired I have no desire to do anything: neither to work or to write letters. Don't be angry with me!

Many thanks for your very kind letter. I will ask Universal Edition to send the music. I hope they will do so. They are very petty about such things.

<div align="right">59</div>

I will be very glad to let the periodical *Die Kunst* have my article on 'Teaching the Arts.'[49] *Should I send it directly to them?* I have no idea whether I have a copy.—I have just found one and will send it there. I will mention your name.

Unfortunately, I will not be in Petersburg this year, but I hope next year. However, my *Gurre-Lieder* will be coming out in Munich in February. I certainly do not look down upon this work, as the journalists always suppose. For although I have certainly developed very much since those days, I have *not improved*, but my style has simply got better, so that I can penetrate more profoundly into what I had already had to say earlier and am nevertheless capable of saying it more concisely and more fully. Thus I consider it important that people give credence to the elements in this work which I retained later. Then on 18 November Fritz Soot[50] is singing some of my older songs. Although they are not as old as the *Gurre-Lieder* (about four to six years later), all the same I like them less, to some extent. Still, few [songs] are written which are so good, but they are the most constrained of anything I have written. At that time I believed I [still] had to learn what I had long been able to do better, and I labored over things. This gives me little pleasure today. Perhaps you would have the inclination and time to hear one or two!

I am very happy that I am having success in Russia. People are more interested in me on the whole abroad than in Germany. But it seems that people will do as little justice to my earlier works as to those of Mahler. People have such a fixed conception of *modernity*, of a fashionable modernity, which completely forgets personality and only grants validity to *stylish technique*, that I have little chance with my earlier works. The classification (!!) is approximately this:

Strauss, or Debussy, or Scriabin and perhaps my latest things.

I believe, however, that this is all nonsense. Style is only important when everything else is present! And even then it is still not important, since we do not like Beethoven because of his style, which was new at the time, but because of his content, which is always new. Naturally, for someone who otherwise hears nothing in a work, a modern style is a convenient means of establishing a relation with the author. But that doesn't give me much joy. I would like people to take notice of *what* I say, not how I say it. Only when people have perceived the former will they realize that the latter is inimitable.

It is ridiculous that I am speaking of myself. But I would like it if you would do the same, and would *tell me about yourself!* I know almost nothing about you any more. Nor about Miss Münter. I am sorry that I still have not answered her delightful letter. I will certainly do so soon. Please ask your dear wife for me to take the will for the deed.

Kindest regards to both of you.

Your Arnold Schoenberg

[Münter's handwriting] 8 November 1913

Dear Mr Schoenberg,
Just a few hurried words: Have you visited the First German Autumn Salon
yet? Don't miss it. There is much there that will interest you.
 Kind regards from both of us.

 Your G. Münter

[Kandinsky's handwriting]
 Kind regards and thanks for the letter, which must certainly be answered! I
have had an awful lot to do.

 Your Kandinsky

 5 February 1914

Dear Mr Schoenberg,
Often I have wanted to write a few lines to you. And your letter gave me great
pleasure . . . months ago. One really becomes giddy—the four seasons—
white, pink, green, orange—rush by so. One imagines in one's mind twenty
such rotations and sees oneself as an old man. And the work is really only
beginning. New possibilities are always revealing themselves in bits and
pieces, and in rare, fortunate hours as a *totality*. Perhaps one should sit from
time to time in a tower and be locked in, in order to be able to shake off *all*
worries. But 'life' scrambles up the tower too and flows in through the
keyhole. So the most important thing is to be able to shut oneself up *mentally*
and fumigate one's mind, disinfect it. On the other hand, I believe that more
peace will now come from the outside as well. In any case, in painting the
explosive period seems to be more or less over. On the scene (of life) the great
sieve appears, and what is small and trivial falls through. All the more, people
will try to gobble up what is left in the sieve. What is now appearing just in the
way of 'art books'! The catch-words have become generally known; they can
be bought for a few pennies in the newspaper—and it is no longer any great
difficulty to write a book. A witches' Sabbath of frenzied writing! The coinage
becomes smaller and greasy from many fingers. Woe to him who uses an
'easier' form and is more 'intelligible,' more explicable. Art is made into a
menagerie: the fine specimens sit in cages and a daring animal trainer with a
whip in his hand explains the characteristics of the artists. Everything
becomes unbelievably easy; the secret has become marketable. Be glad that
no one wants to understand *what* you create. Let the dirty fingers grope about
your form! He who will really make use of the *content* will come in time. He

61

will be recognizable by his clean hands. Now, you see that I am not in a particularly good mood. But that is partly the fault of influenza, which has left behind its poison in all my limbs, and this bad poison hinders me in my work. And that is not exactly favorable to one's good humor.

Many kind regards from house to house, and do not completely forget

Your Kandinsky

27 March 1914

Dear Mr Schoenberg,

Today the portfolio arrived with your letter and the letter from Mr Müller.[51]

It is very painful to me to be in any way unhelpful to you. Please believe this of me! But I cannot bend my conscience. The woodcuts are not bad and not lacking in talent, but are rather far from what is graphic art or painting in my eyes. The forms are modern-conventional, everything done quickly, without feeling, or with so little feeling that I cannot see it. I don't know what the *intention* of it all is. Believe me that your music is little honored by it. These objects are not 'inspired' by anything at all, or only and exclusively in a superficial way. What is called 'creation' is *not* in them. How could I champion them? I am very sorry that I must declare this sharp judgement, but I cannot do otherwise. And the title-page! Such things must be *created*. They should not be 'prettily' painted with a brush. Where would this leave your music, which is so completely felt and thoroughly thought out and, most of all, is a real construction? There is *one* Schoenberg and ten thousand or many more of such sheets of paper.

Don't be angry with me! Both of us greet you and your wife most warmly.

Your Kandinsky

I am constantly reading about you in the Moscow *Music:* your London successes, etc., etc. And each time I rejoice.[52]

Munich 5 May 1914

Dear Mr Schoenberg,

We are *very* happy that you and your family are coming to Bavaria this summer. Really fine! Münter suggests *Uffing** to you—a quiet spot on the Staffelsee (Two hotels: 'Seerose'—simple, pleasant; 'Kurhaus Staffelsee'—

expensive, not very good.) or *Seehausen*, much nearer to us. Both places with very fine opportunities for bathing and boating.

From Uffing to Murnau—one hour by boat, the same on foot. From Neuhausen [= Seehausen]—twenty minutes.

Uffing is pleasanter. But you can just as well take lodgings in Murnau—except that M. is highly situated and one is therefore forced to clamber up the hills after swimming or rowing. The very best would be for us to journey together to the Murnau region and you could look everything over for yourself. Do you want a lodging with kitchen? Or will you not be doing any housekeeping?

Here there are all sorts of theater plans, which you have already heard about from Marc. You are therefore awaited with particular eagerness.

Many kind regards from house to house.

Your Kandinsky

[Münter's handwriting]
*Uffing pleased me particularly in 1908 because of its nearness to the lake, and I wanted to go there the following year instead of to Murnau. Possibilities for swimming seemed good to me—but I cannot guarantee this.

[Münter's handwriting] Murnau, Sunday, 7 May 1914

Dear Mr Schoenberg—we have just seen an excellent detached cottage. The address is *Jos. Staib, 6 Seidlstrasse*, Murnau. The landlord is out the whole day and only comes back to sleep. His wife is also out, so you would have the kingdom entirely to yourself. The husband is a particularly likeable type, the cottage is charming, pretty garden with a large summerhouse. Kerosene lamps. Toilets upstairs and down—a little veranda facing west as well—on the east a roofed balcony.

[Here Münter sketched the ground plan of the house]

Mr Jos. Staib is awfully cheap—for the four rooms for five weeks he wants 300 marks. He will provide storage space for trunks as well. For three rooms, so that he keeps No. 1 for himself, he wants 250 marks. But in that case two or three beds could be put in one room. For example, Room Four

[small sketch]

so that the sofa would go in the center in front of the window.

So what do you say to all this? Please *answer immediately*, preferably *direct to Staib*.

The little 'Seefried' houses are really *too* primitive and small for you. Villa Wild is certainly paradise—but *with* people. Or perhaps you have written to Mr Wild about 'Achilles'—he was even willing to perhaps rent it more

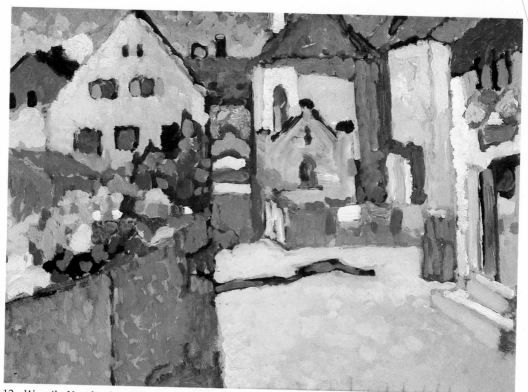

12. Wassily Kandinsky: *Grüngasse in Murnau*, 1909
Oil on pasteboard, 33×44.6cm. Municipal Gallery in the Lenbachhaus, Munich,
Gabriele Münter Bequest

Extended captions to plates 12–19 begin on page 205

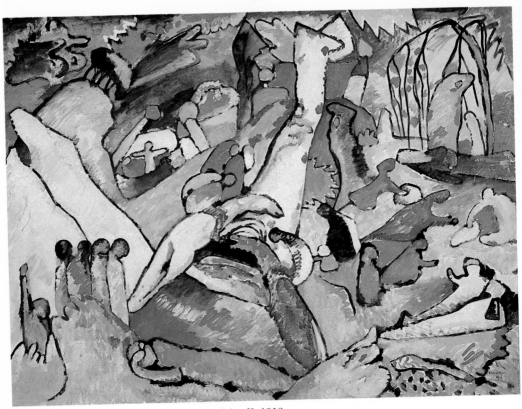

13. Wassily Kandinsky: *Study for Composition II*, 1910
Oil on canvas, 97.5×130.5cm. Signed and dated at lower right. Solomon R. Guggenheim
Museum, New York

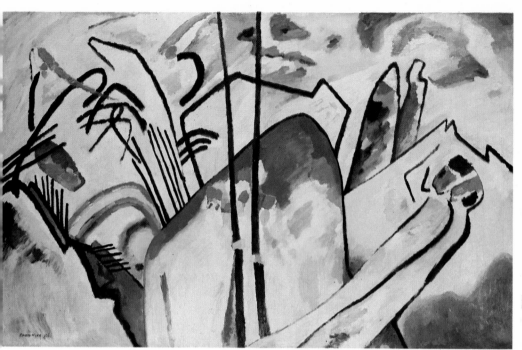

14. Wassily Kandinsky: *Composition IV*, 1911
Oil on canvas, 160×250cm. Signed and dated bottom left. Nordrhein-Westfalen Art
Collection, Düsseldorf

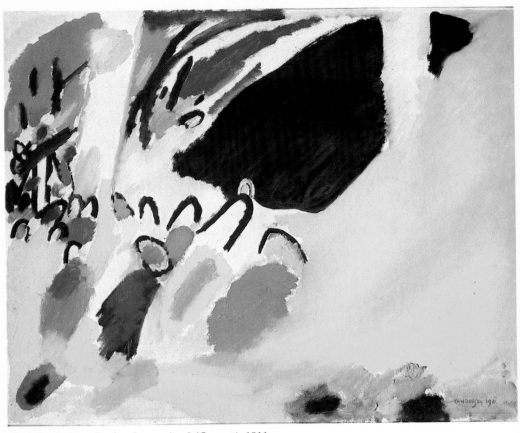

15. Wassily Kandinsky: *Impression 3 (Concert)*, 1911
Oil on canvas 77.5×100cm. Signed and dated lower right. Municipal Gallery in the
Lenbachhaus, Munich, Gabriele Münter Bequest

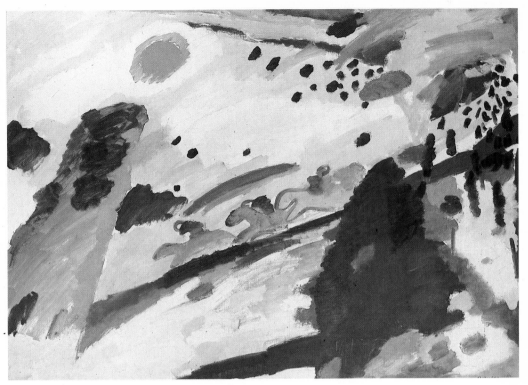

16. Wassily Kandinsky: *Romantic Landscape*, 1911
 Oil on canvas 94.3×129cm. Signed and dated lower right. Municipal Gallery in the
 Lenbachhaus, Munich, Gabriele Münter Bequest

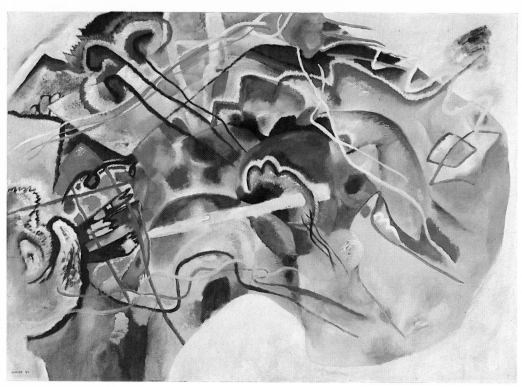

17. Wassily Kandinsky: *Picture With White Border*, 1913
Oil on canvas 140.7×200.7cm. Signed and dated lower left. Solomon R. Guggenheim
Museum, New York

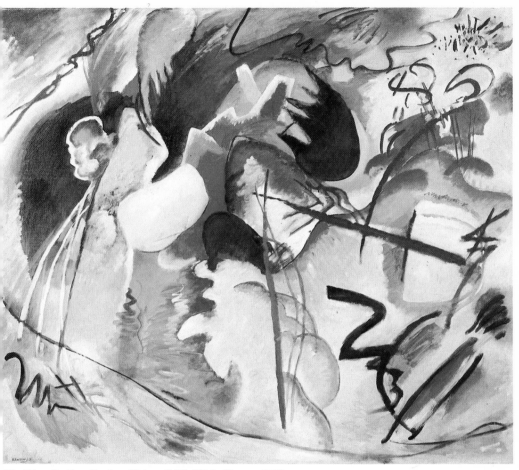

18. Wassily Kandinsky: *Picture With White Shapes*, 1913
Oil on canvas, 120.3×140cm. Signed and dated lower left. Solomon R. Guggenheim
Museum, New York

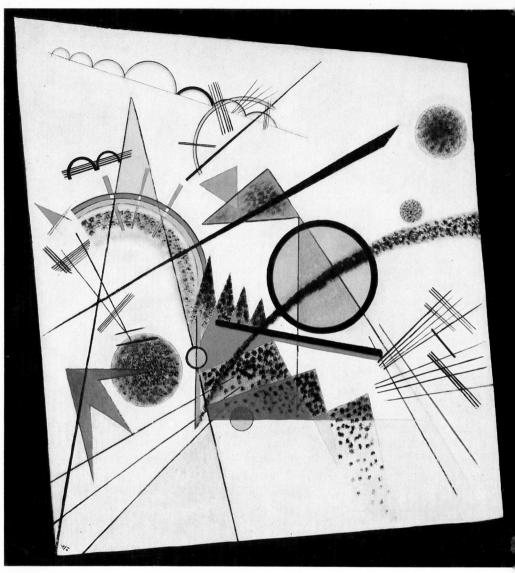

19. Wassily Kandinsky: *Within the Black Square*, 1923
Oil on canvas, 98.5×93.3cm. Monogrammed and dated lower left. Solomon R. Guggenheim
Museum, New York

cheaply for five weeks. Now we are curious—and eating lunch—the fish is just coming.

[Kandinsky's handwriting]
The fish was good! Castle postcards [?]—as well!! And the beer!!! So, to your good health!

The Staib cottage is a simple farmhouse (not a villa), but very clean, free from odors, and has just been painted, put in order, and so on. Neither children nor dogs in the house. The man is young (and newly married) and really *very* nice. About fifteen minutes away from the lake. But the situation is very good and solitary. The drawing is very compressed: the house is *farther* from the street, the railroad tracks *mu-uch farther* from the house, also the lake, etc.

Kind regards,

Your Kandinsky

[Kandinsky's PS]
The cottages on the lake are much too small.

[Münter's PS]
View of the mountains. About five minutes from us. Peaceful location, somewhat off the beaten track, isolated.

[Münter's handwriting] *[undated; 7 May 1914?]*

Sunday around six. Dear Mr Schoenberg, in our opinion, the wooden cottage on the lake is *too* small, *too* primitively furnished—the gnats will bite you *too* much. Cupboards and comfort are mostly lacking—in bad weather you would sit right in the water and catch cold. It is not for five people, one of whom wants to work. On the contrary, we ask you to choose between the Staib house at 6 Seidlstrasse (fully described today) and the Villa Achilles at the lake. Tomorrow we will telegraph you the price of the Achilles after we have inspected it—it is also a completely detached villa—see the list of lodgings! *With every comfort*—down by the lake. It is probably more expensive than Staib, but the landlord will certainly come down from his 1000 marks, since you only need it for five weeks. The Staib house has the advantage of being *heatable* and that up near the town there are fewer gnats and that it is *very inexpensive* and that everything you need is near at hand. The kitchen seems amply equipped.

The beds are sure to be good at Staib's—at Seefried's they look somewhat makeshift. I will again leave the conclusion to K, so that we don't forget anything.

[Kandinsky's handwriting]
At Staib's there are good tiled stoves. Your express letter was received about four o'clock. By Tuesday you will have the Staib description and the price of the Achilles. Please telegraph us then as to which we should take. The Bavarian summer can be cold, and stoves and wood necessary.

Your Kandinsky

12 May 1914

Dear Mr Schoenberg, a few days ago we were in Murnau. There we spoke, as intended, with the former owner of our cottage, who now has another, larger house and rents out rooms. She is a *very* respectable, conscientious, and pleasant woman, whom we both can recommend most warmly. She has various rooms

available, which are free until 4 July (after that everything is rented). The prices are: one mark per bed on the first floor. Second floor—80 pfennigs. And you can also have two rooms, or three, use of the kitchen included. I unfortunately do not know whether there is a special charge if you wish to use the kitchen alone, that is, if you wish to lay claim to it just for yourselves. I believe—not. All the same! 80 pfennigs a day. If you would be interested to learn more details, just write to Mrs Xaver *Streidl*, Kohlgruberstrasse, Murnau on the Staffelsee, Upper Bavaria. Very beautiful view of Murnau and of the lake from some windows. Beautiful balcony. Rooms on the east (Murnau) and south sides (mountains), important for cold Bavaria. Through pleasant parks and woods to the lake. Many rabbits! N.B. for the younger generation!! Meadows, solitary hills. Woods, where deer often show themselves and sing very beautifully.

[Small sketch of the site with lake and Kohlgruberstrasse 'to Kohlgrub and Oberammergau, to which an electric railway also runs']

Five–eight minutes from us! We would be very happy if you would rent from Streidl. But I have forgotten one thing! I do not know how long you will stay in our vicinity! Since the rooms are only free until 4 July. But then you could move on to the neighborhood of Kochel—Kochel itself or the beautiful Walchensee. But Kochel is also fine! We just find Murnau more varied, freer.

I will quickly put this letter in the box. Do write us a few words as to what you decide! Agreed?

Many warm domestic greetings,

Your Kandinsky

Berlin 25 May 1914

Dear Mr Kandinsky,

Warmest thanks for your very delightful letter. But you have misunderstood me: I intend to spend the holidays in Bavaria—that is from *4 July* to *13/14 August*. And since I would like to compose a lot, I must live *very peacefully* and *undisturbed*. Preferably in a small, separate house.

It must also be a real residence, where not even the eye of a stranger is admitted. Thus [it must be] completely self-contained. I have no idea whether you have time to concern yourself with this matter. In any event, I am sending you a *'questionnaire,'* on which everything I desire is stated precisely. What is particularly important to me I have marked in red. You see that I am unfortunately very exacting. This is explained by the fact that I must

67

use the summer for work and it is therefore important to me to have everything which is available in the way of rural pleasures as close as possible, since I will not be able to devote many hours of the day to them; and: to live comfortably. It seems I must be getting old, since I need so many conveniences.

I would be very glad if it were possible for you to pursue this matter a little. If, on the other hand, you have no time, I would understand that completely. It would be a great joy to me if we could be together this summer.

Many kind regards to you and Miss Münter.

<div style="text-align: right">Your Arnold Schoenberg</div>

[Münter's handwriting] 4 June 1914

Dear Mr Schoenberg—in haste—

I. Mrs Anna Andre. House 2–5 min. from the lake on the lake promenade. Beautiful garden. A nice, small, brown dog, who perhaps barks rather a lot, is included. The ground floor is rented to a family with three or four well-behaved children, school-age boys and a younger girl. The second floor is to let. Two rooms with four beds and one room with one bed, that could also be made into a sitting room without a bed. Third floor—maid's room—storage space sufficient, or even good (it seems to me). Well-appointed kitchen. Toilet on this floor—but not a water closet. Price 470 marks (for two months—she doesn't want rent in any other way). Running water.

II. On a spit of land in the lake, cosy, idyllic wooden cottage—a real temporary summer dwelling. Very out-of-the-way, but not too lonely. Shared use of boat and bathing. *Approximate* diagram on the next page.

[ground plan of the house by Münter]

The house is in the middle of a space with trees— right on the lake.

The site on which the cottage stands is not large, and also includes a pond. There are eight beds in the house—it is not terribly comfortable. Toilet without water. Good drinking water one minute from the house from a flowing spring. *Approximate* diagram of the ground floor. The proportions of the diagram are certainly wrong. Everything is very small. Up above, there is also a balcony on the front. One wardrobe and one place with a curtain to hang clothes and one rack. Price for the season 400–500, but surely it could be had for 80 or 70 per week. Screens to keep out the gnats at the lake will probably be provided. The young lady could say nothing completely definite, but that is [nevertheless] certain. There are only two of these tiny little

68

houses. One is lived in by the landlord and is situated somewhat farther from the lake and somewhat higher. Probably it can easily get cool and damp so near the lake. Perhaps they would let you have the other cottage where they are at present living themselves, but it is somewhat smaller still—to make up for this it has a larger, beautiful meadow-garden and a summerhouse. We find this last place charming—if it is not too small. Built completely of wood— only the weather side is sheathed with tin—with slate in II. Six beds in III. Layout is similar to the other house. Address: *Mrs Seefried, Murnau.* Villa Seefried.

IV. On the same spit of land is a large house in a *gigantic* park-like garden. A nice eccentric lives there and is visited by his relatives and the ground floor is probably also rented. A piano is available, would perhaps be given over to you? It can also be played in the people's part of the house, by way of exception. For your consideration the second floor. Three rooms, five–six beds, kitchen—with all conveniences. The landlord said 70–80 per week, as you require. Dog allowed only with precautions, because there are tame

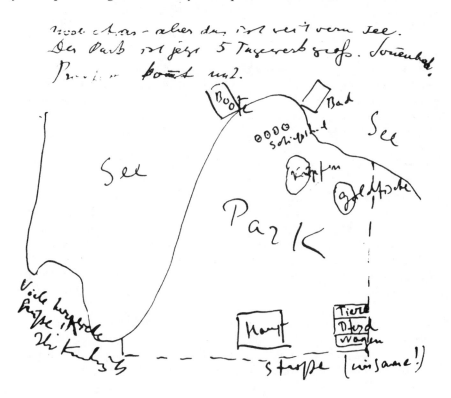

animals and birds *everywhere* in the park which are easily scared away. Private swimming place. Fishing, boat, sailboat, tennis court, etc.—all for your use—rifle range, etc., etc. This is a *very beautiful* place! There is a great rush and you are asked to give your decision *immediately* as to which place you are considering.

Villa Wild—always in demand. In general it is already rather late and most places are rented. On Seidlstrasse there is *perhaps* still something—but that is far from the lake. The park is now five acres. Sun-bath. Picture enclosed.

[at the margin of first page of letter]

Mr Wild also owns Villa Achilles—he is willing to discuss the price for five weeks—we haven't seen it yet—write to him if you would rather have Achilles to yourself than Villa Wild. See Villa Achilles on the list of dwellings.

Berlin 6 June 1914

Dear Mr Kandinsky,
or actually, as I conclude from the handwriting (in spite of the signature),
Dear Miss Münter, warmest thanks. Your answer pleases me very much. All the more so as it means that in any case we will be together this summer. For I have already made up my mind.

I would like the larger of the two wooden cottages (the one on the lake, slate-covered, with eight beds and pond)—but is it really for exclusive habitation??!! Piano and dog allowed, my existence permitted??—for the time from

4 July (day of arrival, in the morning) until 9 August inclusive (departure morning of the 10th), if the landlady will provide it for 400 marks at the most. Of course I would prefer it, if you could persuade her—by appealing to the fame that she could thereby win in the history of music—to accept 50 or more marks less (I hope this Frau Seefried is ambitious).

I could send a deposit by telegraph, in the event that you want to give her one in advance—please send me notice by telegraph of how much is necessary.

I am assuming that the kitchen is completely equipped for cooking.

Is there a place for the maid to sleep?

I would be very grateful if you would answer a couple of questions for me:

I. How many habitable rooms does the house have?

II. Do you think that I can put an upright piano in the dining room?

70

Quite right: I have just read this letter once again, and see that I have not expressed myself clearly.

I will therefore repeat:

Please be kind enough definitely to rent the above-mentioned house for me, if the above stipulations (framed or underlined in blue) prove correct. Please notify me of the agreement by telegraph. A stamped telegram is enclosed.

I am very happy that I will be together with you, and thank you most warmly once more. Many kind regards,

Your Arnold Schoenberg

Murnau 10 June 1914

Dear Mr Schoenberg,

So everything is arranged. I hope you will be satisfied. 50 marks received and today your telegraphic letter. Before we definitely decided to follow your latest instructions, we fought more than a little with doubts and hesitations. Wild (Achilles) is near the lake, has its own bathhouse, a good garden, and the rooms are much (though not very much) larger than Staib's. On the other hand: no stoves (kerosene was promised, which is known to have more effect on the nose than of the body temperature—and even July can be cold here sometimes), far from the village (shopping, doctor, pharmacy, which can be very important for children), not much of a view from house and garden, and finally 50-100 marks more expensive. At Staib's: everything freshly painted and put in order (Achilles is in a very neglected state at the moment; the prospect of repairs was held out, but what if they should fail to take place?), a stove in *every* room, good beds, completely equipped kitchen (Achilles—incomplete), vast sweeping view, more opportunities for walks, a *very* nice landlord, pharmacy very near by, also *doctors*, situated almost in the village, but completely off the beaten track all the same. We (I?) only reported one thing wrongly: 15 minutes from the lake—correct, but for you (and perhaps for me, since I walk fast), but with children it will probably take 20–25 minutes. This point displeases me *very* much. To make up for it (aside from the money question), you are closer to people at Staib's, but nevertheless more 'solitary': your neighbors would be real Murnauers, who as a rule are nice and *reserved*. Achilles, however, lies on a spit of land which is like a little provincial town: nothing but educated neighbors, who generally like to stick their noses into other people's business when they are cut off from the 'world.' In bad weather it would be too dismal there and perhaps damp

71

and . . . gnats. So we considered the matter repeatedly and stayed with Staib all the same. Now I will soon go to him (he doesn't come home till about six), pay the 50 marks, and put the letter in the mailbox.

Many warm greetings to you and your family from both of us.

Your Kandinsky

[Münter's handwriting] *[undated—between 10 and 25 June 1914]*

Dear Mr Schoenberg,

Your landlord, Mr Josef Staib, asks if you would be kind enough to give him your arrival time well in advance. He wants to take time off from work that day and pick you up at the station. He was of the opinion that 'most of the people who come are usually females, who cannot walk around with baggage,' so he is glad to help. If you arrive early in the day, the necessary changes in your accommodations can perhaps be made according to your instructions—if, however, you arrive in the evening, people should know beforehand which room you want to assign to the servant girl. It seems to me it should be the upper one on the north side, since she will certainly want to have sunshine for herself and the children. That is, the north room has windows on the N, W, and E, and there are two beds in it, but the one on the south side (built just like the north one), see plan *[here follows Münter's small sketch]*, has *one* bed and a *sofa*. The downstairs room has two beds. The best thing would be for you to see and then decide for yourself, but if you will be arriving late, please give us written orders and we will see to it.

We must send you back your fifty marks; they were not wanted here. Now, until we meet again soon.

Kindest regards from house to house.

Yours truly, Gabriele Münter

[Münter wrote to Schoenberg's wife Mathilde on 25 June(?) 1914 about housekeeping details. On 1 July the latter answered: 'We are already reproaching ourselves greatly for having caused you and Mr Kandinsky so much trouble.'*]*

Editor's note: The weeks which Schoenberg and his family spent near Kandinsky during the summer of 1914 were interrupted by the outbreak of World War I. Kandinsky then returned to Russia and all contacts were broken off between the two until after Kandinsky's return to Berlin in December 1921.

Weimar
State Bauhaus[53] 3 July 1922

My dear Schoenberg,
I was very disappointed when I arrived in Berlin and heard that you were no longer there. When our journey was first being planned, I rejoiced to think that I would find you in Berlin. However, I was told: Schoenberg has left and will not be coming back any more. And letters are such an awkward substitute. I had hoped that we would see each other very often and discuss so many questions. Everything has really changed since our time together in Bavaria. Much that was a daring dream at that time has now become the past. We have experienced centuries. At times I am amazed that anything from the 'old' days is still to be seen. Here in Germany I have been overwhelmed by new impressions. You know of course that we lived in Russia for four years— seven in all—completely cut off from the whole world and had no idea of what was taking place here in the West. I came with mouth wide open and gulped and gulped—until I felt completely different. I have not worked at all myself, and now lie buried under a mountain of different tasks which I must quickly finish. There is so much I must do that I do not know where to begin. But it is a lovely feeling to have so much of one's *own* work before one. In Russia I did a great deal of work, but for the 'public Good'[54]—my [own] work was always left behind; I stole the time for it from the public Good. And I arrived so drained and worn out that I was ill a whole month—could only lie down and read stupid books.

Do write to me and tell me everything you're doing. In Berlin I tried to send your *Theory of Harmony* to the Russian Academy of Fine Arts through the Russian Commission. However, up until now I have not succeeded—lack of money at the Commission. The Russian musicians are hungry for your book. We spoke of you a great deal at various meetings. A good friend of mine, the young composer A. Shenshin,[55] who also has a fine theoretical mind, is particularly devoted to you. Perhaps he will come to Germany.

I shake your hand most warmly, and hope that you will soon tell me your news. Kindest regards to your family and associates. My wife sends you her best regards.

Your Kandinsky

Traunkirchen 20 July 1922

My dear Kandinsky,
I'm very glad to have heard from you at long last. How often I've thought of

73

you with anxiety during these eight years! And how many people I have asked about you, without ever getting any definite and reliable information. You must have been through a great deal!

I expect you know we've had our trials here too: famine! It really was pretty awful! But perhaps—for we Viennese seem to be a patient lot—perhaps the worst was after all the overturning of everything one has believed in. That was probably the most grievous thing of all.

When one's been used, where one's own work was concerned, to clearing away all obstacles often by means of one immense intellectual effort and in those 8 years found oneself constantly faced with new obstacles against which all thinking, all power of invention, all energy, all ideas, proved helpless, for a man for whom ideas have been everything it means nothing less than the total collapse of things, unless he has come to find support, in ever increasing measure, in belief in something higher, beyond. You would, I think, see what I mean best from my libretto 'Jacob's Ladder'* (an oratorio): what I mean is—even though without any organizational fetters—religion. This was my one and only support during those years—here let this be said for the first time.

* Shall I send you the book? I'd like to know what you think of it.

I can understand your being surprised by the artistic situation in Berlin. But are you also pleased about it? Personally, I haven't much taste for all these movements, but at least I don't have to worry that they'll irritate me for long. Nothing comes to a standstill sooner than these movements that are brought about by so many people.

For the rest, all these people aren't peddling their own precious skins, but ours—yours and mine. I find it perfectly disgusting, at least in music: these atonalists! Damn it all, I did my composing without any 'ism' in mind. What has it got to do with me?

I hope you'll soon be able to get down to work. I think it's precisely these movements that can do with your putting some hindrances in their way.— What are your plans?—How is your book *Das Geistige in der Kunst* ['On the Spiritual in Art'] getting on? I think of it because it appeared at the same time as my *Harmonielehre* [Theory of Harmony], a much revised new edition of which I am just sending to the printers.—It may interest you to know I am at present working on 'Jacob's Ladder'. I began it several years ago, but had to break off work (at one of the most rapt passages) in order to join the army. Since then I've never got back into the mood to go on with it. It seems, however, that it is meant to go ahead this year. It will be a big work: choir, solo voices, orchestra. Apart from that I plan to write a smaller theoretical book, *Lehre vom musikalischen Zusammenhang* [Theory of Musical Unity], which has

74

also been in my mind for several years and which is always being postponed—probably because it hasn't yet matured. For the rest: chamber music, etc. Further, I am thinking about a Theory of Composition, for which I've been making preliminary studies for years now.

Well, now I've gone jabbering on like a small child, which I actually stopped being some decades ago. But that's the way it is with letter-writing: by the time one's warmed up, one is also worn out.

Will you be able to come to Austria one of these days? I'd very much like to see you.

In any case I hope to hear from you more often now; it does me a lot of good. I greet you most warmly [. . .] also your wife. Greetings as well from my wife and daughter, now Mrs Gertrud Greissle (née Schoenberg). My boy is already an enthusiastic football player, who is making my name known in wider circles—I am the father of Georg Schoenberg, the well-known football player.

<div style="text-align: right">

Many, many kind regards,
Arnold Schoenberg

</div>

N.B.: My *Theory of Harmony* has been out of print for three years (I have been working almost that long, with interruptions, on the new edition); that is why you can't buy it anywhere. I will send it to you as soon as it is published.

Weimar
Bauhaus 15 April 1923

Dear friend,
Your letter gave me much pleasure, and only the frantic tempo of present-day life can explain my long silence. It is exactly like a bad dream—you want to jump on to a departing train, run with all your might, but your legs cannot keep up with you so fast. I thought at first that this was only a Russian way of living, and hoped to find another life here—with more possibility for concentration. In Berlin I led a particularly hurried life, which I regarded as temporary, since I hoped to find sufficient peace in 'quiet Weimar'. This was an illusion, however. I never can accomplish half of what I would like to. And all the same it is nice here: there are many possibilities and above all the possibility of forming a center that can radiate out and ignite others. But to do this, prominent forces beyond our restricted circle are necessary. How often I have said to myself: 'if only Schoenberg were here!' And imagine, now he could perhaps come, since a circle has formed here which has a certain influence on the necessary authorities. *Perhaps* the decision only depends on

75

you. *In confidence:* the music school here is to get a new director. And so we immediately thought of you. Do write to me as *immediately as possible,* whether you would be agreeable just in principle. If the answer is yes, then we will immediately set to work with a will.

Many warm greetings to you and your family, from my wife as well.

As ever, your Kandinsky

Has the new edition of your *Theory of Harmony* appeared? The Russian musicians await it eagerly.

Mödling bei Wien
Bernhardgasse 6 19 April 1923

Dear Mr Kandinsky,
If I had received your letter a year ago I should have let all my principles go hang, should have renounced the prospect of at last being free to compose, and should have plunged headlong into the adventure. Indeed I confess: even today I wavered for a moment: so great is my taste for teaching, so easily is my enthusiasm still inflamed. But it cannot be.

For I have at last learnt the lesson that has been forced upon me during this year, and I shall not ever forget it. It is that I am not a German, not a European, indeed perhaps scarcely even a human being (at least, the Europeans prefer the worst of their race to me), but I am a Jew.

I am content that it should be so! Today I no longer wish to be an exception; I have no objection at all to being lumped together with all the rest. For I have seen that on the other side (which is otherwise no model so far as I'm concerned, far from it) everything is also just one lump. I have seen that someone with whom I thought myself on a level preferred to seek the community of the lump; I have heard that even a Kandinsky sees only evil in the actions of Jews and in their evil actions only the Jewishness, and at this point I give up hope of reaching any understanding. It was a dream. We are two kinds of people. Definitively!

So you will realize that I only do whatever is necessary to keep alive. Perhaps some day a later generation will be in a position to indulge in dreams. I wish it neither for them nor for myself. On the contrary, indeed, I would give much that it might be granted to me to bring about an awakening.

I should like the Kandinsky I knew in the past and the Kandinsky of today each to take his fair share of my cordial and respectful greetings.

[No signature on Schoenberg's carbon copy.]

76

Weimar
Bauhaus 24 April 1923

Dear Mr Schoenberg,
Yesterday I received your letter, which shocked and grieved me extraordinarily. In earlier days I would never have been able to suppose that we—of all people—could write to each other in such a way. I do not know who, and why, someone was interested in upsetting and perhaps definitively destroying our (as I certainly thought) enduring, purely human relationship. You write 'definitively'! Whom would that benefit?

I love you as an artist and a human being, or perhaps as a human being and an artist. In such cases I think least of all about nationality—it is a matter of the greatest indifference to me. Among my friends who have been tested through many years (the word 'friend' has a great meaning for me, so I seldom use it) are more Jews than Russians or Germans. With one of these I have a firm relationship that began when I was in grammar school, and thus has lasted forty years. Such relationships go on until 'the grave.'

When I didn't find you in Berlin—after my return to Germany—I was very depressed, because I had looked forward for years to our reunion. If I had met you in Berlin, we probably would have discussed, along with many other urgent questions, the 'Jewish problem' as well. I would like so much to hear your opinion about it. There are times when 'the devil' scrambles up to the surface and seeks out brains and mouths suitable for his activities. Since every nation has particular characteristics which can move in a particular orbit, there are sometimes, in addition to 'possessed' human beings, 'possessed' nations. This is a sickness which can also be cured. During this sickness two dreadful characteristics appear: negative (destructive) power and the lie, which also brings about destruction. Surely you understand me? Only thus far can 'lumping together' be spoken of. Neither of us belong in the lump, and the sorriest sight would be for us to mutually push each other into a lump. If one is not suited to life in a lump, one can at least reflect on one's nation cold-bloodedly, or with pain, but always objectively, and examine its innate qualities and the temporary variations in these qualities.

Such questions should only be spoken about by human beings who are free. Unfree men misunderstand such questions and the consequence is gossip.

Why didn't you write to me at once when you heard of my remarks? You could have written to me that you objected to these remarks.

You have a frightful picture of the 'Kandinsky of today:' I reject you as a Jew, but nevertheless I write you a good letter and assure you that I would be so glad to have *you* here in order to work *together!* Dear Mr Schoenberg, before

77

you say 'definitively' just think over whether it is possible to send such a '[Kandinsky] of today' respectful regards. Surely the 'dis-' is missing there.

We, so few of us, who can be inwardly free to some extent, should not permit evil wedges to be driven in between us. This piece of work is also a 'black' work. One must resist it.

I do not know whether I have been able to describe my feelings clearly enough. It is no great fortune to be a Jew, Russian, German, European. Better to be a human being. But we should strive to be 'supermen.' That is the duty of the few.

Even if you disassociate yourself from me, I send you kindest regards and the expression of my high esteem.

Kandinsky

[At the top of page 2 of Schoenberg's carbon copy:]

Written without first draft

Mödling 4 May 1923

Dear Kandinsky,
I address you so because you wrote that you were deeply moved by my letter. That was what I hoped of Kandinsky, although I have not yet said a hundredth part of what a Kandinsky's imagination must conjure up before his mind's eye if he is to be my Kandinsky! Because I have not yet said that for instance when I walk along the street and each person looks at me to see whether I'm a Jew or a Christian, I can't very well tell each of them that I'm the one that Kandinsky and some others make an exception of, although of course that man Hitler is not of their opinion. And then even this benevolent view of me wouldn't be much use to me, even if I were, like blind beggars, to write it on a piece of cardboard and hang it round my neck for everyone to read. Must not a Kandinsky bear that in mind? Must not a Kandinsky have an inkling of what really happened when I had to break off my first working summer for 5 years, leave the place I had sought out for peace to work in, and afterwards couldn't regain the peace of mind to work at all.[56] Because the Germans will not put up with Jews! Is it possible for a Kandinsky to be of more or less one mind with others instead of with me? But is it possible for him to have even a single thought in common with HUMAN BEINGS who are capable of disturbing the peace in which I want to work? Is it a thought at all that one can have in common with such people? And: can it be right? It seems to me: Kandinsky cannot possibly have even such a thing as geometry in common

78

with them! That is not his position, or he does not stand where I stand!

I ask: Why do people say that the Jews are like what their black-marketeers are like?

Do people also say that the Aryans are like their worst elements? Why is an Aryan judged by Goethe, Schopenhauer and so forth? Why don't people say the Jews are like Mahler, Altenberg, Schoenberg and many others?

Why, if you have a feeling for human beings, are you a politician? When a politician is, after all, someone who must not take any count of the human being but simply keep his eyes fixed on his party's aims?

What every Jew reveals by his hooked nose is not only his own guilt but also that of all those with hooked noses who don't happen to be there too. But if a hundred Aryan criminals are all together, all that anyone will be able to read from their noses is their taste for alchohol, while for the rest they will be considered respectable people.

And you join in that sort of thing and 'reject me as a Jew'. Did I ever offer myself to you? Do you think that someone like myself lets himself be rejected! Do you think that a man who knows his own value grants anyone the right to criticize even his most trivial qualities? Who might it be, anyway, who could have such a right? In what way would he be better? Yes, everyone is free to criticize me behind my back, there's plenty of room there. But if I come to hear of it he is liable to my retaliation, and no quarter given.

How can a Kandinsky approve of my being insulted; how can he associate himself with politics that aim at bringing about the possibility of excluding me from my natural sphere of action; how can he refrain from combating a view of the world whose aim is St Bartholomew's nights in the darkness of which no one will be able to read the little placard saying that I'm exempt! I, myself, if I had any say in the matter, would, in a corresponding case, associate myself with a view of the world that maintains for the world the right view of the 2–3 Kandinskys that the world produces in a century—I should be of the opinion that only such a view of the world would do for me. And I should leave the pogroms to the others. That is, if I couldn't do anything to stop them!

You will call it a regrettable individual case if I too am affected by the results of the anti-Semitic movement. But why do people not see the bad Jew as a regrettable individual case, instead of as what's typical? In the small circle of my own pupils, immediately after the war, almost all the Aryans had not been on active service, but had got themselves cushy jobs. On the other hand, almost all the Jews had seen active service and been wounded. How about the individual cases there?

But it isn't an individual case, that is, it isn't merely accidental. On the contrary, it is all part of a plan that, after first not being respected on the ordinary conventional road, I now have to go the long way round through

politics into the bargain. Of course: these people, to whom my music and my ideas were a nuisance, could only be delighted to find there is now one more chance of getting rid of me for the time being. My artistic success leaves me cold, you know that. But I won't let myself be insulted!

What have I to do with communism? I'm not one and never was one! What have I to do with the Elders of Zion? All that means to me is the title of a fairy-tale out of a Thousand and One Nights, but not one that refers to anything remotely as worthy of belief.

Wouldn't I too necessarily know something of the Elders of Zion? Or do you think that I owe my discoveries, my knowledge and skill, to Jewish machinations in high places? Or does Einstein owe his to a commission from the Elders of Zion?

I don't understand it. For all that won't stand up to serious examination. And didn't you have plenty of chance in the war to notice how much official lying is done, indeed that official talk is all lies. How our brain, in its attempt to be objective, shuts down on the prospect of truth for ever. Didn't you know that or have you forgotten?

Have you also forgotten how much disaster can be evoked by a particular mode of feeling? Don't you know that in peace-time everyone was horrified by a railway-accident in which four people were killed, and that during the war one could hear people talking about 100,000 dead without even trying to picture the misery, the pain, the fear, and the consequences? Yes, and that there were people who were delighted to read about as many enemy dead as possible; the more, the more so! I am no pacifist; being against war is as pointless as being against death. Both are inevitable, both depend only to the very slightest degree on ourselves, and are among the human race's methods of regeneration that have been invented not by us, but by higher powers. In the same way the shift in the social structure that is now going on isn't to be lodged to the guilty account of any individual. It is written in the stars and is an inevitable process. The middle classes were all too intent on ideals, no longer capable of fighting for anything, and that is why the wretched but robust elements are rising up out of the abysses of humanity in order to generate another sort of middle class, fit to exist. It's one that will buy a beautiful book printed on bad paper, and starve. This is the way it must be, and not otherwise—can one fail to see that?

And all this is what you want to prevent. And that's what you want to hold the Jews responsible for? I don't understand it!

Are all Jews communists? You know as well as I do that that isn't so. I'm not one because I know there aren't enough of the things everyone wants to be shared out all round, but scarcely for a tenth. What there's enough of (misfortune, illness, beastliness, inefficiency and the like) is shared out

80

anyway. Then, too, because I know that the subjective sense of happiness doesn't depend on possessions; it's a mysterious constitution that one either has or has not. And thirdly because this earth is a vale of tears and not a place of entertainment, because, in other words, it is neither in the Creator's plan that all should fare equally well, nor, perhaps, has it any deeper meaning at all.

Nowadays all one needs is to utter some nonsense in scientifico-journalistic jargon, and the cleverest people take it for a revelation. The Elders of Zion—of course; it's the very name for modern films, scientific works, operettas, cabarets, in fact everything that nowadays keeps the intellectual world going round.

The Jews do business, as business men. But if they are a nuisance to their competitors, they are attacked; only not as business men, but as Jews. As what then are they to defend themselves? But I am convinced that they defend themselves merely as business men, and that the defence as Jews is only an apparent one. I.e., that their Aryan attackers defend themselves when attacked in just the same way, even though in somewhat other words and by adopting other (more attractive???) forms of hypocrisy; and that the Jews are not in the least concerned with beating their Christian competitors, but only with beating *competitors!* and that the Aryan ones are in exactly the same way out to beat *any* competitors; and that any association is thinkable among them if it leads to the goal, and every other contradiction. Nowadays it is race; another time I don't know what. And a Kandinsky will join in that sort of thing?

The great American banks have given money for communism, not denying the fact. Do you know why? Mr Ford will know that they aren't in a position to deny it: Perhaps if they did they would uncover some other fact much more inconvenient to them. For if it were true, someone would long ago have proved it is untrue.

WE KNOW ALL THAT! THAT'S THE VERY THING WE KNOW FROM OUR OWN EXPERIENCE! Trotsky and Lenin spilt rivers of blood (which, by the way, no revolution in the history of the world could ever avoid doing!), in order to turn a theory—false, it goes without saying (but which, like those of the philanthropists who brought about previous revolutions, was well meant)—into reality. It is a thing to be cursed and a thing that shall be punished, for he who sets his hand to such things must not make mistakes! But will people be better and happier if now, with the same fanaticism and just such streams of blood, other, though antagonistic, theories, which are nevertheless no more right (for they are of course all false, and only our belief endows them, from one instance to the next, with the shimmer of truth that suffices to delude us), are turned into reality?

But what is anti-Semitism to lead to if not to acts of violence? Is it so difficult

81

to imagine that? You are perhaps satisfied with depriving Jews of their civil rights. Then certainly Einstein, Mahler, I and many others, will have been got rid of. But one thing is certain: they will not be able to exterminate those much tougher elements thanks to whose endurance Jewry has maintained itself unaided against the whole of mankind for 20 centuries. For these are evidently so constituted that they can accomplish the task that their God has imposed on them: To survive in exile, uncorrupted and unbroken, until the hour of salvation comes!

The anti-Semites are, after all, world-reforming busybodies with no more perspicacity and with just as little insight as the communists. The good people are Utopians, and the bad people: business men.

I must make an end, for my eyes are aching from all this typing. . . . I had to leave off for a few days and now see that morally and tactically speaking I made a very great mistake.

I was arguing! I was defending a position!

I forgot that it *is not a matter* of right and wrong, of truth and untruth, of understanding and blindness, but of power; and in such matters everyone seems to be blind, in hatred as blind as in love.

I forgot, it's no use arguing because of course I won't be listened to; because there is no will to understand, but only one not to hear what the other says.

If you will, read what I have written; but I do ask that you will not send me an argumentative answer. Don't make the same mistake as I made. I am trying to keep you from it by telling you:

I shall not understand you; I cannot understand you. Perhaps a few days ago I still hoped that my arguments might make some impression on you. Today I no longer believe that and feel it as almost undignified that I uttered any defence.

I wanted to answer your letter because I wanted to show you that for me, even in his new guise, Kandinsky is still there; and that I have not lost the respect for him that I once had. And if you would take it on yourself to convey greetings from me to my former friend Kandinsky, I should very much wish to charge you with some of my very warmest, but I should not be able to help adding this message:

We have not seen each other for a long time; who knows whether we shall ever see each other again; if it should, however, turn out that we do meet again, it would be sad if we had to be blind to each other. So please pass on my most cordial greetings.

[No signature on Schoenberg's carbon copy.]

[Picture postcard from Juan les Pins, 'La Girelle,' to Schoenberg in Roquebrune, Cap Marta, Pavillon Sévigné.]

18 [*May ?*] 1928

And indeed 'chance' has brought us to the same region at any rate. Originally we wanted to go on farther along the ocean, but the heat and the beautiful countryside have kept us here. How would it be if you and your good wife were to visit us here? Kind regards,

Your Kandinsky

Do you know Juan les Pins? If not, then you must get to know it. It will be very nice if you visit us. Write to us beforehand.

Your Nina Kandinsky

Neuilly sur Seine (Seine)
135 Bd. de la Seine
France 1 July 1936

Dear Mr Schoenberg,
I was very happy to get a few lines from you through Mr Danz.[57] He visited me a few days ago and made a very interesting impression on me. He also gave me his book *Zarathustra*, which I have already read some of (it is not so easy for me to read a lot of English), and where I repeatedly came across your name accompanied by what I find to be very successful character sketches.

I made repeated inquiries to Mme Scheyer[58] about you and how you are doing, and know that you are really doing splendidly, which gave me real pleasure. Mr Danz confirmed the earlier information and said you were now a (or rather 'the') dictator of music in California. Wonderful! I hope that you yourself are happy with this appointment, [and] also your dear wife.

Both of us—you and I—have for many years led a really 'active' life—one just rushed around and often out. We do really have a little right to some peace. Let us modestly say 'relative' peace. My wife and I will soon have been in Paris for three years, where we hoped to find this relative peace. Actually we have it, although it is perhaps somewhat *too* relative: there were a couple of times when we asked ourselves whether to 'pack our bags again.' As regards myself, I have already packed them three times and think 'all good things come in threes'—so. . . Now unfortunately the Russians say 'a (farm) house cannot be built without four corners.' So?

After I arrived here, I had a wonderful feeling of freedom. Twofold

83

freedom—external and inner—just because after fourteen years of teaching I suddenly had no more fixed obligations. My wish would be to keep it, to preserve it further, not to lose it any more. That unfortunately depends upon [one's] purse. In the good days before the time of crisis I had 'put something aside' from which we now live, for the most part, since current sales would not be sufficient. So one is 'eating up' one's 'capital.' But I hope that 'Justice' will also remember artists at some point. Defenceless artists who cannot even paint. Especially in Paris, there are other dark sides as well, which cannot always be avoided. We live a rather retired life here, that is, I in particular try to keep myself as far as possible from 'artistic politics,' also from too close communication with colleagues. But art politics is like a gnat, since if it is not actually small, it is nevertheless petty and possesses the evil ability to slip through the smallest keyhole. Communication with colleagues. . . I do not need to tell you about. Still, we have our more intimate circle, which is very congenial and very international. Otherwise one gets to see many foreigners who come to Paris in the tourist season ([which is] right now, in summer), and who are sometimes worthwhile and pleasant.

One can work very well here, which is the 'sunny side' of Paris. Both sorts of colour—physical and spiritual—are very stimulating here. By spiritual I don't really mean the painting that is done here, but rather the spiritual atmosphere of Paris—God knows where it comes from or of what it consists.

Indefinable. Of course the confusion and juxtapositions here suit the Slavic soul. Surely in no other land could one hear an explanation of a police decree such as I heard from a French policeman here: 'Monsieur, it's idiotic—but that's nevertheless the way it is.' Here everything *lives* at the same time—the oldest tradition and the avant-garde—side by side. The Frenchman wants at the same time to 'be left in peace' and to revolutionize. He can flare up furiously and immediately afterwards become profoundly good-natured. And that is reflected in everything—confusion—juxtaposition. You know Paris, of course? Even externals reflect the inner situation clearly—just take for example the wild contrasts between houses (which cannot always be called houses, but Heaven only knows what) in the so-called 'decent' streets—a palace and right beside it a 'witch's cottage' that slowly but surely for years has been falling into ruin. Or: here it is thought unnecessary to remove old posters—the rain will take care of it one day—and so you may see a fresh-looking poster advertising a concert that took place a year ago. You ask a bus conductor for the timetable of his line and get as an answer 'yes, you know, that varies.' But *how* it 'varies' you will scarcely find out from anyone. One loses one's temper, laughs and accepts it. For a true German, such a state of affairs would be death.

Do you still remember, dear Mr Schoenberg, how we met—I arrived on the

steamer wearing short Lederhosen and saw a black-and-white graphic—you were dressed completely in white and only your face was deeply tanned. And later the summer in Murnau? All our contemporaries from that time sigh deeply when they remember that vanished epoch and say: 'That was a beautiful time.' And it really was beautiful, more than beautiful. How wonderfully life pulsated then, what quick spiritual triumphs we expected. Even today I expect them, and with the most complete certainty. But I know that a long, long time will still be necessary.

The report which you requested from me has become long and detailed. I shall wait for you to 'return the favor.' In the meantime, many very kind regards, to your wife as well, in which my wife joins just as warmly.

<div align="right">Your Kandinsky</div>

Yes, it would be lovely to come to America, even if only for a visit. I have been planning it for years. But even apart from the not inconsiderable costs there have always been all kinds of obstacles until now. During the first years after emigration, I didn't want to leave Paris at all, in order to enjoy and turn to account as fully as possible the freedom to work which had finally come. But the dream of some day seeing America will persist.

Texts by
Arnold Schoenberg

FOREWORD TO TEXTS

Texte *(Vienna/New York: Universal Edition, 1926) including the words of* Die glückliche Hand, Totentanz der Principien, Requiem, *and* Die Jakobsleiter.

These are texts: that means, they only yield something complete together with the music. However, that is not said in order to ask more indulgence for them than is granted to my music. For the quality of the finished product which one envisages is surely not dependent on the quality of the component parts, since each of these needs only to be as good at any given time as circumstances demand: that good, and good in that particular way! But one who has looked upon the whole also sees it in the smallest component and could not let anything pass muster as suitable if it were not so in every respect.

Just as little as one can expect a reader to form an idea of music which is unknown to him, can one expect from an author that he write music which corresponds to such a conception. The author of the text must save space on the surface for music to occupy, since music's aim is to penetrate the depths. The incompleteness then shows itself as imperfection on the most exposed flank, and this is no doubt the reason why an artist in several art-forms has seldom had the experience of achieving more recognition than had been his due from one art. On the contrary: people always conclude from that achievement which they find slight that the other one is slighter still.

The musician is in the position of being relatively untouched by his text. He needs it mainly in order to arrange the vowels and consonants according to principles which would also be decisive without it. His music might also be slower and faster, higher and lower, louder and softer, without the text, and singers are most satisfactory when they perform it as euphoniously as a well-understood 'do–re–mi.'

There are too many people who are not sure enough of their enjoyment of a work of art and, only after having proved to themselves by reading criticism that they can discriminate, manage to pass over the good, in order to choose the average. To be sure, the latter is surrounded to an inappropriate degree by the aura of the unusual, a defect which is more than outweighed by the circumstance that only thus does it become clear who is actually an outsider to

artistic and intellectual matters: he who must criticize first before he can enjoy, or still criticizes, after he has enjoyed. Like the lover in Liliencron who, in a room full of beautiful women, perceives nothing but caryatids, a well-functioning organism passes heedlessly over the imperfect. If only this were also the case in art and an alleged science, which cannot read our notes or understand our musical language, at least did not strive to dissect our souls: if only it did not thus use the text to observe that which is not put on show at all; if only it did not thus distract from true artistic worth and put art judgement and art criticism in place of the sensation caused by a work of art; if only, finally, it did not analyse the author instead of the work, the musician would not have to concern himself any more with the question of why he publishes such texts, and would not need to make the admission that he can declare no better reason for this than for his purely musical publications: none, that is, that would withstand such an interrogation; none that explains his craving to preserve his privacy in public.

Art is—we can hardly escape the fact—a part of culture, and therefore belongs to all who stretch out their hands toward it: to society as a whole. Therefore the intention which at first can be inferred from the work of art cannot, for a while, be a matter of indifference. But after this pales, characteristics become noticeable which society as a whole disregards, since they cannot change the overall impression. Only then is the art work without great influence held in great respect.

DIE GLÜCKLICHE HAND
('The Lucky Hand')*
Drama with Music, Op. 18

Text finished end of June 1910; music written between 9 September 1910 and 18 November 1913. First publication of the text in the Austrian music journal *Der Merker*, vol. II, no. 17, June 1911. Second and final authorized publication in A. Schoenberg, *Texte* (Vienna/New York, 1926).

CHARACTERS

A MAN
A WOMAN
A GENTLEMAN
SIX WOMEN
SIX MEN

SCENE I

Left and right are from the spectators' point of view. The stage is almost completely dark. In front lies the MAN, *face down. On his back crouches a cat-like, fantastic animal (hyena with enormous, bat-like wings) that seems to have sunk its teeth into his neck.*

The visible portion of the stage is very small, somewhat round (or shallow curve). The rear stage is hidden by a dark-violet velvet curtain. There are slight gaps in this curtain from which green-lit faces peer: SIX MEN, SIX WOMEN.

The light very weak. Only the eyes are clearly visible. The rest is swathed in soft red veiling, and this too reflects the greenish light.

THE SIX MEN AND THE SIX WOMEN:*(spoken very softly, with deepest pity)* Be still, won't you? You know how it always is, and yet you remain blind. Will you never be at rest? So many times already! And once again? You know

* Translator's note: Schoenberg plays on the ambiguity of the German word 'glücklich,' whose several meanings include fateful, happy and fortunate.

that the pattern once again repeats itself. Once again the same ending. Must you once again rush in? Will you not finally believe? Believe in reality: it is thus, thus it is, and not otherwise. Once again you trust in the dream. Once again you fix your longing on the unattainable. Once again you give yourself up to the sirens of your thoughts, thoughts that roam the cosmos, that are unworldly, but thirst for worldly fulfillment! Worldly fulfillment—you poor fool—worldly fulfillment! You, who have the divine in you, and covet the worldly! And you cannot win out! You poor fool!

They disappear (the gaps in the curtain grow dark). The fantastic animal also disappears. For a while everything is still and motionless. Then long, black, shadows (veils) fall slowly across the MAN. *Suddenly, behind the scene, loud, gay music is heard, a joyous uproar of instruments. The shrill, mocking laughter of a crowd of people mingles with the final chord of the backstage music.*

At the same moment the MAN *springs to his feet. The dark curtains at the back are rent asunder.*

The MAN *stands there, upright. He wears a dirty yellow-brown jacket of very coarse, thick material. The left leg of his black trousers comes down only to the knee; from there on it is in tatters. His shirt is half open, showing his chest. On his stockingless feet are badly torn shoes; one is so torn that his naked foot shows through, disclosing a large, open wound where it has been cut by a nail. His face and chest are in part bloody, in part covered with scars. His hair is shorn close.*

Rising, the MAN *stands for a moment with head sunk, then fervently:*

THE MAN: Yes, oh yes! *(sung)*

Scene change. At the same instant, the stage becomes light, and now shows the following picture:

SCENE II

A somewhat larger stage area, deeper and wider than the first. In the background a soft blue, sky-like backdrop. Below, left, close to the bright brown earth, a circular cut-out five feet in diameter through which glaring, yellow sunlight spreads over the stage. No other lighting but this, and it must be very intense. The side curtains are of pleated, hanging material, soft yellow-green in color.

THE MAN *(singing)*: The blossoming: oh, longing!

Behind him, left, a beautiful young WOMAN *emerges from one of the folds of the side-hanging. She is clothed in a soft deep-violet garment, pleated and flowing;*

yellow and red roses in her hair; graceful figure. The MAN *trembles (without looking around). After a few small steps, the* WOMAN *pauses about a quarter of the way across the stage, and looks with unspeakable pity at the* MAN.

THE MAN: O you blessed one! How beautiful you are! How sweet it is to see you, to speak with you, to listen to you. How you smile, how your eyes laugh! Ah, your lovely soul!

The WOMAN *holds a goblet in her right hand and, stretching forth her right arm (the sleeve of her garment hangs down to her wrist), offers it to the* MAN. *From above violet light falls upon the goblet.*

Rapturous pause.

Suddenly the MAN *finds the goblet in his hand, although neither has stirred from their place and the* MAN *has never looked at her. (The* MAN *must never look at her; he always gazes ahead; she always remains behind him.) The* MAN *holds the goblet in his right hand, stretching out his arm. He contemplates the goblet with rapture. Suddenly he becomes deeply serious, almost dejected; reflects a moment; then his face brightens again and with a joyous resolution he puts the goblet to his lips and drains it slowly.*

As he drinks, the WOMAN *watches him with waning interest. A coldness takes possession of her face. With a rather ungraceful motion she gathers her dress to her, rearranges its folds, and hastens to the other side of the stage. Remains standing not far from the side curtain on the right, always behind him.*

With the goblet still raised to his lips, the MAN *takes several steps forward and to the left, so that he stands approximately at stage center.*

When he lets his hand and the goblet sink, the WOMAN's *face shows indifference, over which a hostile impulse sometimes slips. He stands deep in thought, moved, entranced.*

THE MAN: How beautiful you are! I am so glad when you are near me; I live again . . .

He stretches out both his arms, as if she stood before him.

THE MAN: Oh, you are beautiful!

Meanwhile she begins slowly to withdraw. When she has turned far enough so that she is looking directly at the side curtain on the right, her face lights up. At the same time a GENTLEMAN *appears before this curtain, in a dark gray overcoat, walking stick in hand, elegantly dressed—a handsome, genteel figure. He stretches his hand to her; she goes smilingly to him; confidently, as to an old acquaintance. He takes her impetuously in his arms, and both disappear through the right-hand curtain. As she begins to smile at the* GENTLEMAN, *the* MAN *becomes uneasy. He turns around by degrees, as if the back of his head perceived*

these things. He bends forward slightly. At the moment when the GENTLEMAN *stretches his hand toward the* WOMAN, *the* MAN'S *left hand stiffens convulsively; and as she rushes into the arms of the* GENTLEMAN, *the* MAN *groans:*

THE MAN: Oh. . . .

He takes several steps forward and to the left, and then stands still in utter dejection.

 But in a moment the WOMAN *rushes from the side curtain on the left and kneels before him. The* MAN *listens to her without looking at her (his glance is directed upward). His face glows happily. Her face is full of humility and she seems to beg forgiveness.*

THE MAN: Oh, you are sweet, you are beautiful!

She gets slowly to her feet, and seeks his left hand in order to kiss it. He comes before her and sinks down on his knees and reaches toward her hands (without touching them, however). As she stands and he kneels, her face changes somewhat—takes on a slightly sarcastic expression. He looks blissfully up at her, raises his hand and touches hers lightly. While he continues to kneel, deeply stirred, directing his gaze at his own upraised hand, she quickly flees through the left curtain.

 The MAN *does not realize that she has gone. To him, she is there at his hand, which he gazes at uninterruptedly. After a while he rises by a colossal effort, stretching his arms high in the air, and remains standing giant-like on tip-toe.*

THE MAN: Now I possess you forever.

Scene change. For a moment the stage darkens and then immediately grows bright. Now its entire practicable depth and width show the following picture:

SCENE III

Wild, rocky landscape; blackish-gray, overgrown cliffs with a scattering of pine trees, their branches silver-gray.

 About at stage center, a small, rocky plateau, flanked by high, sheer rocks that stretch right and left as far as the apron of the stage. The plateau slopes forward slightly. Somewhat to the right of stage center it towers up steep and slanting. Here a ravine winds between two rock formations, its brim visible. Before it lies a lower plateau, connected with the higher one. Towering above the ravine stands a single, man-sized fragment of rock. In back of the plateau (and higher than it) are two grottos, hidden by

dark-violet material. The scene must be lighted from behind and above, so that the rocks throw shadows over the otherwise rather bright stage. The entire effect should not imitate nature, but rather be a free combination of colors and forms. At first a gray-green light falls across the stage (only from behind). Later, when the grottos are illuminated, yellow-green light is cast from the front on to the rocks, and blue-violet light on to the ravine.

As soon as the scene grows bright, the MAN *is seen climbing out of the ravine (whose edge must therefore project above the level of the stage floor). He climbs without difficulty, although it is plainly a treacherous place to gain a foothold. He is dressed as in the first scene, save that he has a rope bound around his waist from which dangle two Saracens' heads, and he holds a naked, bloody sword in his hand.*

Just before the MAN *has completely emerged from the ravine, one of the two grottos (left) slowly grows bright, changing rather quickly from dark-violet to brown, red, blue and green, and then to a bright, delicate yellow (citrus-yellow). (Not too bright!) In the grotto, which is something between a machine shop and a goldsmith's workshop, several* WORKERS *are seen at work in realistic workingmen's dress. (One files, one sits at a machine, one hammers, etc.) The light in the grotto now seems to come mainly from the lamps hanging above the* WORKERS *(twilight glow). In the middle stands an anvil, near it a heavy hammer.*

When the MAN *has completely climbed from the ravine, he walks behind a rock formation toward the center, stands still, and contemplates the* WORKERS *thoughtfully. An idea seems to occur to him; he breathes heavily. Then he brightens, grows more cheerful, and says quietly and simply:*

THE MAN: That can be done more simply.

He goes to the anvil, lets the sword fall, picks up a piece of gold lying on the ground, lays it on the anvil and grasps the hammer with his right hand. Before he strikes, the WORKERS *spring up and make as if to throw themselves upon him. They must not go so far as actually to attack him, but their intention should be clear to the audience. Meanwhile, without noticing these menacing gestures, the* MAN *contemplates his raised left hand, whose fingertips are lighted bright blue from above. He looks at them with deep emotion, then—radiant, swelled with a sense of power—he grasps the hammer with both hands and brings it down in a powerful swing. When the hammer falls, the* WORKERS' *faces express astonishment: the anvil splits down the middle and the gold sinks into the cleft.*

The MAN *bends down and pulls it out with his left hand. Raises it slowly on high. It is a diadem, richly set with precious stones.*

THE MAN (*simply, without emotion*): This is the way to make jewels.

95

The WORKERS' *gestures grow threatening again; then disdainful; they take counsel together and seem to be planning to make some move against the* MAN. *The* MAN *throws his handiwork to them, laughing. They prepare to rush upon him. He has turned away and does not see them. He stoops to pick up his sword.*

As he touches it with his left hand, the grotto grows dark.

Every trace of the workshop disappears behind the dark curtain.

As it darkens, a wind springs up. At first it murmurs softly, then steadily louder (along with the music).

Conjoined with this wind-crescendo is a light-crescendo. It begins with dull red light (from above) that turns to brown and then a dirty green. Next it changes to a dark blue-gray, followed by violet. This grows, in turn, into an intense dark red which becomes ever brighter and more glaring until, after reaching a blood-red, it is mixed more and more with orange and then bright yellow; finally a glaring yellow light alone remains and inundates the second grotto from all sides. This grotto was already visible at the beginning of the light-crescendo and underwent the same gamut of color changes from within (although less brightly than the rest of the stage). Now it too streams with yellow light.

During this crescendo of light and storm, the MAN *reacts as though both emanated from him. He looks first at his hand (the reddish light); it sinks, completely exhausted; slowly, his eyes grow excited (dirty green). His excitement increases; his limbs stiffen convulsively, trembling, he stretches both arms out (blood-red); his eyes start from his head and he opens his mouth in horror. When the yellow light appears, his head seems as though it is about to burst.*

He does not turn toward the grotto, but looks straight ahead.

When it is completely bright, the storm breaks off and the yellow light changes swiftly to a mild, bluish light. For a moment the grotto remains empty, bathed in this light. Then the WOMAN *enters from the left, quickly and lightly. She is dressed as in the second scene, but the upper left section of her clothing is missing, so that this part of her upper body is completely naked to her hip.*

When she reaches the middle of the grotto she stands still and looks inquiringly about her for a moment. Then she stretches her arms toward the GENTLEMAN, *who at the same moment becomes visible at the right side of the grotto. He holds the missing portion of her dress in his right hand and beckons her with it.*

Meanwhile the MAN'S *despair increases. He crooks his fingers into claws, presses his arms to his sides, bends his knees and leans the upper part of his body backward. When the* GENTLEMAN *beckons with the scrap of clothing, the* MAN *turns around with a violent jolt and falls on his knees, then on his hands, and tries to reach the grotto on all fours. But he is unable to climb up.*

THE MAN (*sings*): You, you! You are mine . . . you were mine . . . she was mine . . .

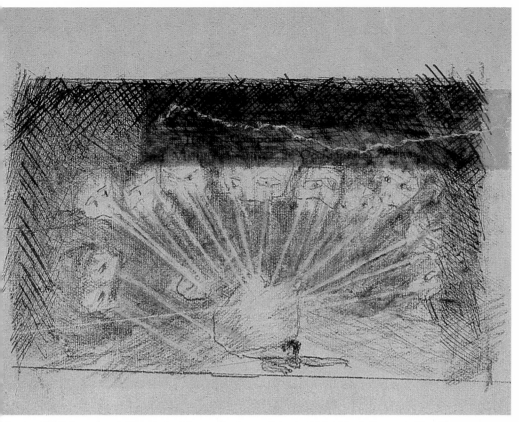

20. Arnold Schoenberg: Sketch for his music drama *Die glückliche Hand*. Scene 1: The Chorus
 Crayon on paper, 14×11cm

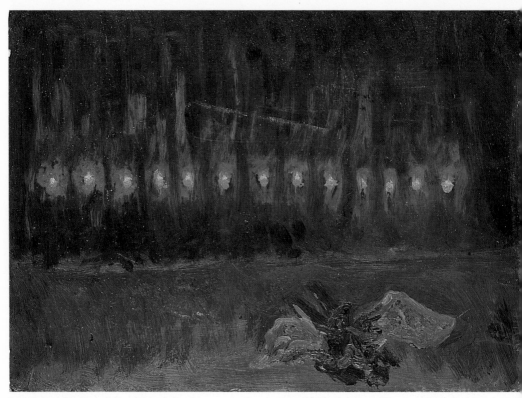

21. Arnold Schoenberg: Sketch for his music drama *Die glückliche Hand*. Scene 1: The Chorus
 Oil on pasteboard, 30×22cm

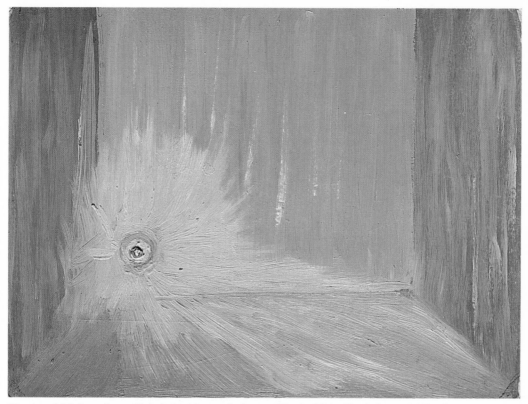

22. Arnold Schoenberg: Sketch for his music drama *Die glückliche Hand*. Scene 2: The Source
of Light
Oil on pasteboard, 30×22cm

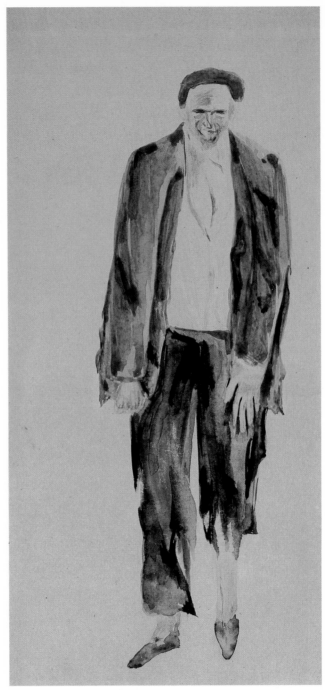

23. Arnold Schoenberg: Sketch for his music drama
Die glückliche Hand. The Man
Watercolor on paper, 27×13cm

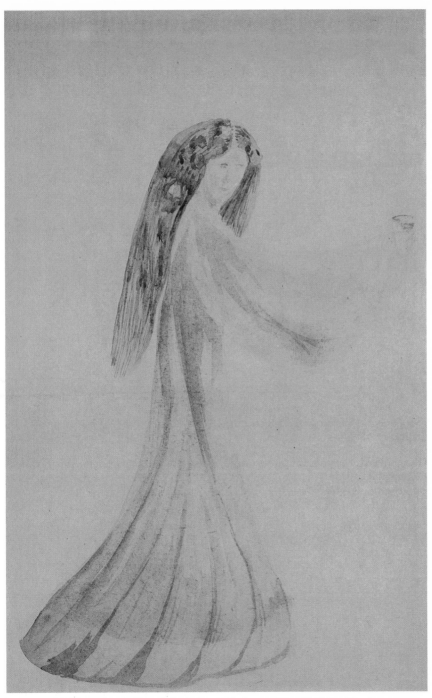

24. Arnold Schoenberg: Sketch for his music drama *Die glückliche Hand*.
The Woman
Watercolor on paper, 27×18cm

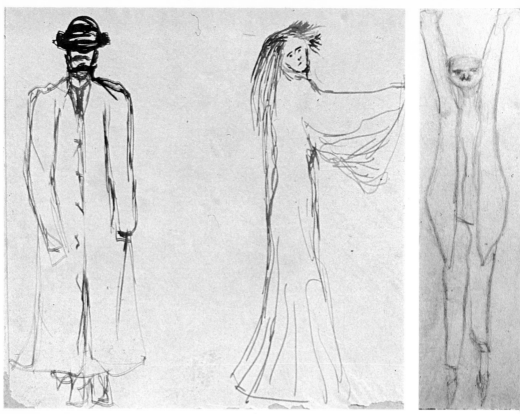

25. Arnold Schoenberg: Sketch for his music drama *Die glückliche Hand.* The Woman and the Man
 Ink on paper, 21×21cm

26. Arnold Schoenberg: Sketch for his music drama *Die glückliche Hand.* Scene 3: The Man
 Pencil on paper, 22×8cm

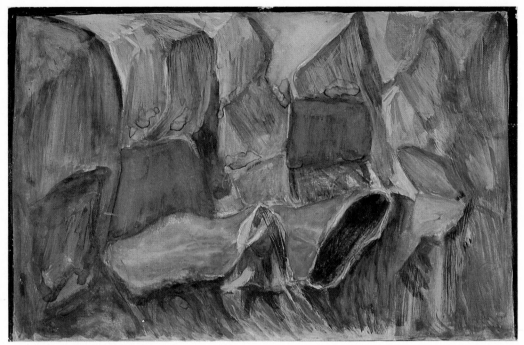

27. Arnold Schoenberg: Sketch for his music drama *Die glückliche Hand*. Scene 3: Rocks
 Watercolor on paper, 18×27cm

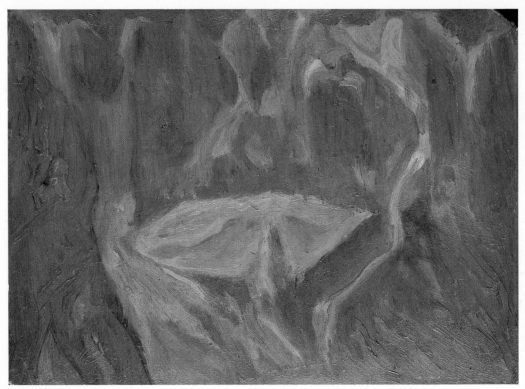

28. Arnold Schoenberg: Sketch for his music drama *Die Glückliche Hand*. Scene 3: Rocks
Oil on pasteboard, 25×35cm

He rises, and tries desperately to clamber up to the grotto. But he does not succeed, for the walls are slippery as marble.

As the MAN *sings, the* GENTLEMAN *notices him but makes this known only by the cool glance he casts upon him. When the* MAN *attempts to clamber up, the* GENTLEMAN *throws him the scrap of clothing with a calm, cold gesture, and exits with utter indifference, never changing the expression of his face.*

Suddenly the stage grows completely dark and then immediately light again. Half-bright: a pale, greenish-gray light. The grotto is again dark, as at the beginning. With the return of light, the WOMAN *springs from the grotto on to the plateau, seeking the scrap of clothing. She sees it lying near the* MAN, *hastens to it, picks it up and covers herself with it. During the momentary darkness the* MAN *has leaned his head against the wall, his back turned to the* WOMAN. *When she puts on the fragment of her dress, he turns round, throws himself on his knees, and sings beseechingly:*

THE MAN: Beautiful vision, stay with me.

Sliding on his knees, he tries to reach her, but she slips from him and hastens up the rock. He leaps after her and slides farther on his knees. She gains the top quickly and hurries to the man-sized stone near the ravine. At the moment when she had leapt from the grotto to the plateau, this stone had begun to glow (from within) with a dazzling green light. Now, its peak looks like a monstrous sneering mask, and the shape of the entire stone changes so that one might take it to be the fantastic animal of the first scene, standing upright. At this moment the MAN *stands below and directly opposite the* WOMAN, *so that, when she gives the stone a slight push with her foot, it topples over and hurtles down upon him.*

Scene change. At the moment the stone buries the MAN *it grows dark, and the loud music and mocking laughter of the first scene are heard again.*

SCENE IV

The stage is lighted again quickly. The same as the first scene: the SIX MEN *and the* SIX WOMEN. *Their faces are now lit by a gray-blue light, and the fantastic animal is once again gnawing the neck of the* MAN, *and he is lying on the ground in the same spot where the stone had been cast down on top of him (thereby strengthening the impression that the stone and the fantastic animal are one and the same).*

THE SIX MEN AND THE SIX WOMEN (*accusingly, severely*): Did you have to live again what you have so often lived? Can you never renounce? Never at last resign yourself? Is there no peace within you? Still none? You seek to

lay hold of what will only slip from you when you grasp it. But what is in you, around you, wherever you may be, do you not feel it? Do you not hear it? Do you understand only what you hold? Do you feel only what you touch, the wounds only in your flesh, the pain only in your body?

And still you seek.

And torment yourself, and are without rest.

The gray-blue light that falls on their faces is somewhat tinted with red.

You poor fool!

The stage grows slowly dark, and the curtain falls.

INSTRUCTIONS FOR THE STAGING OF *DIE GLÜCKLICHE HAND*

From a 14 April 1930 letter to Ernst Legal, General Director of the Kroll Opera in Berlin. Quoted from Arnold Schoenberg Letters, *ed. Erwin Stein, trans. Eithne Wilkins and Ernst Kaiser, pp. 140–1.*

In the 'Glückliche Hand' the main thing is:

I. The use of colored lights. Strong lights are needed, and *good colors*. The set must be painted in such a way that it *takes on* the colors!

II. For an infinite number of reasons the construction of the stage and the set must be carried out to a T in accordance with my directions, otherwise nothing will work. I did once make drawings for this, which I would have to look for. Anyway I ought to be sent the sketches in plenty of time to have a look at them.

III. I have also exactly fixed the positions of the actors and the lines along which they have to move. I am convinced that this must be exactly kept to if everything is to turn out all right.

IV. Lighting up the 12 faces in the 1st and 4th scenes, making them disappear and appear again (and instantly!) is very difficult and must be discussed.

V. The mystical animal must be very big. The experiment made in Vienna and Breslau, of having a human being to do it, has so far turned out to be no good at all. Above all at the end of the 3rd scene, where the boulder begins to shine and topples on the man and then turns into the mythical animal. Above all no performer has been able to jump so far (about 8-9 feet). But anyway a jump like that doesn't look like toppling. Here it would probably be best to come back to my description.

VI. At the end of the 1st scene the curtain should *tear*. So far not even a suggestion of this has been managed anywhere. My wife thinks [it could be done] by projection. I think a skilled upholsterer ought to be able to contrive it with a system of blind-cords.

VII. Likewise, at the end of the 1st scene 'black veils' descend on the man. Hitherto not solved either.

VIII. The 'sun' in the second scene isn't easy to do either. It must be low down!

I think I have indicated most of what has caused difficulties so far.

I have no liking for what is called 'stylized' decorations (what style?) and always want to see a set done by the good old experienced hand of a painter who can draw a straight line straight and not model his work on children's drawings or the art of primitive peoples. The objects and settings in my pieces *also play their parts,* and so they should be just as clearly recognizable as the pitch of the notes. If the people in the audience are confronted with a picture-puzzle ('Where is the hunter?') and have to begin by asking what it means, they miss hearing part of the music. Although this may suit them, it is not what I want.

ON THE PROJECTED FILM

A letter to Emil Hertzka (1869–1932), director of Universal Edition in Vienna and for twenty years Schoenberg's publisher. The letter is undated and without indication of place. E. Stein, in Arnold Schoenberg Letters, *pp. 43 ff, surmises Berlin, autumn 1913, thus still in the days of silent films. The projected filming of the music drama did not take place.*

Dear Herr Direktor,
You ask what are the artistic terms on which my 'Glückliche Hand' might be

99

reproduced cinematographically. There is little I can say at the moment about details, which will arise only during the work of adaptation. But in general I can say as follows:

I. *No change is to be made in the music!*

II. If *I* find it necessary to make improvements in the text, I shall make them myself and nobody else, whoever it may be, shall have the right to require them of me.

III. As many rehearsals as I think necessary! This cannot be estimated in advance. Rehearsals must go on until it goes as well as 'Pierrot lunaire'.

IV. Performances may be given only with performers approved by me, and if possible with the original ensemble. But I am prepared to consider rehearsing with several sets of performers, or, alternatively, to let friends of mine rehearse them under my supervision.

V. Performances may be given only with a (full) orchestra rehearsed and directed by me or my trusted deputies, or (if these mechanical organs turn out to be as good as I hope) with an organ (e.g., Aeolian organ). Further, in large cities it must always be an orchestra. When and under what conditions an organ may be used cannot be said at this stage. For that, after all, depends to a great extent on what these organs are like. If they satisfy me, I shall make no difficulties. On the contrary, I expect great things of these instruments with their magnificent bass stops and the innumerable precisely defined timbres.

VI. What I think about the sets is this: the basic unreality of the events, which is inherent in the words, is something that they should be able to bring out even better in the filming (nasty idea that it is!). For me this is one of the main reasons for considering it. For instance, in the film, if the goblet suddenly vanishes as if it had never been there, just as if it had simply been forgotten, that is quite different from the way it is on the stage, where it has to be removed by some device. And there are a thousand things besides that be easily done in this medium, whereas the stage's resources are very limited.

My foremost wish is therefore for something the opposite of what the cinema generally aspires to. I want:

The utmost unreality!

The whole thing should have the effect (not of a dream) but of chords. Of music. It must never suggest symbols, or meaning, or thoughts, but simply the play of colors and forms. Just as music never drags a meaning around with it, at least not in the form in which it [music] manifests itself, even though meaning is inherent in its nature, so too this should simply be like sounds for the eye, and so far as I am concerned everyone is free to think or feel something similar to what he thinks or feels while hearing music.

100

What I have in mind is therefore the following:

A painter (say: I, Kokoschka, or II, Kandinsky, or III, Roller*) will design all the main scenes. Then the sets will be made according to these designs, and the play rehearsed. Then, when the scenes are all rehearsed to the exact tempo of the music, the whole thing will be filmed, after which the film shall be colored by the painter (or possibly only under his supervision) according to my stage-directions. I think however that mere coloring [will] not suffice for the 'Color Scene' and other passages where strong color effects are required. In such passages there would also have to be colored reflectors casting light on the scene.

Another problem, it seems to me, is that of the opening and concluding scenes, which are to be *almost entirely in darkness'*. I do not know whether the cinematograph can do this, since there is no such thing as 'dark light'. But I dare say there are solutions even for such problems.

Regarding the music:

The 6 men and the 6 women would of course have to be there, just like the Man. I mean: they would have really to sing and speak. Naturally behind the stage or the orchestra, beside the organ, or in some such place. That can be worked out.

They would naturally have to be outstandingly good singers. Still, that is a comparatively small expense. What I mean is: e.g., one of the 6 men (the first) has to be a good soloist, the others capable choral singers. The same applies to the women!

For the film the part of the Man can be played by somebody who does not need to sing. The actor chosen should therefore be an outstandingly good one.

For the time being I can't think of any other details. Everything else will transpire in rehearsal.

One very important thing: try to interest a Berlin company. If for no other reason than that I can then take all rehearsals myself. [. . .]

* Editor's note: Alfred Roller (b. 1864 in Brno, d. 1938 in Vienna), painter, graphic artist and scenic designer. From 1899 on teacher at the School of Applied Arts in Vienna, from 1902 on scenic designer at the Court Opera and collaborator of Gustav Mahler, as when in 1903 he provided anti-naturalistic, stylized stage settings, suited to the nature of the work, for a production of Wagner's *Tristan und Isolde*. Schoenberg, who saw the production after his return from Berlin, and followed all of Roller's further creations, was particularly impressed by the novel and predominant lighting. Thus, Roller may have transmitted to him the newly conceived function of pure and colored light on the stage, which was then developing on all sides along with Expressionism. This was surely to have decisive importance for his *Die Glückliche Hand*. See Roller's article 'Bühnenreform?' ('Stage Reform?') in *Der Merker*, Vol. I, no. 5, 10 December 1909, p. 193.

BRESLAU LECTURE ON
DIE GLÜCKLICHE HAND

1928. Undated nine-page typescript with handwritten corrections (Schoenberg legacy, Los Angeles), written on the occasion of the Breslau production in 1928.

The German text was first published in Ivan Vojtěch (ed.), Arnold Schoenberg, Gesammelte Schriften, Vol. I, *pp. 235 ff; see also note on p. 495 of that work for further references.*

In as much as we do not possess extensive knowledge of astronomy, the sun generally rises for most of us more or less in the East, and the starry sky is a handsome carpet pattern, in which a few shapes are to some extent familiar to us, but which nevertheless does not change its form substantially. However, we know that the small changes, which anyone can perceive, represent huge movements, and, when we notice them, it is perhaps a couple of thousand years ago that they happened. Although worlds may have been destroyed in the process, we have in any case no need to get excited about it: the distance is fortunately so great. . . !

Let us look from a human, and thus much smaller distance, at an artistic fact:

Wagner tells us that Spontini called himself the inventor of the *suspension of the sixth,* and held this discovery to be so significant that he declared the further development of music beyond that point to be impossible. In his opinion, the musical universe should obviously have stood still after he had (as Wagner quotes him) 'made this great revolution. . . .'

Today we scarcely know Spontini, and in any case can no longer conceive the great revolution that was brought about through the introduction of this suspension. . . .

Now compare our equanimity in regard to a collision of two planets with the excitement of the opera audience at the premiere of Spontini's *La Vestale* in Paris, revolutionized by the suspension of the sixth. . . .

But: even if we had reasons to take a more hostile stand towards the menaces of the stars than towards changes in art, we cannot deny that the latter, as insignificant as they might be in themselves, concern us *more* than

DIE OPER

BLÄTTER DES
BRESLAUER STADTTHEATERS
(OPERNHAUS)

REDIGIERT VON
DR. HERBERT GRAF
DRAMATURG

Zu den Uraufführungen:

Schönberg „Die glückliche Hand"
Rameau „Das Fest des Königs"
Händel „Josua"

SONDERHEFT
HEFT 14 SPIELZEIT 1927 28

Special number of the Breslau Stadttheater's journal on the occasion of the
production there of *Die glückliche Hand* in 1928

the former, although the portent which they give us is misunderstood at first and only grasped decades later. But they give us information whose truth we can test within the span of a man's life.

Let us, however, hold to the position that these changes seem extraordinarily insignificant in themselves, so insignificant, that we can hardly imagine any more a music without the suspension of the sixth; that we perceive the difference between Haydn and Mozart only as a difference in personality; that, however, the difference between Bach's forerunners appears to us almost negligible, and only much vaster differences, as for instance between Wagner and Bach, are recognized absolutely and directly.

And we ask:

How is it that such changes are perceived as upheavals; that they are called revolutions; that people become so excited over them?

In reality, the obvious reason is this: that the effect of such changes within the work of art is equivalent to the change of course of a planet—at least as far as our perceptive faculties are concerned, which fear to find a new, unknown, and incomprehensible reality behind the new surface.

And rightly so: for this is actually the case.

As in chemistry, one atom of hydrogen more, one less of carbon, or a different stratification or pressure, changes an *un*interesting substance into a pigment or even an explosive—so is it also in music: a small change in the succession of tones, another way of combining them, and previously harmless tones radiate colored light, or threaten to burst a form that shortly before was rigid.

This is the case not only in music, but in all the arts. It is also the case in the art of music drama, which in many ways is more of a composite than any other art; in which, therefore, the smallest change in the position or the connection of the combined parts fundamentally changes the face of the whole, which is why it requires the most sensitive awareness on the part of all the performers to realize the will of an author.

Actually, all changes of style in the development of musical drama are based on such changes of *quantity* and *position*. If one period has emphasized the *drama* and *loosened* the form in its favor, perhaps the very next will again regard *singing* as the most important, dominating element, and will understand by this a *melodic* or *coloratura* style. If, however, for another epoch, the sovereignty of music consists in the symphonic treatment of the orchestra, a 'return to nature' will probably soon be considered the only means of salvation. This can lead *either* to a period of 'healthy realism' or to one of symbolistic treatment of subject-matter.

So much does the outward form change, and yet, after a hundred years, everything which at the outset was incompatible with accustomed

concepts, has faded so much that one sees more similarities than differences.

Now *Die glückliche Hand* came into being long before the war, at a time when Realism had already been superseded and Symbolism was also coming to an end. As always in such periods, one felt then that one could go no farther with the old means; that the expressive means had withered and representational possibilities were exhausted. One thirsted for new structures, new contents.

For a long time a form had been in my mind which I believed to be the only one in which a musician might express himself in the theater. I called it, in my own private language, *making music with the media of the stage.*

It is not easy to say what was meant by that; I will try to explain it.

In reality, tones, if viewed clearly and prosaically, are nothing but a particular kind of vibrations of the air. As such they indeed make some sort of impression on the affected sense organ, the ear. By being joined with each other in a special way, they bring about certain artistic and, if I may be permitted the expression, certain spiritual impressions. Now since this capability is certainly not present in tones alone, it should also be possible, under certain conditions, to bring about such effects with other media; that is to say, if they were treated like tones; if, without denying their material meaning, but *independently* of this meaning, one managed to combine them, like tones, by measuring them as to time, height, breadth, intensity and many other dimensions; if one knew how to bring them into relationship with each other according to deeper laws than the laws of the material—according to the laws of a world rationally constructed by its creator.

I cannot maintain that I considered it possible to carry out this intention in a 'dry' way, so to speak. Because in reality the media of the stage are indeed not tones, and it would be completely arbitrary if one were, for example, to construct a scale of mime, or a rhythm of light. Naturally, such an endeavor could only be risked by someone who could trust his feeling for form and could say to himself that however the thoughts to be represented might be constituted, he was sure of being able to think them; however the feelings to be expressed might revolt others, he was sure he could *order* them. If one had this self-confidence, however, one could serenely abandon oneself to one's imagination, without theories. This kind of art, I don't know why, has been called expressionist: it has never expressed more than was *in it!* I also gave it a name, which did not become popular, however, I said that it is the *art of the representation of inner processes.* But I must not say that loudly, for all that is despised today as romantic. While people can still not attempt to determine whether Brahms or Bruckner was the greater composer; while people can still not come to any agreement about the significance of Mahler; while people can still not even determine whether Schiller is really as great a poet as Goethe . . . people have already incontestably determined that the Age of

Romanticism lasted until November 1918, and that everything written up to that time has long since become obsolete.

Die glückliche Hand was written around 1912 and thus is already very out of date. Nevertheless, I will show you by means of some examples how I conceived this 'making music with the media of the stage.'

At the beginning, you see twelve light spots on a black background: the faces of the six women and six men. Or rather: *their gazes.* This is part of the mime performance, thus, of a medium of the stage. The impression under which this was written was approximately this: it was as if I perceived a chorus of stares, as one *perceives* stares, even without seeing them, as they say something to one. What these stares say here is also paraphrased in words, which are sung by the chorus, and by the colors which show on the faces. The musical way in which this idea is composed testifies to the unity of conception: in spite of the diverse shaping of some *Hauptstimmen* this whole introduction is, as it were, held fast in place by an *ostinato-like* chord. Just as the gazes are rigidly and unchangeably directed at the Man, so the musical ostinato makes clear that these gazes form an ostinato on their part.

Another example: *the crescendo of light, storm and the Man's acting:* certainly this whole incident could be interpreted realistically, as the expression of jealous feelings and premonitions. Nevertheless, the totality is much more than that, and I consider it important to explain that one gets a distorted picture from a simple symbolic interpretation of such details. To be sure, this crescendo is clothed externally in the form of an *increasing pain.* But this clothing is only an outer husk, only a line of demarcation. This can be discerned most clearly in the fact that the light and also the colors, and particularly the music, follow paths that by no means lead so directly upward as those of the wind-machine or other dynamic elements. These last are less suited to more complicated developments and therefore remain limited to a straight line, to a direct ascent. On the one hand they form the *backbone of the development* and on the other hand they serve to let the higher type of elements stand out better. The play of light and of colors, however, is not based *only* on intensities, but on values that can only be compared with pitches. Tones, also, can only be easily combined with each other when they have a basic relationship to each other. In the same way, different shades of color can only be combined by means of their basic relationship to each other.

But the most decisive thing is that an emotional incident, definitely originating in the plot, is expressed not only by *gestures, movement* and *music,* but also by *colors* and *light;* and it must be evident that *gestures, colors* and *light* are treated here similarly to the way tones are usually treated—that music is made with them; that figures and shapes, so to speak, are formed from

individual light values and shades of color, which resemble the forms, figures and motives of music.

Another example are the black veils which, according to the stage direction at the end of the first scene, sink down on the man. The basic idea behind it is roughly this: darkness in motion! like deep chords! The clouding of a darkness, like a change of color in a dark, dismal chord.

It would of course lead too far afield if I were to point out all the examples which give an idea of this 'making music with the media of the stage.' I think I can say, however, that this is done by each word, each gesture, each beam of light, each costume and each setting: none of these is meant to symbolize anything but that which is usually symbolized by tones. All of it is intended to mean no less than sounding tones mean.

Finally, I would like to explain to you something that I have often been asked about: the meaning of the *title of the piece*. This title, *Die glückliche Hand*, is connected to the text at the end of the second scene, where it says: 'The man does not realize that *she* is gone. To him, she is there at his hand, which he gazes at uninterruptedly.' Perhaps this is also a good opportunity to show what I mean by 'making music with the media of the stage.' Because here, *music is made with ideas*, so to speak. Our extremities, including our hands, serve to carry out our wishes, to express, to make manifest, that which does not have to remain inside. A fortunate [= *glückliche*: see footnote on p.91] hand operates externally, far outside our well-protected self—the farther it reaches, the farther it is from us. Further, a fortunate hand is only 'fortunate fingertips;' and further, a fortunate body is a fortunate hand, is: fortunate fingertips. A fortune at your fingertips: 'You, who have the other-worldly within you, long for that which is earthly. . . ?'

It is a certain pessimism which I was compelled to give form to at that time: 'Fateful [*glückliche*] Hand, which tries to grasp that which can only slip away from you, if you hold it.'

Fateful Hand, which does not hold what it promises!

Texts by
Wassily Kandinsky

ON STAGE COMPOSITION

Written 1911/12, published as introduction to the stage work Der gelbe Klang *in the* almanac Der blaue Reiter (Munich: Piper, 1912).

Every art has its own language, i.e., those means which it alone possesses.

Thus every art is something self-contained. Every art is an individual life. It is a realm of its own.

For this reason, the means belonging to the different arts are externally quite different. Sound, color, words! . . .

In the last essentials, these means are wholly alike: the final goal extinguishes the external dissimilarities and reveals the inner identity.

This *final* goal (knowledge) is attained by the human soul through finer vibrations of the same. These finer vibrations, however, which are identical in their final goal, have in themselves different inner motions and are thereby distinguished from one another.

This indefinable and yet definite activity of the soul (vibration) is the aim of the individual artistic means.

A certain complex of vibrations—the goal of a work of art.

The progressive refinement of the soul by means of the accumulation of different complexes—the aim of art.

Art is for this reason indispensable and *purposeful.*

The correct means that the artist discovers is a material form of that vibration of his soul to which he is forced to give expression.

If this means is correct, it causes a virtually identical vibration in the receiving soul.

This is inevitable. But this second vibration is complex. First, it can be powerful or weak, depending upon the degree of development of him who receives it, and also upon temporal influences (degree of absorption of the soul). Second, this vibration of the receiving soul will cause other strings within the soul to vibrate in sympathy. This is a way of exciting the 'fantasy' of the receiving subject, which 'continues to exert its creative activity' upon the work of art* *[am Werke 'weiter schafft'].* Strings of the soul that are made to

* Among others, theater designers in particular count today upon this 'collaboration,' which has of course always been employed by artists. Hence derived also the demand for a certain distance, which should separate the work of art from the ultimate degree of expressiveness. This not-saying-the-ultimate was called for by, e.g., Lessing and Delacroix, among others. This distance leaves space free for the operation of fantasy.

111

vibrate frequently will, on almost every occasion other strings are touched, also vibrate in sympathy. And sometimes so strongly that they drown the original sound: there are people who are made to cry when they hear 'cheerful' music, and vice versa. For this reason, the individual effects of a work of art become more or less strongly colored in the case of different receiving subjects.

Yet in this case the original sound is not destroyed, but continues to live and works, even if imperceptibly, upon the soul.*

Therefore, there is no man who cannot receive art. Every work of art and every one of the individual means belonging to that work produces in every man without exception a vibration that is at bottom identical to that of the artist.

The internal, ultimately discoverable identity of the individual means of different arts has been the basis upon which the attempt has been made to support and to strengthen a particular sound of one art by the identical sound belonging to another art, thereby attaining a particularly powerful effect. This is one means of producing [such] an effect.

Duplicating the resources of one art (e.g., music), however, by the identical resources of another art (e.g., painting) is only *one* instance, *one* possibility. If this possibility is used as an internal means also (e.g., in the case of Scriabin),[†] we find within the realm of contrast, of complex composition, first the antithesis of this duplication and later a series of possibilities that lie between collaboration and opposition. This material is inexhaustible.

The nineteenth century distinguished itself as a time far removed from inner creation. Concentration upon material phenomena and upon the material aspect of phenomena logically brought about the decline of creative power upon the internal plane, which apparently led to the ultimate degree of abasement.

Out of this one-sidedness other biases naturally had to develop.

Thus, too, on the stage:

1. There necessarily occurred here also (as in other spheres) the painstaking elaboration of individual, already existing (previously created) constituent parts, which had for the sake of convenience been firmly and definitively separated one from another. Here, one sees reflected the specialization that always comes about immediately when no new forms are being created.

* Thus, in time, every work is correctly 'understood.'

† See the article by L. Sabaneiev in this book [i.e. in the almanac *Der blaue Reiter*].

2. The positive character of the spirit of the times could only lead to a form of combination that was equally positive. Indeed, people thought: two is greater than one, and sought to strengthen every effect by means of repetition. As regards the inner effect, however, the reverse may be true, and often one is greater than two. Mathematically, $1+1 = 2$. Spiritually, $1-1$ can $= 2$.

Re (1). Through the *primary consequence of materialism,* i.e., through specialization, and bound up with it, the further external development of the individual [constituent] parts, there arose and became petrified three classes of stage works, which were separated from one another by high walls:

A) Drama
B) Opera
C) Ballet

(A) Nineteenth-century drama is in general the more or less refined and profound narration of happenings of a more or less personal character. It is usually the description of external life, where the spiritual life of man is involved only in so far as it has to do with his eternal life.* *The cosmic element is completely lacking.*

External hâppenings, and the external unity of the action comprise the form of drama today.

(B) Opera is drama to which music is added as a principal element, whereby the refinement and profundity of the dramatic aspect suffer greatly. The two constituent [elements] are bound up with one another in a completely external way. I.e., either the music illustrates (or strengthens) the dramatic action, or else the dramatic action is called upon to help explain the music.

Wagner noticed this weakness and sought to alleviate it by various means. His principal object was to join the individual parts with one another in an organic way, thereby creating a monumental work of art.[†]

Wagner sought to strengthen his resources by the repetition of one and the same external movement in two substantive forms, and to raise the effect produced to a monumental level. His mistake in this case was to think that he disposed of a means of universal application. This device is in reality only one

* We find few exceptions. And even these few (e.g., Maeterlinck, Ibsen's *Ghosts*, Andreev's *The Life of Man*, etc.) remain dominated by external action.

† This thought of Wagner's took over half a century to cross the Alps, on the other side of which it was expressed in the form of an official paragraph. The musical 'manifesto' of the Futurists reads: 'Proclamer comme une nécessité absolue que le musicien soit l'auteur du poème dramatique ou tragique qu'il doit mettre en musique' [To proclaim as an absolute necessity that the musician should be the author of the dramatic poem or tragedy that he would set to music] (May 1911, Milan).

113

of the series of often more powerful possibilities in [the realm of] monumental art.

Yet apart from the fact that a parallel repetition constitutes only *one* means, and that this repetition is only external, Wagner gave to it a new form that necessarily led to others. E.g., movement had before Wagner a purely external and superficial sense in opera (perhaps only debased). It was a naive appurtenance of opera: pressing one's hands to one's breast (love), lifting one's arms (prayer), stretching out one's arms (powerful emotion), etc. These childish forms (which even today one can still see every evening) were externally related to the text of the opera, which in turn was illustrated by the music. Wagner here created a direct (artistic) link between movement and the progress of the music: movement was subordinated to tempo.

The link is, however, only of an external nature. The inner sound of movement does not come into play.

In the same artistic, but likewise external way, Wagner on the other hand subordinated the music to the text, i.e., movement in a broad sense. The hissing of red-hot iron in water, the sound of the smith's hammer, etc., were represented musically.

This *changing* subordination has been, however, yet another enrichment of means, which of necessity led to further combinations.

Thus, Wagner on the one hand enriched with the effect of one means, and on the other hand diminished the inner sense—the purely artistic inner meaning of the auxiliary means.

These forms are merely the mechanical reproduction (not inner collaboration) of the purposive progress of the action. Also of a similar nature is the other kind of combination of music with movement (in the broad sense of the word), i.e., the musical 'characterization' of the individual roles. This obstinate recurrence of a [particular] musical phrase at the appearance of a hero finally loses its power and gives rise to an effect upon the ear like that which an old, well-known label on a bottle produces upon the eye. One's feelings finally revolt against this kind of consistent, programmatic use of one and the same form.*

Finally, Wagner uses words as a means of narration, of expressing his thoughts. He fails, however, to create an appropriate setting for such aims, since as a rule the words are drowned by the orchestra. It is not sufficient to allow the words to be heard in numerous recitatives. But the device of interrupting the continuous singing has already dealt a powerful blow

* This programmatic element runs right through Wagner's work, and is probably to be explained in terms not only of the character of the artist, but also of the search for a precise form for this new type of creation, upon which the spirit of the nineteenth century impressed its stamp of the 'positive.'

to the 'unity'. And yet the external action remains untouched even by this.

Apart from the fact that Wagner here remains entirely in the old traditions of the external, in spite of his efforts to create a text (movement), he still neglects the third element, which is used today in isolated cases in a still more primitive form*—color, and connected with it, pictorial form (decoration).

External action, the external connection between its individual parts and the two means employed (drama and music) is the form of opera today.

(C) Ballet is a form of drama with all the characteristics already described and also the same content. Only here, the seriousness of drama loses even more than in the case of opera. In opera, in addition to love, other themes occur: religious, political, and social conditions provide the ground upon which enthusiasm, despair, honor, hatred, and other similar feelings grow. Ballet contents itself with love in the form of a childish fairy-tale. Apart from music, individual and group movement both help to contribute. Everything remains in a naive form of external relationships. It even happens that individual dances are in practice included or left out at will. The 'whole' is so problematic that such goings-on go completely unnoticed.

External action, the external connection between its individual parts and the three means employed (drama, music and dance) is the form of ballet today.

Re (2). Through the *secondary consequence of materialism*, i.e., on account of positive addition (1+1=2, 2+1=3), the only form that was employed involved the use of combination (alternatively, reinforcement), which demanded a parallel progression of means. E.g., powerful emotions are at once emphasized by an *ff* in music. *This mathematical principle also constructs affective forms upon a purely external basis.*

All the above-mentioned *forms,* which I call substantive forms [*Substanzformen*] (drama—words; opera—sound; ballet—movement), and likewise the combinations of the individual means, which I call affective means [*Wirkungsmittel*], are composed into an *external unity. Because all these forms arose out of the principle of external necessity.*

Out of this springs as a logical result the limitation, the one-sidedness (= impoverishment) of forms and means. They gradually become orthodox, and every minute change appears revolutionary.

Viewing the question from the standpoint of the internal, the whole matter becomes fundamentally different.

1. Suddenly, the external appearance of each element vanishes. And its inner value takes on its full sound.
2. It becomes clear that , if one is using the inner sound, the external action

* See the article by Sabaneiev.

can be not only incidental, but also, because it obscures our view, dangerous.

3. The worth of the external unity appears in its correct light, i.e., as unnecessarily limiting, weakening the inner effect.
4. There arises of its own accord one's feeling for the necessity of the *inner unity*, which is supported and even constituted by the external lack of unity.
5. The possibility is revealed for each of the elements to retain its own external life, which externally contradicts the external life of another element.

Further, if we go beyond these abstract discoveries to practical creation, we see that it is possible

re (1) to take only the inner sound of an element as one's means;

re (2) to eliminate the external procedure (= the action);

re (3) by means of which the external connection between the parts collapses of its own accord;

likewise,

re (4) the external unity, and

re (5) the inner unity place in our hands an innumerable series of means, which could not previously have existed.

Here, the only source thus becomes that of internal necessity.

The following short stage composition is an attempt to draw upon this source.

There are here three elements that are used as external means, but for their *inner value*:

1. musical sound and its movement
2. bodily spiritual sound and its movement, expressed by people and objects
3. color-tones and their movement (a special resource of the stage).

Thus, ultimately, drama consists here of the complex of inner experiences (spiritual vibrations) of the spectator.

re 1. From opera has been taken the principle element—music—as the source of inner sounds, which need in no way be subordinated to the external progress of the action.

re 2. From ballet has been taken dance, which is used as movement that produces an abstract effect with an inner sound.

re 3. Color-tones take on an independent significance and are treated as a means of equal importance.

116

All three elements play an equally significant role, remain externally self-sufficient, and are treated in a similar way, i.e., subordinated to the inner purpose.

Thus, e.g., music can be completely suppressed, or pushed into the background, if the effect, e.g., of the movement is sufficiently expressive, and could be weakened by combination with the powerful effect of the music. The growth of musical movement can correspond to a decrease in the movement of the dance, whereby both movements (the positive and the negative) take on a greater inner value, etc., etc. A series of combinations, which lie between the two poles: collaboration and opposition. Conceived graphically, the three elements can take entirely individual, in external terms, completely independent paths.

Words as such, or linked together in sentences, have been used to create a particular 'mood,' which prepares the ground of the soul and makes it receptive. The sound of the human voice has also been used purely, i.e., without being obscured by words, by the sense of the words.

The reader is asked not to ascribe to the principle the weaknesses of the following short composition, *Yellow Sound*, but to attribute them to the author.

DER GELBE KLANG
('The Yellow Sound')
A Stage Composition

First rough draft, with the title Riesen *('Giants'), c. 1909, written in German in Thomas von Hartmann's handwriting—probably from Kandinsky's dictation (G. Münter Bequest, Municipal Gallery, Munich). Second, more detailed version, written in Russian in Kandinsky's handwriting, dated 'March 1909;' the title* Riesen *is changed to* Der gelbe Klang *(Nina Kandinsky Archive, Paris). First printed in the* almanac Der blaue Reiter, 1912.

PARTICIPANTS

FIVE GIANTS

INDISTINCT BEINGS

117

TENOR *(behind the stage)*
A CHILD
A MAN
PEOPLE IN FLOWING GARB
PEOPLE IN TIGHTS
CHORUS *(behind the stage)*
[Thomas von Hartmann was responsible for the music]

INTRODUCTION

Some indeterminate chords from the orchestra.
 Curtain.
Over the stage, dark-blue twilight, which at first has a pale tinge and later becomes a more intense dark blue. After a time, a small light becomes visible in the center, increasing in brightness as the color becomes deeper. After a time, music from the orchestra. Pause.
 Behind the stage, a CHORUS *is heard, which must be so arranged that the source of the singing is unrecognizable. The bass voices predominate. The singing is even, without expression, with pauses indicated by dots.*

 At first, DEEP VOICES.
 Stone-hard dreams. . . . And speaking rocks. . . .
 Clods of earth pregnant with puzzling questions. . . .
 The heaven turns. . . . The stones. . . . melt. . . .
 Growing up more invisible . . . rampart. . . .

 HIGH VOICES:
 Tears and laughter. . . . Praying and cursing. . . .
 Joy of reconciliation and blackest slaughter.

 ALL:
 Murky light on the . . . sunniest . . . day
 (Quickly and suddenly cut off).
 Brilliant shadows in darkest night!!

The light disappears. It grows suddenly dark. Long pause. Then orchestral introduction.

SCENE I

(Right and left as seen by the spectator.)
 The stage must be as deep as possible. A long way back, a broad green hill. Behind the hill a smooth, matt, blue, fairly dark-toned curtain.

118

The music begins straight away, at first in the higher registers, then descending immediately to the lower. At the same time, the background becomes dark blue (in time with the music) and assumes broad black edges (like a picture). Behind the stage can be heard a chorus, without words, which produces an entirely wooden and mechanical sound, without feeling. After the CHOIR *has finished singing, a general pause: no movement, no sound. Then darkness.*

Later, the same scene is illuminated. Five bright yellow GIANTS *(as big as possible) appear from right to left (as if hovering directly above the ground).*

They remain standing next to one another right at the back, some with raised, others with lowered shoulders, and with strange, yellow faces which are indistinct.

Very *slowly, they turn their heads toward one another and make simple arm movements.*

The music becomes more definite.

Immediately afterward, the GIANTS' *very low singing, without words, becomes audible (pp), and the* GIANTS *approach the ramp* very *slowly. Quickly, red, indistinct creatures,* somewhat *reminiscent of birds, fly from left to right, with big heads, bearing a distant resemblance to human ones. This flight is reflected in the music.*

The GIANTS *continue to sing more and more softly. As they do so, they become more indistinct. The hill behind grows slowly and becomes brighter and brighter, finally white. The sky becomes completely black.*

Behind the stage, the same wooden chorus becomes audible. The GIANTS *are no longer to be heard.*

The apron stage turns blue and becomes ever more opaque.

The orchestra competes with the chorus and drowns it.

A dense, blue mist makes the whole stage invisible.

SCENE 2

The blue mist recedes gradually before the light, which is a perfect, brilliant white. At the back of the stage, a bright green hill, completely round and as large as possible.

The background violet, fairly bright.

The music is shrill and tempestuous, with oft-repeated a and b and b and a-flat. These individual notes are finally swallowed up by the raging storm. Suddenly, there is complete stillness. A pause. Again is heard the plangent complaint, albeit precise and sharp, of a and b. This lasts for some time. Then, a further pause.

At this point the background suddenly turns a dirty brown. The hill becomes dirty green. And right in the middle of the hill forms an indefinite black patch, which appears now distinct, now blurred. At each change in definition, the brilliant white light becomes progressively grayer. On the left side of the hill a big yellow flower suddenly becomes visible. It bears a distant resemblance to a large, bent cucumber,

119

and its color becomes more and more intense. Its stem is long and thin. Only one narrow, prickly leaf grows sideways out of the middle of the stem. Long pause.

Later, in complete silence, the flower begins to sway very slowly from right to left; still later the leaf, but not together. Still later, both begin to sway in an uneven tempo. Then again separately, whereupon a very thin b accompanies the movement of the flower, a very deep a that of the leaf. Then both sway together again, and both notes sound together. The flower trembles violently and then remains motionless. In the music, the two notes continue to sound. At the same time, many PEOPLE come on from the left in long, garish, shapeless garments (one entirely blue, a second red, a third green, etc.; only yellow is missing). The PEOPLE hold in their hands very large white flowers that resemble the flower on the hill. The PEOPLE keep as close together as possible, pass directly in front of the hill and remain on the right-hand side of the stage, almost huddled together. They speak with various different voices and recite:

> The flowers cover all, cover all, cover all.
> Close your eyes! Close your eyes!
> We look. We look.
> Cover conception with innocence.
> Open your eyes! Open your eyes!
> Gone. Gone.*

At first, they all recite together, as if in ecstasy (very distinctly). Then, they repeat the same thing individually: one after the other—alto, bass and soprano voices. At 'We look, we look' b sounds; at 'Gone, gone' a. Occasional voices become hoarse. Some cry out as if possessed. Here and there a voice becomes nasal, sometimes slowly, sometimes with lightning rapidity. In the first instance, the stage is suddenly rendered indistinct by a dull red light. In the second, a lurid blue light alternates with total darkness. In the third, everything suddenly turns a sickly gray (all colors disappear!). Only the yellow flower continues to glow more strongly!

Gradually, the orchestra strikes up and drowns the voices. The music becomes restless, jumping from ff to pp. The light brightens somewhat, and one can recognize indistinctly the colors of the people. Very slowly, tiny figures cross the hill from right to left, indistinct and having a gray color of indeterminate value. They look before them. The moment the first figure appears, the yellow flower writhes as if in pain. Later it suddenly disappears. With equal suddenness, all the white flowers turn yellow.

The PEOPLE walk slowly, as if in a dream, toward the apron stage, and separate more and more from one another.

The music dies down, and again one hears the same recitative.† Suddenly, the

* 'Vorbei' in the German; in the earlier Russian version 'mimo', which means 'passed' only in the spatial sense, hence 'passed by' or 'missed.'

† Half the sentence spoken in unison; the end of the sentence very indistinctly by *one* voice. Alternating frequently.

120

PEOPLE *stop dead as if spellbound and turn around. All at once they notice the little figures, which are still crossing the hill in an endless line. The* PEOPLE *turn away and take several swift paces toward the apron stage, stop once more, turn around again, and remain motionless, as if rooted to the spot.* At last they throw away the flowers as if they were filled with blood, and wrenching themselves free from their rigidity, run together toward the front of the stage. They look around frequently.† It turns suddenly dark.*

SCENE 3

At the back of the stage: two large rust-brown rocks, one sharp, the other rounded and larger than the first. Backdrop: black. Between the rocks stand the GIANTS *(as in Scene 1) and whisper noiselessly to one another. Sometimes they whisper in pairs; sometimes all their heads come together. Their bodies remain motionless. In quick succession, brightly colored rays fall from all sides (blue, red, violet and green alternate several times). Then all these rays meet in the center, becoming intermingled. Everything remains motionless. The* GIANTS *are almost invisible. Suddenly, all colors vanish. For a moment, there is blackness. Then a dull yellow light floods the stage, which gradually becomes more intense, until the whole stage is bright lemon yellow. As the light is intensified, the music grows deeper and darker (this motion reminds one of a snail retreating into its shell). During these two movements, nothing but light is to be seen on the stage: no objects. The brightest level of light is reached, the music entirely dissolved. The* GIANTS *become distinguishable again, are immovable, and look before them. The rocks appear no more. Only the* GIANTS *are on the stage: they now stand further apart and have grown bigger. Backdrop and background remain black. Long pause. Suddenly, one hears from behind the stage a shrill tenor voice, filled with fear, shouting entirely indistinguishable words very quickly (one hears frequently [the letter]* a: *e.g., 'Kalasimunafakola!'). Pause. For a moment it becomes dark.*

SCENE 4

To the left of the stage a small crooked building (like a very simple chapel), with neither door nor window. On one side of the building (springing from the roof) a narrow, crooked turret with a small, cracked bell. Hanging from the bell a rope. A SMALL CHILD *is pulling slowly and rhythmically at the lower end of the rope, wearing a white blouse and sitting on the ground (turned toward the spectator). To the right, on the same level, stands a very fat* MAN, *dressed entirely in black. His face completely white, very indistinct. The chapel is a dirty red. The tower bright blue. The bell made of brass.*

* This movement must be executed as if at drill.
† These movements should not be in time to the music.

121

Background gray, even, smooth. The black MAN *stands with legs apart, his hands on his hips.*

The MAN *(very loud, imperiously; with a beautiful voice):*

Silence!!

The CHILD *drops the rope. It becomes dark.*

SCENE 5

The stage is gradually saturated with a cold, red light, which slowly grows stronger and equally slowly turns yellow. At this point, the GIANTS *behind become visible (as in Scene 3). The same rocks are also there.*

The GIANTS *are whispering again (as in Scene 3). At the moment their heads come together again, one hears from behind the stage the same cry, only very quick and short. It becomes dark for a moment; then the same action is repeated again.* As it grows light (white light, without shadows) the* GIANTS *are still whispering, but are also making feeble gestures with their hands (these gestures must be different, but feeble). Occasionally, one of them stretches out his arms (this gesture must, likewise, be the merest suggestion), and puts his head a little to one side, looking at the spectator. Twice, all the* GIANTS *let their arms drop suddenly, grow somewhat taller, and stand motionless, looking at the spectator. Then their bodies are racked by a kind of spasm (as in the case of the yellow flower), and they start whispering again, occasionally stretching out an arm as if in feeble protest. The music gradually becomes shriller. The* GIANTS *remain motionless. From the left appear many* PEOPLE, *clad in tights of different colors. Their hair is covered with the corresponding color. Likewise their faces. (The* PEOPLE *resemble marionettes.) First there appear gray, then black, then white, and finally different-colored* PEOPLE. *The movements of each group are different; one proceeds quickly forward, another slowly, as if with difficulty; a third makes occasional merry leaps; a fourth keeps turning around; a fifth comes on with solemn, theatrical steps, arms crossed; a sixth walks on tiptoe, palm upraised, etc.*

All take up different positions on the stage; some sit in small, close-knit groups, others by themselves. The whole arrangement should be neither 'beautiful' nor particularly definite. It should not, *however, represent* complete *confusion. The* PEOPLE *look in different directions, some with heads raised, others with lowered heads, some with heads sunk on their chests. As if overcome by exhaustion, they rarely shift their position. The light remains white. The music undergoes frequent changes of tempo; occasionally, it too subsides in exhaustion. At precisely these moments, one of the white figures on the left (fairly far back) makes indefinite, but very much quicker movements sometimes with his arms, sometimes with his legs. From time to time he*

* Naturally, the music must also be repeated each time.

122

continues one movement for a longer space of time, and remains for several moments in the corresponding position. It is like a kind of dance, only with frequent changes of tempo, sometimes corresponding with the music, sometimes not. (This simple action must be rehearsed with extreme care, so that what follows produces an expressive and startling effect.) The other PEOPLE *gradually start to stare at the white figure. Many crane their necks. In the end, they are all looking at him. This dance ends, however, quite suddenly; the white figure sits down, stretches out one arm as if in ceremonious preparation and, slowly bending this arm at the elbow, brings it toward his head. The general tension is especially expressive. The white figure, however, rests his elbow on his knee and puts his head in his hand. For a moment, it becomes dark. Then one perceives again the same groupings and attitudes. Many of the groups are illuminated from above with stronger or weaker lights of different colors: one seated group is illuminated with a powerful red, a large seated group with pale blue, etc. The bright yellow light is (apart from the* GIANTS, *who now become particularly distinct) concentrated exclusively upon the seated white figure. Suddenly, all the colors disappear (the* GIANTS *remain yellow), and white twilight floods the stage. In the orchestra, individual colors begin to stand out. Correspondingly, individual figures stand up in different places: quickly, in haste, solemnly, slowly; and as they do so, they look up. Some remain standing. Some sit down again. Then all are once more overcome by exhaustion, and everything remains motionless.*

The GIANTS *whisper. But they, too, remain now motionless and erect as from behind the stage the wooden chorus, which lasts only for a short time, becomes audible.*

Then one hears again in the orchestra individual colors. Red light travels across the rocks, and they begin to tremble. The GIANTS *tremble in alternation with the passage of light.*

At different ends of the stage, movement is noticeable.

The orchestra repeats several times b and a: on their own, together, sometimes very shrill, sometimes scarcely audible.

Various PEOPLE *leave their places and go, some quickly, some slowly, over to other groups. The ones who stood by themselves form smaller groups of two or three people, or spread themselves among the larger groups. The big groups split up. Many* PEOPLE *run in haste from the stage, looking behind them. In the process, all the* BLACK. GRAY, AND WHITE PEOPLE *disappear; in the end, there remain only the* DIFFERENTLY COLORED PEOPLE *on stage.*

Gradually, everything takes on an arhythmical movement. In the orchestra— confusion. The same shrill cry as in Scene 3 is heard. The GIANTS *tremble. Various lights cross the stage and overlap.*

Whole groups run from the stage. A general dance strikes up, starting at various points and gradually subsiding, carrying ALL THE PEOPLE *with it. Running, jumping, running to and fro, falling down. Some, standing still, make rapid movements with their arms alone, others only with their legs, heads, or behinds. Some*

123

combine all these movements. Sometimes, there are group movements. Sometimes, whole groups make one and the same movement.

At that movement, at which the greatest confusion in the orchestra, in the movement and in the lighting occurs, it suddenly becomes dark and silent. Only the yellow GIANTS remain visible at the back of the stage, being only slowly swallowed up by the darkness. The GIANTS seem to go out like a lamp, i.e. the light glimmers several times before total darkness ensues.

DER BLAUE REITER

HERAUSGEBER: KANDINSKY
FRANZ MARC

MÜNCHEN, R. PIPER & CO. VERLAG, 1912

SCENE 6

(This scene must follow as quickly as possible.)
 Dull blue background, as Scene 1 (without black edges).
 In the middle of the stage, a bright yellow GIANT, *with an indistinct, white face and large, round, black eyes. Backdrop and background black.*
 He slowly lifts both arms parallel with his body (palms downward), and, in doing so, grows upward.
 At the moment he reaches the full height of the stage, and his figure resembles a cross, it becomes suddenly *dark. The music is expressive, resembling the action on stage.*

THE PICTURES
(originally titled 'Schoenberg's Painting')

This was first printed in Arnold Schönberg *(ed. Alban Berg et al.), a kind of Festschrift for the master, which was to be presented to him on the occasion of a concert in Prague on 29 February 1912. Kandinsky changed the original title, 'Schoenberg's Painting,' on Berg's suggestion, since Paris von Gütersloh (see note 20) had already chosen the more general title for his essay on Schoenberg's painting. On 4 January 1912, Kandinsky assured Berg: 'I have no objection to changing my title to "Schoenberg's Pictures"' (Berg Legacy, Music Collection of the National Library, Vienna). In the second galley proof of 3 February 1912, the title was changed to 'The Pictures.' Kandinsky also provided two plates of Schoenberg's pictures from the* Blaue Reiter *almanac, for which Berg expressed his thanks in a letter of 7 February 1912 (letter in the G. Münter and J. Eichner Bequest, Munich).*

Schoenberg's pictures fall into two groups: those painted directly from nature (people, landscapes); and those intuitively felt heads that he calls 'visions.'
 Schoenberg himself describes the former as five-finger exercises, which he finds necessary, but to which he attaches no special importance, exhibiting them only unwillingly.
 The latter he paints (just as rarely as the former) in order to give expression to those motions of his spirit that are not couched in musical form.
 These two groups are outwardly different. Inwardly, they have their origin in one and the same soul, which is made to vibrate sometimes by external nature, sometimes—by internal.

125

This dichotomy is, of course, only of very general significance, having a pronouncedly schematic character.

But in reality, internal and external experiences cannot be so brusquely separated. Both kinds of experience have, so to speak, many long roots, fibers, branches that permeate one another, become intertwined, and as a final result, constitute a complex of enduring significance for the soul of the artist.

This complex is, as it were, the soul's digestive system, its transforming, creative power. This complex is the prime mover in that inner process of transformation which expresses itself outwardly in altered form. It is due to the characteristics of this same complex, unique every time, that the creative system of the individual artist produces works that, as one says, bear his 'stamp,' enable one to recognize the artist's 'handwriting.' Of course, these popular descriptions are entirely superficial, because they emphasize only the external, formal aspect and leave the internal almost completely out of the picture. That is, in this case—as so often—too much reverence is accorded to the external in general.

For the artist, the external is not merely determined, but indeed created by the internal, as is the case in every form of creation, including the cosmic.

Regarded from this point of view, Schoenberg's pictorial works enable us to recognize, beneath the stamp of his own form, his spiritual complex.

For one thing, we see *at once* that Schoenberg paints, not in order to produce 'beautiful,' 'nice,' etc., pictures; rather, while painting he does not even think about the picture itself. Ignoring the objective result, he seeks only to pin down his subjective 'sensation,' and in doing so, employs only those resources that appear to him at that moment indispensable. Not even all professional painters can boast of this manner of painting! Or, in other words, there are very few professional painters who possess this fortunate ability, at times heroism, this capacity for rejection, which enables them to ignore (or even reject) all kinds of pictorial pearls and diamonds thrust upon them. Schoenberg proceeds in a straight line, directly toward his goal or, guided by his goal, directly toward the result that is here necessary.

The purpose of a picture is to give in pictorial form outward expression to an inner impression. This may sound like a well-known definition! But if we draw from this the logical conclusion, namely, that a picture has no other purpose, then I would like to ask: How many pictures can be described as lucid, unclouded by anything superfluous? Or: How many pictures are entitled to the name after being subjected to this strict, undeviating test? And not *'objets d'art,'* which willfully deceive us as to the necessity of their existence.

126

A picture is the external expression of an internal impression in pictorial form.

He who, after carefully examining this definition of a picture, accepts it, has accepted therein a correct and, it should be emphasized, unalterable criterion that may be applied to every picture, regardless of whether it was painted today, stands still wet upon the easel, or has come to light as a fresco in the course of excavating a city long buried in the earth.

Accepting this definition involves altering many 'opinions' regarding questions of art. In passing, I would like to rescue one such opinion from the darkness of accepted prejudice, in the light of the above definition. Not only art critics and public, but also as a rule artists themselves perceive in an artist's 'development' the search for that artist's own corresponding form.

From this opinion often derive quite different, fatal consequences.

The artist himself maintains that, having 'at last found his own form,' he can now continue *calmly* to create further works of art. Unfortunately, he himself usually fails to notice that from this very moment (from the 'calmly') on, he rapidly begins to lose this form he has at last discovered.

The public (in part led by the critics) is not so quick to observe this lapse, and feeds on these products of a dying form. On the other hand, convinced of the possibility of an artist's 'finally attaining the appropriate form,' it sternly condemns those artists who have remained without such a form, who reject one form after another in their search for the 'right' one. The works of such artists are deprived of the respect they deserve, nor does the public attempt to draw from these works their necessary content.

Thus, there arises an entirely wrong attitude to art, whereby the dead passes for the living, and vice versa.

In reality, the artist's progress consists not of *external* development (the search for a form that corresponds to the unchanging condition of the soul), but of *internal* development (reflection of spiritual desires attained in pictorial form).

It is the content of the artist's soul that develops, becomes more precise, assuming ever greater internal dimensions: upward, downward, in all directions. In that moment at which a certain *inner level* is attained, one will find at one's disposal an outward form corresponding to this inner value.

Moreover, in the movement at which this inner development is halted and falls victim to the decrease of this inner dimension, then too that form which the artist has 'already attained' escapes from his grasp. Thus, we see often this etiolation of form that corresponds to the etiolation of inner desire. Thus, the artist frequently loses control over his own form, which becomes dull, weak, bad. Thus is to be explained the phenomenon of the artist suddenly, e.g., no longer able to draw, or whose color, previously alive, now lies upon the canvas as a mere lifeless semblance, like a pictorial carcass.

The decline of form is the decline of the soul, i.e., of content. And the growth of form is the growth of content, i.e., of the soul.

If we apply the criterion I have described to Schoenberg's pictorial works, we see at once that we are here confronted with *painting*, whether this painting stands 'outside' the mainstream 'present-day movement' or not.

We observe that in every one of Schoenberg's pictures, the inner desire of the artist speaks forth in a form appropriate to it. Just as in his music (insofar as I, being a layman, may venture an opinion), in his paintings Schoenberg renounces the superfluous (i.e., the harmful) and pursues a direct path toward the essential (i.e. the necessary). All prettification, all refinements of *peinture* are ignored.

His *Self Portrait* is painted with the so-called 'scrapings of the palette.' And yet, what other colors could he choose to achieve this powerful, sober, precise, concise effect?

A portrait of a lady reveals, more or less pronouncedly, *only* the sickly pink color of the dress—no other 'colors.'

One landscape is gray-green—*only* gray-green. The drawing is simple and quite 'unskilled.'

One of the *Visions,* painted on a tiny canvas (or else on a piece of cardboard) consists *only* of a head. Highly expressive are *only* the eyes ringed with red.

I would prefer to describe Schoenberg's painting as *Nurmalerei* [only painting].

Schoenberg personally reproaches himself for his 'deficient technique.'

I would like to amend this reproach in accordance with the above-defined criterion: Schoenberg is mistaken—it is not his technique that fails to satisfy him, but his inner desires, his soul, of which he demands more than it is today able to give.

I would wish that all painters should suffer the same dissatisfaction—for all time.

It is not difficult to make outward progress. It is not easy to progress inwardly.

May 'fate' grant that we should not avert our inner ear from the voice of the soul.

COMMENTARIES ON SCHOENBERG'S *THEORY OF HARMONY*

Schoenberg had published a part of the chapter 'On Parallel Octaves and Fifths' from his Theory of Harmony *as an advance excerpt in the periodical* Die Musik *(vol. X, no. 2, October 1910, pp. 96–105). He mentioned this in his first letter to Kandinsky (24 January 1911). Kandinsky immediately ordered the issue (see his letter of 26 January 1911), was enthusiastic about the text (6 February 1911) and found it suitable for the catalog of the large exhibition 'Salon 2, International Art Exhibition, Odessa 1910/11' organized by his friend Vladimir Izdebskii (see note 2). This first introduction of Schoenberg to Russia has been unknown to scholars up to the present.*

Kandinsky chose carefully and omitted passages from Schoenberg's advance excerpt which were overly specialized musically, or digressive. Everything of importance, and of interest also to non-musicians, he translated accurately and sympathetically into Russian, dóing the work personally in spite of lack of time, in order to enter properly into the spirit of the text (see letter of 9 April 1911). These excerpts appeared under Schoenberg's name as 'Paralleli v oktavach i kvintach' with Kandinsky's commentaries in the Odessa catalog before the Theory of Harmony *was published (1911).*

The chapter is found in the Theory of Harmony *(English edn, pp. 52 ff) in the larger context of 'The Inversions of Triads,' which, in its turn, is part of 'The Major Mode and the Diatonic Chords.' Kandinsky's first comment refers to the article as a whole:*

This translation I have made is part of an article published in *Die Musik* (X,2). The article is an excerpt from the author's *Theory of Harmony*, shortly to be brought out by the publisher Universal Edition. Schoenberg is one of the most radical, consistent, gifted, and sincere creators of the 'new' music. I venture to recommend to all those interested in art not to be put off by the specialized title, and to read this brief extract. And to notice in particular how keenly this revolutionary composer feels the inviolable, *organic* link, the inevitable natural development of the new music out of the old, indeed from the depths of its most remote sources. 'Art travels . . . along the path of human nature.' With the development of the human spirit, art too is eternally enriched, and enriches in its turn with new means of expression the human spirit. There is a limit, however, to the attainments of every age, just as there

is a limit to the inner knowledge attainable by each era of human development. Schoenberg, too, is of this opinion: every chord, every progression is permissible, 'but I feel even today that there are certain limits which determine my use of this or that dissonance.'

Schoenberg combines in his thinking the greatest freedom with the greatest belief in the ordered development of the spirit!

Kandinsky's second comment refers to the following problem: momentary innovations are often too highly thought of, and, after their defence is no longer necessary, the attempt is made to consolidate them by means of exaggerations. But exaggerations are harmful and, most of all, they inhibit further innovations.

These few brief lines convey clearly the reality that lies behind all human progress (in the spiritual realm; in the material realm, on the other hand, people are inclined to grasp eagerly at every 'novelty.' Hence, for example, the present craze for aeronautics, especially in Western Europe). People, filled with panic, hide their heads in the sand or arm themselves by legitimate or illicit means against every new achievement, which they must, however, ultimately acknowledge as their salvation. Only then will the new credo *immediately* come about. What yesterday was rejected with derision today is deified. Any 'breach' of law is regarded as an affront before the Almighty. And woe to him who comes bringing with him new progress, a new law. And the same old story repeats itself over again. This human tendency, to reject the 'new,' and then to cast it into an iron form—in other words, an immeasurable spiritual fatalism—is perhaps the worst, most tragic aspect of the human condition.

Kandinsky appends his third and last comment to a passage on pedagogical questions: after the long prohibition of parallel fifths they were forgotten, and sounded offensive, like everything unfamiliar. In spite of the textbooks' prohibition, they were made use of in practice from time to time, and are no more bad and ugly than octaves.

Why should the student then not be permitted to write them? Schoenberg goes on to say that the student should use them only at a later stage, since instruction should lead through the development, but not furnish end results and thereby prepare the ground for possible errors.

Here the author touches upon one of the most vexed questions, giving rise to doubts even in the mind of the most 'radical' artist-teacher. The problem is exactly the same in painting: once painting no longer recognizes organic-anatomical construction, i.e., consistently rejects it in favor of linear-painterly construction, does it not follow that one should exclude from one's

130

instruction all the preliminary exercises practiced by earlier schools, in particular the mastery of organic-anatomical construction? Here one must remember earlier epochs and the outstanding works produced by the great early masters, who from lack of knowledge made what appear to our eyes unpardonable and often amusing mistakes of anatomy (Persians, Japanese, early Italians, early Germans—among them the great artist, draftsman and painter Albrecht Dürer). In the works of these masters, their mistakes served, as if involuntarily, creative purposes. And who would dare raise his hand to correct Dürer for drawing a *fibula* in one of his engravings, instead of the *crista fibulae*, or the *tibia* instead of the *malleolus externus?* Then again, should—or could—the contemporary artist, like the musician who rules out parallel octaves, tell us, his pupil: You absolutely *must* know that the *malleolus externus* is the lower, external appendage of the *fibula?* Above all, it seems to me wrong for the teacher to instruct the pupil in art in the same way a sergeant-major instructs a soldier in the use of firearms. Moreover, I do not believe that the teacher is obliged to burden (and, as often happens, to fetter) his student with 'immutable' laws. Rather, his task is to open before his students' eyes the doors of the great arsenal of resources, i.e., means of expression in art, and to say: Look! Over there, in that dusty corner, you'll find a heap of expressive weapons no longer in use *today*. Among them you'll find organic-anatomical construction; if you need it, you know where to look for it. . . . The time has come to open these great doors.

Kandinsky and Schoenberg

JELENA HAHL-KOCH

STAGES OF THE FRIENDSHIP

On 1 January 1911 Kandinsky, together with Franz Marc, Alexei Jawlensky, Marianne Werefkin,[59] Gabriele Münter and other colleagues from the Neue Künstlervereinigung (New Artists' Association), attended a concert in which Schoenberg's Second String Quartet, Op. 10 (1907–8) and the Three Piano Pieces, Op. 11 (1909), were played. It was thus not even Schoenberg's latest compositions that—as so often—provoked the majority of the listeners to demonstrations of displeasure, but filled Kandinsky with enthusiasm.

Without doubt, Kandinsky was musically gifted. He played the cello from childhood on and we know from his years in Munich that he devoted himself to playing the piano intensively enough to play before a circle of friends, but not so well as to have come up to professional standards.[60] A single sheet of music written by him is preserved in the legacy: for his stage piece *Violetter Vorhang* ('Violet Curtain,' 1914) he had composed a couple of simple melodies;[61] he also advised his partner Gabriele Münter on her song compositions. Nevertheless, his theoretical knowledge seems to have been little greater than was common with educated laymen (see his admission of this in the letters of 9 April and 22 August 1912, and his repeated request to Schoenberg to revise a Russian musicological article in his letters of 16 January and 6 February 1912). But his fine musical sensitivity, in particular his ability to discriminate between the timbres of various instruments and their differing effects on the hearing and the emotions, manifests itself in all his theater pieces, just as it does in the theoretical comparisons between the effects of color and sound which occupied him for many years and which are worked out in his book *On the Spiritual in Art*. His interest in music, particularly in the period between 1909 and 1912, is documented in the notes taken by his friend Thomas von Hartmann (see note 24), which will be discussed in detail below, as also by the considerable number of music books in his library, whose contents until 1914 are preserved in Gabriele Münter's legacy (G. Münter and J. Eichner Bequest, Munich). In any case, Kandinsky was among the first non-musicians to recognize Schoenberg's significance.

When Kandinsky heard Schoenberg's music for the first time—in the

above-mentioned January 1911 concert—he may have been struck by the strangely dissociative tonal language and the clearly increasing atonality from movement to movement in the String Quartet, Op. 10, which showed itself more decidedly in the Piano Pieces, Op. 11 written two years later. The Second String Quartet introduces that compositional period which 'renounces a tonal center,' as Schoenberg himself explains. Particularly in the fourth movement 'the overwhelming abundance of dissonant sounds could no longer be counterbalanced by the occasional use of tonal chords.'[62] The view of the composer Hans Pfitzner—well-known as a conservative—may be quoted here as representative of the opponents of Schoenbergian atonality (a word, moreover, which originated not as a technical term, but as a term of abuse): 'The international-atonal movement[. . .] the atonal chaos[. . .] is the artistic parallel of the Bolshevism which is menacing political Europe. Fundamentally, no one wants anything to do with this group; it is being violently forced on the world by a minority.'[63] Kandinsky may have been fully aware of the significance of Schoenberg's musical innovations, but perhaps he felt more through intuition an intrinsic relationship to this music that, like his painting of those years, oversteps the limits of the traditional rules.

In any case, Kandinsky was so impressed by this music that, although otherwise rather reserved, he immediately wrote a letter to a composer he did not know and thereby initiated the lively correspondence of the ensuing years.

Kandinsky's friend Franz Marc also reacted to the concert in a letter to August Macke dated 14 January 1911:

Can you imagine a music in which tonality (that is, the adherence to any key) is completely suspended? I was constantly reminded of Kandinsky's large *Composition,* which also permits no trace of tonality [. . .] and also of Kandinsky's 'jumping spots' in hearing this music, which allows each tone sounded to stand on its own (a kind of *white canvas* between the spots of color!). Schoenberg proceeds from the principle that the concepts of consonance and dissonance do not exist at all. A so-called dissonance is only a more remote consonance—an idea which now occupies me constantly while painting.[. . .]

The aim 'most earnestly to be desired' is now naturally to produce something of the sort without theoretical deliberations, purely from a healthy instinct for color, such as the primitive peoples all possessed. That we wish to make pictures out of it, and not only colorful columns and capitals and straw hats and earthen vessels—is our advantage, our 'Europeanness.'

Schoenberg seems, like the Association [Neue Künstlervereinigung], to

be convinced of the irresistible dissolution of the European laws of art and harmony and seizes upon the musical art-means of the Orient, which have remained primitive (until today).

And on 14 February 1911 he adds:

I recently had a long conversation with Kandinsky about Schoenberg, and laid before him the conclusion (somewhat surprising to me) that Maria has drawn from this music (she maintains that he works with completely unresolvable sound-mixtures, without any tonal color, *only expression*, gesture). Kandinsky was very inspired by it: that is his aim. His 'beautiful coloring,' the dissolving of his colors into a *grand* harmony, is a *faute de mieux* in his creation which he has still to get over; the young Frenchmen (Rouault, Braque, Fauconnier, Picasso, etc.) have already grasped this Schoenbergian principle, etc. I also saw Kandinsky's latest things in his studio, and I confess I have scarcely ever received such a deep and awesome impression from pictures as here; Kandinsky pierces the deepest of all. I am happy that I will be on rather neighborly terms with him and Fräulein Münter this summer (Murnau-Sindelsdorf).[64]

Thus in 1911 Marc had already acutely perceived what music historians were to discuss only later on.

Kandinsky and Schoenberg met for the first time in the middle of September 1911, when Schoenberg was spending the late summer in Berg on the Starnberger See, not far distant from Munich and also not far from Murnau, in the foothills of the Alps, where Kandinsky had a house. The letters correct many false conjectures about the beginning of the relationship and the first meeting: that, for example, it was supposed to have taken place 'in 1906 in Egern-Rottach on the Starnberger See' or in 1909 at the Tegernsee.[65] Such unproved assertions permeated the entire Schoenberg literature until recent years, and unfortunately led other scholars, who relied upon them, to false conclusions. The dating of their first meeting between 1906 and 1909, which was regarded as certain, led to the assumption that Kandinsky exercised an influence on Schoenberg's painting, his stage works and many theories discussed in the *Theory of Harmony*. As will be seen in what follows, none of this is in accordance with the facts.

Kandinsky and Schoenberg recognized each other as partners of the same intellectual and creative rank; their relations quickly developed into friendship, in which their families and associates were also included. That they always kept the formal address 'Sie' should not astonish us today. For one thing, the intimate 'Du' was then much less common, and for another, it is known of Kandinsky that in his whole life he only had one 'Duzfreund', the

137

composer Thomas von Hartmann, with whom he had been friends since 1909. Even in his relations with his closest painter friend, Paul Klee, Kandinsky still retained the 'Sie' after decades of friendship.[66]

Kandinsky was the more active partner. No sooner had he read an advance excerpt from Schoenberg's *Theory of Harmony* in 1911, than he translated and annotated it for the catalog of a Russian exhibition, for which he then also wished to procure Schoenberg's pictures (see p.129 and note 2). At the same time, he took pains to establish contact between Schoenberg and his Petersburg acquaintance, Nikolai Kul'bin. Kandinsky and Schoenberg were also invited to become members of the 'ARS' alliance, founded by Kul'bin, in which painters, musicians, theater people and other artists were to work together. Schoenberg's trip to St Petersburg at the end of 1911 took place through these initiatives (see note 47). For the *Blaue Reiter* almanac, Kandinsky pressed Schoenberg for a contribution until the composer finally wrote 'The Relationship to the Text.' In the almanac, Kandinsky reproduced the Schoenberg pictures which he had shown in the Blaue Reiter group exhibition. In addition, he printed the score of the song 'Herzgewächse,' Op. 20, a revealing example of free atonality with a text by Maurice Maeterlinck. Kandinsky also esteemed the Belgian Symbolist: the first edition of the Russian translation of Maeterlinck's short dramas is to be found in his library (St Petersburg, 1896; in the G. Münter and J. Eichner Bequest, Munich) and in *On the Spiritual in Art* he names Maeterlinck several times as a forerunner of the New Theater.

After the years of most active correspondence, Schoenberg, with his family, spent the summer of 1914 near Kandinsky in the country, so that their exchange of thoughts, to the regret of future generations, was now carried on without letters. Their meetings were ended by the news of the outbreak of war. Kandinsky returned to his homeland, and contact with Schoenberg was interrupted for a long time. Indeed, as Kandinsky laments in the first 1922 letter after his renewed emigration to Germany, Russia had been isolated from the West for seven years. After a short transition period in Berlin, Kandinsky was called to Weimar as teacher of painting at the Bauhaus. In many respects, work at this artistic and intellectual center meant for him a continuation of his activity in Moscow (see note 54); however, because of greater freedom than he had ultimately had in Russia, it was much more satisfactory. Particularly in collaborative work in which the different arts overlapped, Kandinsky was once more in his element, and his declared wish was to have Schoenberg also participate in this. He was just searching for possibilities for getting him to the Weimar Musikhochschule when an ugly misunderstanding arose about what Schoenberg had construed as Kandinsky's anti-Semitic attitude. As a convinced cosmopolitan Kandinsky

was all his life far removed from any discriminatory turn of mind. Though it is not possible to reconstruct Kandinsky's remark, one may well see the objective cause of the conflict in the different backgrounds of Schoenberg and Kandinsky. In the generalized derogatory expressions, already familiar to him from Odessa, about the 'Jewish problem' (he himself put the words in quotation marks, signaling his reservations), Kandinsky did not yet recognize the fatal consequences that Schoenberg, who clearsightedly recognized the tendency toward genocide indicated by Hitler, was already experiencing personally. Understandably agitated, Schoenberg—in this case ahead of his friend in historical foresight—judged him incapable of catching up in this learning process, and broke off the correspondence. What Alma Mahler-Werfel writes in her memoirs about the anti-Semitism of Wassily and Nina Kandinsky is absurd; she herself caused the dissension. When Kandinsky received Schoenberg's deeply moving reply (see p.76), he showed it in his perplexity to Walter Gropius, founder of the Bauhaus and at that time Alma Mahler's husband. Kandinsky's widow Nina remembers:

'Gropius turned pale and said spontaneously: 'That is Alma's doing.' And he was right in his assumption, because Schoenberg wrote in May 1923 to his informant Alma: 'Add to this, that even without you I could perhaps have learned what was being thought at Weimar.'[67]

Alma Mahler alienated the friends for many years—until the summer of 1927 when Kandinsky was on holiday with his wife Nina at Pörtschach on the Wörthersee:

One afternoon we were taking a walk on the lakeshore and suddenly heard a voice: 'Kandinsky! Kandinsky!' It was Schoenberg. He was staying there with his young wife Gertrud during the summer months.[. . .] Two friends, who had become acquainted in Munich, saw each other once more. No word was spoken about the painful intrigue which had been brought into the world by Alma Mahler-Werfel. In the meantime, Schoenberg must certainly also have heard that Alma enjoyed a somewhat questionable reputation as a rumor-monger.[68]

They did not, however, resume a regular correspondence.

In the later years information about the Schoenberg–Kandinsky relationship becomes increasingly scarce; apart from Kandinsky's last known letter of 1936, there is only the unpublished correspondence between him and Galka Scheyer, the German-Jewish friend and agent of the 'Blue Four' (Kandinsky, Jawlensky, Klee and Feininger) in the United States (see note 58). On 10 February 1935, she notified Kandinsky that she had contacted Schoenberg (who after all had been living in Los Angeles since 1934) by

phone, and given him his regards; he wanted to come with his wife to her house in the Hollywood hills, in order to see her Kandinsky exhibition. On 5 March 1935 Kandinsky answered: 'Is Schoenberg much played in America? [. . .]Please give Schoenberg my regards once again.'[69]

PARALLELS IN THEIR ARTISTIC DEVELOPMENT

Kandinsky was eight years older than Schoenberg, but since he had only begun to paint when he was thirty, they were both at about the same stage of their development. They actually always reached their most important breakthroughs at almost the same time and their paths ran parallel. This is so striking to observe that one would at first suspect reciprocal influence. That certainly does not prove to be the case, however, since—as their letters show—they knew nothing of one another during the decisive period before 1911, and before 1921, the second important point of demarcation, they had had no contact for seven years.

Soon after the turn of the century one can already find the first instances of parallel development in their more conventional early works. Kandinsky's woodcuts from 1903 on (up to the large tempera picture 'Das bunte Leben' ('Motley Life') [1907]), which still contain naturalistic, but fairy-tale-like or mythical representations of knights, lovers and folk motifs, correspond to Schoenberg's *Pelleas und Melisande* (1903) and *Gurre-Lieder* (begun in 1900, instrumentation finished 1911), which are thematically similar and also indebted to the Jugendstil period. Then around 1906/7, in the search for new means of expression which seemed necessary to him, Schoenberg began to curtail the temporal dimensions of his compositions and to concentrate their expression, to change the harmony from a structure of thirds to fourths and, above all, to extend the limits of tonality step by step from functional harmony, by way of extended tonality, to 'atonality'. The tonal center, a tonic as point of reference for consonances, is now absent; dissonances no longer need consonances in order to resolve; tones, melodic progressions and sound combinations are freely at Schoenberg's disposal. He did not take this step lightly or with irresponsible haste, as he and also Kandinsky were accused of by contemporary critics, but strictly according to his artistic conscience and on the basis of profound study of both old and new music.[70]

On the subject of Kandinsky's comparably protracted analysis of traditional materials and his conscientious search for the right path for himself, we have authentic information from his friend and collaborator in stage compositions, the young Russian composer Thomas von Hartmann (see note 24). In 1913 he wrote an article 'The Indecipherable Kandinsky', of which only Kandinsky's translation from the Russian is preserved, along with his accompanying letter to Herwarth Walden of 1 August 1913 (G. Münter and J. Eichner Bequest, Munich). Kandinsky evidently did not send the article and letter; perhaps it was too late for the 'Album,' the volume *Kandinsky 1901–13* published by Walden. Nevertheless, the essay is to a certain extent authorized by Kandinsky in that he translated it. Hartmann reports that as early as 1908–9 he had noticed a gradual moving away from the usual pictorial representation:

> The next logical step in this direction is to remove the core of the work still further from the representational, to leave only unassertive, hint-like reminiscences of the representational in the picture, whose only function is to serve as the ingredients of pure graphic and coloristic combinations. Painting is put on the same level as music, which seeks only the purity and appropriateness of sound combinations.
>
> I can confidently assert that Kandinsky is the founder and chief representative of this direction in painting. With regard to the *object*, which the opponents of the new art clasp to themselves so desperately, Kandinsky treats it with great care and uses it much more profoundly than is imagined by those who do not know his manner of creation. And those who know it are aware that in many works, particularly in the first sketches, he remains very *close to the object*, and only in the course of time, by means of long and often agonizing struggles and experiments, almost unconsciously pushes the object into the background, so that usually only a faint indication of its essence remains, which consists of the graphic or pictorial worth of the object.

In consistent pursuit of his chosen path, Kandinsky abandoned perspective along with every other illusionistic method, and reduced the objects in his pictures even further, 'abridged' them, until they only reveal themselves to the most attentive observer as abbreviation or hieroglyphs.

When, at the climax of his 'anarchistic' period, he painted the first abstract watercolors and Schoenberg completely dissolved tonality, many contemporaries like Marc and Hartmann—but, most of all, later scholars— saw music and painting coming even closer together in their development, a tendency which had been noticeable ever since the Romantic period.

An important article on this topic by Werner Hofmann appeared in 1969,[71]

and it was followed in 1974, the 'Schoenberg Year,' by many other publications: in addition to Stuckenschmidt's Schoenberg monograph, works by Josef Rufer, Werner Haftmann, K. Kropfinger and R. Waissenberger were particularly relevant.[72] Two years later, on the occasion of the twenty-fifth anniversary of the composer's death, a Schoenberg exhibition in East Germany (for the first time after a long period of being outlawed on the grounds of 'formalism') was accompanied by a valuable collection of essays.[73] From very different points of view, the above publications throw light on the following questions: does not the dissolution of the portrayed object correspond to the dissolution of traditional tonality in music? Does not the emancipation of colors and forms (their collisions and disproportions) correspond to the emancipation of dissonance? And do not both correspond to the dissolution of grammar and syntax which began about the same time, as for example with the German Expressionists, with the Russian Velemir Khlebnikov and his younger friends, the Futurists, on up to Dadaism and concrete poetry?

The common basis for these phenomena seems to me to have been the will to express the primordial, to get past the impediments of artistic tradition in order to discover once more the elemental origin of art. This explains why so many artists were interested in the reduction of artistic means to their smallest components, and the return to primary forms, with a predilection for the archaic, primitive and anarchic. Even for Schoenberg, who resisted the primitive, this was true to the extent that he, just like Kandinsky, was a radical theorist and creator who questioned everything and thought it through to its logical conclusion. Otherwise he would not have been able to open up tonal spheres which had hitherto been taboo, as for example that of dissonance, which after all—according to Adorno—sounds more primitive and archaic than consonance and seems not yet (rather than 'no longer') smoothed out by the principle of orderly classification. Franz Marc also had this impression (see p. 136). Thus this relativistic observation seems to have been typical at that time, even if we perhaps see it in the opposite way today. In accord with the Expressionism which was just manifesting itself in literature, painting and music, Kandinsky and Schoenberg radicalized art in order to lay open deep strata of the human consciousness, in order to shape their powerful visions from within the inner world (understood as clearly distinct from the outer).

Both Kandinsky and Schoenberg persisted for a long time in their revolt against tradition, hence in negation; they did not set up any immediately recognizable system in place of the old values which had been destroyed. The works created were of the greatest interest, of unquestionable rank, but irritatingly subjective and anarchical; contemporaries were much more

clearly aware of this than we can understand today. Moreover, the previous order was not completely eliminated: again and again there are deliberate 'relapses,' the old and the new placed in confrontation.

Schoenberg's 'method of composing with twelve tones related only to one another' is the first that may be considered as structural, as a new constraint and order, and also as a conscious reduction of means. In this method, a row made up of the twelve notes of the octave is the organizational principle of the composition. He used the twelve-tone technique for the first time in the Suite for Piano, Op. 25, in the year 1921. This second phase of objectification also begins for Kandinsky in the same year (in Russia), as he gradually changes his pictorial language to stricter geometric forms. From 1922 on, his new style consolidates itself: there is a reduction to primary forms, and often also to primary colors—entirely so during his Bauhaus period. Perhaps it would even be worth seeing if one could compare Schoenberg's principle of the non-repetition of tones with the almost serial use of colors in Kandinsky's pictures of the Bauhaus period.

Neither Schoenberg nor Kandinsky went beyond a certain, likewise comparable point in their artistic revolution, one that was to be overtaken only later on. Both retained the traditional forms and concept of a work, to the extent that Schoenberg still wrote operas, chamber music and oratorios, and orchestrated in a manner that remained related to post Romanticism and Impressionism, and that Kandinsky still produced easel pictures in oil, watercolors, drawings and woodcuts. Only tentatively did they try to make their works more dynamic in a way which points toward the modern concept of an art which is realized in the process of reception. With Schoenberg and Kandinsky, the work is no longer a representation of beauty, which in its turn might be a vision of truth or an interpretation of objective reality. It is for this reason that rounding-out, symmetry and harmony are lacking. The work is intended rather to function as a medium of spiritual communication, to express and stimulate spiritual forces directly. Behind this operational purpose stands a monistic world-view, which admits spirit and matter only as different stages of one and the same essence: a monism which was of course born of a rejection of the prevailing materialism, which stresses the overcoming of positivism and rationalism and is thus definitely on the side of the irrational-spiritual. The objective element in the work of art is consequently reduced by Kandinsky, and as it were dematerialized, to the point where it becomes something spiritual and transparent. The same mystical negativity characterizes Schoenberg's thinking in regard to the dissolution of harmonies consolidated by tradition.

Equally characteristic of Kandinsky and Schoenberg is their pronounced analytical understanding, so that creative vision and intellectual, critical

143

work were active in close proximity without getting in each other's way. Since it is rare to possess this double gift to such an extent, many historians of art and music doubted the authenticity of the creative process and, imputing 'brain-work' to Kandinsky and Schoenberg in this sphere as well, saw in their works primarily demonstrations of theories, sometimes even accusing them of conscious mystification. The only true part of this is the great zeal with which both artists dedicated themselves to intellectual work. Their first major theoretical works at this time, Schoenberg's *Theory of Harmony* and Kandinsky's *On the Spiritual in Art,* appeared shortly after one another in 1911. They were completed before the exchange of ideas between the authors began. The strong intellectual relationship is not surprising, since both artists were in the tradition of Romanticism and Richard Wagner. This, however, does not mean that they remained committed to Wagner throughout their lives. Kandinsky, in particular, showed that his enthusiasm for Wagner was only relative by calling it youthful fanaticism and, in his article 'On Stage Composition,' attacked Wagner's concept of the *Gesamtkunstwerk* (total work of art) on individual points (see p. 111). His accusation that Wagner had piled up effects all aimed in the same direction implies a weightier criticism of the superficiality of Wagner's artistic method, which still belongs to the 'materialistic' era. Moreover, in his more experimental procedures, his unconstrained and extremely tolerant relationship to his disciples and artist-colleagues, and in his deliberate internationalism, Kandinsky takes a position clearly contrary to Wagner.

Schoenberg and Kandinsky, who attributed such a high value to the irrational, the unconscious and intuition, naturally looked upon theosophy, which was flourishing just at that time, with curiosity and goodwill, without, however, allowing themselves to get entangled in its sectarianism. Moreover, theosophy was still in an experimental stage: many qualified natural scientists and artists in all fields felt drawn to it and discussed it seriously. For that reason, and because the circumstances of the time favored its spread, it played a bigger role at the beginning of the twentieth century and enjoyed more respect than it does today. Schoenberg's preoccupation with Swedenborg and Strindberg in 1912 is documented,[74] and from the letters we know of his enthusiasm for Balzac's *Seraphita*, which led to his oratorio *Die Jakobsleiter*. In his confessional letter to Kandinsky of 19 August 1912 he demands that 'our creation of such puzzles mirror the puzzles with which we are surrounded' and agrees in this with Kandinsky's statement about the content of art as 'Speaking of the hidden by means of the hidden.'[75] A fundamental investigation of Kandinsky's relationship to theosophy, spiritualism and occultism is to be found in the excellent book by Sixten Ringbom, *The Sounding Cosmos*. The irrationalism of Kandinsky's and

Schoenberg's world-view, their cultural pessimism accompanied by eschatological optimism, are problematical characteristics of their thought, which nevertheless, as Ringbom demonstrates, corresponded with the above-named intellectual trends and belonged to the widespread signs of crisis at the turn of the century.

Even if the success of spiritualism and theosophy can be retrospectively explained as a result of ideological flight from the social problems of the age, the subjective honesty of the parties concerned need not be called into question. The persuasive power of speculative monism was increased by the new discoveries in the natural sciences concerning radiation, the splitting of the atom and the convertibility of mass and energy phenomena which people euphorically took for empirical confirmation of the conversion of matter into spirit. Schoenberg refers to Einstein as a kindred spirit; Kandinsky speaks of spiritual 'vibrations' (waves, rays) which emanate from the work of art and interests himself in thought-photography.

Schoenberg's and Kandinsky's basic attitude is religious, though not in the narrow ecclesiastical or dogmatic sense. Both believe firmly in another, ungraspable world, which must be made visible in art. Their further priorities also derive from this fundamental metaphysical stance: they place content above form, the inner nature of things above the form of their outward appearance, truthfulness above beauty, and therefore emancipate the dissonance of tones as well as colors from traditional harmony. Both polemicize sharply against materialism in all its manifestations and are fundamentally mistaken in their optimistic prediction that in the twentieth century the age of great spirituality would finally begin. The wholesale condemnation of the 'materialistic' epoch, as expressed by many artists at that time, seems too facile today, and certainly went too far; nevertheless, it was based on their actual experience of life in society.

In particular, Kandinsky's homeland, Russia, was pervaded by an insipid positivism which was severely detrimental to the freedom of art. In Germany, the crisis of materialistic mass culture was reflected in the success of aesthetic and ideological reform movements, which extended from the illustrious Bayreuth or George circles down to the *Kunstwart* ('Art Curator'), the taste-forming periodical for elementary school teachers and their like. That the socialistic idea behind Kandinsky's remarks is laid to the account of the unacceptable materialist signs of the times and that Schoenberg, in his letter of 4 May 1923 to Kandinsky breaking off the friendship, had nothing but rejection for the Russian Revolution, may be regretted for non-partisan reasons as well. Here it should also be pointed out, however, that the conflict between the 'free-floating' intelligentsia and the workers' movement had more serious causes than just the lack of good will. Alfred Döblin, a professed

145

socialist during the Weimar period, still warned in his 1931 work *Wissen und Verändern* ('Knowledge and Change') of party Marxism's hostility to intellectuals, and argued for the maintenance of an independent point of view by the intelligentsia. The rapid purge of German communist intellectuals who had hoped for refuge from Nazi persecution by means of exile in Moscow cruelly justified this warning.

Finally, in assessing the role of ideology in twentieth-century art, the degree to which the idea of their being an 'intellectual élite' actually influenced the social conduct and the work of the artists must be taken into, account. Many spoke of the artist's role as leader and prophet, but not everyone transformed this idea into social reality, as did Wagner and George. Thus the *Blaue Reiter* almanac by no means served an exclusive circle, formed by strict personal selection and avoiding any publicity—like George's *Blätter für die Kunst*—but, on the contrary, sought to establish understanding among the artistic avant-garde in an open way. Kandinsky invited the collaboration of artists whose point of view was far removed from his own, for example. It can be said of the personal circle around Kandinsky, and also of that around Schoenberg, that it lacked a definite master-disciple relationship with the homoerotic component and personal ruptures characteristic of Wagner and George. In Kandinsky's case, in spite of his artistic doctrine, a willingness to experiment is evident, in that he really tries to put to the test the conversion of the intellectual and spiritual in the sense of the monism mentioned above. The dogmatic art-symbolism that may be seen in *Der gelbe Klang*—for instance the cross, signifying salvation through art—is (like all neo-mystical symbolism in Kandinsky) certainly strongly dematerialized, in contrast to Wagner, who establishes it firmly in a mythic plot.

Kandinsky also advanced a messianic claim *for art*. The image of the steadily ascending triangle, whose upper part is a spiritual élite, and whose summit is an artist-prophet, corresponds to the belief expressed by Schoenberg in the *Theory of Harmony*, that the laws of the man of genius are the laws of the humanity of the future. Kandinsky's central concept of 'inner necessity,' understood as the objective truth anchored in our inner being which demands expression, we find in the first sentence of Schoenberg's essay 'Probleme des Kunstunterrichts' ('Problems in Teaching Art') (1911): 'I believe art is born of "I must," not of "I can."'[76] Also: 'that I follow an inner compulsion that is stronger than education, that I obey a law which is natural to me, and therefore stronger than my artistic training,'[77] which is certainly to be understood more broadly than just as applying to his composition. They not only promoted this uncompromising attitude and intellectual honesty, they lived it as well. Out of responsibility to their art, both unashamedly spoke up for their convictions passionately, at times

pugnaciously and with messianic commitment (and for this reason they also had many enemies in common). That this attitude was conditioned in Schoenberg's case by 'the social sensitivity of the déclassé petit bourgeois, the human being genuinely fighting for his existence, struggling for advancement and prestige,' as Frank Schneider assumes, sounds plausible, but does not suffice as an explanation.[78] In the case of the upper-middle-class Kandinsky we can ascertain the same ethic and rebellion, and can cite as a biographical reason for it at most his status as a foreigner in Germany. It seems to me that these characteristics, in the case of both men, were still more fundamentally impressed on their artistic personalities, and more deeply anchored there, so that they could be no more than reinforced by their actual experience of the society around them. I see the proof of this in the fact that, along with all the community of artistic aims and attitude toward life, human closeness and friendship were also possible between two men who by their origins, surrounding and culture could scarcely have been more opposite: Schoenberg, who had grown up in a poor, lower-middle-class Jewish family in Imperial Vienna; Kandinsky, who had grown up in an upper-middle-class, liberal family of Russian Orthodox faith in Moscow and Odessa, with coachman, cook and private tutors, accustomed from earliest childhood to cultural journeys to Italy, Paris and elsewhere.

One can therefore speak without exaggeration, in the case of Kandinsky and Schoenberg, of a very close community of spirit and of a similar personality structure. These were decisive factors which led, along with an immediate and general-historical necessity, to their revolutions in painting and music.

In addition to the parallelism of their artistic development, their theories and their attitude of mind, further important common traits are their pedagogical talent and involvement (Schoenberg, in particular, became a great teacher), and their dual artistic gifts. They belonged to the doubly- and multi-talented who, research suggests, have increasingly proliferated since the Romantic period. This phenomenon reached its climax during the period of Symbolism and the first decade of the twentieth century. Among the Russian Futurists, for example, Nikolai Kul'bin, the brothers David and Vladimir Burlyuk, Vladimir Mayakovsky and others, there was literally no one who was not active in at least two branches of the arts. The most frequent combination, since the Romantic era, has tended to be painting and writing; composers who paint and write are, on the other hand, more rarely found.

KANDINSKY'S THEORIES ON
SYNTHESIS OF THE ARTS

Even to the casual observer, Kandinsky's picture titles from the field of music are striking, such as 'Impression,' 'Improvization,' and 'Composition,' the prose poems called *Klänge* ('Sounds'), and the theater pieces *Der gelbe Klang* and *Der grüne Klang* ('The Green Sound'), as also Schoenberg's piece entitled 'Farben' ('Colors') from his Five Orchestral Pieces, Op. 16 (1909), the forerunner of the *Klangfarben* (sound-color) compositions common today in post-serial music. Students of Schoenberg's music also know of his efforts to include in it the spatial element inherent in painting. This conforms to Kandinsky's wish to allow the temporal element to operate in his pictures, in that, even in his early pictures, he purposely makes the 'content,' the vestiges of a still objective 'story,' unclear, and thereby forces the onlooker to deduce it bit by bit in a temporal succession, beginning with the clearer portions. Later, in the abstract pictures, he achieves the same result through definite ordering of color forms: the eye is perhaps first guided to the warm, 'welcoming' colors and then travels further to those that are cold and less conspicuous.[79]

It is not necessary to repeat here what Kandinsky himself, from 1912 on, and many later art historians, have made categorical: Kandinsky never wished to 'paint music.' Rather, he attributed to music, as the only truly 'abstract' art (since only program music is imitative), a special, exemplary significance in his search for the common denominator of all the arts. Just as tones are the sole material of music, in painting colors and forms could be used for their own sake, independent of any imitation of nature, and could speak for themselves. This endeavor, whose beginning is already to be found in German Romanticism, experienced further logical development during the course of Symbolism, and virtually found its definitive realization in Kandinsky. The historical connections between painting and music have been investigated in more detail in the writings of the art historians Werner Hofmann, Klaus Lankheit and Werner Haftmann; here we must limit ourselves to Kandinsky and Schoenberg.

Kandinsky's interest in the correlations between the arts and their peripheral phenomena may be traced from his Moscow period in the 1890s on. In his 'Reminiscences' he recalls two events of that time, which—as he

says—left their stamp on his whole life, and moved him deeply. These were the exhibition of French Impressionists and a performance of *Lohengrin*. Previously Kandinsky had described the symphony of colors into which Moscow was transformed at sunset, and in the face of which he felt so powerless as a painter. Typically, he uses ideas from music in the rendering of his color impressions; he speaks of a wild tuba, of the

> final chord of the symphony, which brings every color vividly to life, which allows and forces the whole of Moscow to resound like the *forte fortissimo* of a giant orchestra. Pink, lilac, yellow, white, blue, pistachio-green, flame-red houses, churches, each an independent song [. . .], the singing snow with its thousand voices, or the Allegretto of the bare branches [. . .] to paint this hour, I thought, must be for an artist the most impossible, the greatest joy.

Here Kandinsky's synesthetic gift is documented for the first time, and it seems to be active in both directions: color impressions arouse sound sensations and, conversely, he associates purely pictorial memories when hearing music, for he continues:

> *Lohengrin*, on the other hand, seemed to me the complete realization of that Moscow. The violins, the deep tones of the basses, and especially the wind instruments at that time embodied for me all the power of that pre-nocturnal hour. I saw all my colors in my mind; they stood before my eyes. Wild, almost crazy lines were sketched in front of me. I did not dare use the expression that Wagner had painted 'my hour' musically.[80]

Again and again Kandinsky occupied himself with this question, devoting considerable space to it in his book *On the Spiritual in Art*, where he mentions the experiments in 'color-hearing' by the psychologist Freudenberg, and the successes of the Russian music teacher Zachar'ina-Unkovskaja in teaching unmusical children melodies with the aid of a system of correspondence between color, sound and number. The presence of a brochure, a drawing and music by this musician in Kandinsky's legacy supports the assumption that he analyzed her system in greater detail. When he was creating a forum for all types of art in his *Blaue Reiter* almanac (1912), he sought contact with other artists who experimented by extending into other artistic disciplines. He took a lively interest in Alexander Scriabin's experiments with music and the color keyboard and his plan for a *Gesamtkunstwerk* (see note 41), and he cultivated a lively exchange of ideas with Kul'bin, the painter, music theorist, doctor and psychologist (see note 47). Kandinsky's experiments with music and drama, which he pursued with Thomas von Hartmann (see note 24) and the young dancer Alexander Sakharoff[81] occurred at this same time. In an

149

article which is unknown in the West and 'forgotten' in Russia, Kandinsky recalls:

> I myself experimented while abroad together with a young musician and a dancer. The musician picked out from a series of my watercolors the one that seemed the clearest to him with regard to music. In the absence of the dancer, he played this watercolor. Then the dancer joined us, the musical work was played for him, he set it as a dance and then guessed the watercolor that he had danced.[82]

What Kandinsky sought to investigate here was nothing less than the common denominator of all the arts, their correlations and—in spite of their specific means—the 'translatability' of one kind of art into another. Kandinsky believed firmly in this overreaching law of all the arts, he pursued it all his life, and always hoped for the scientific evidence that would definitively confirm his surmises. He considered that exact measurability had already been attained in the experiments of the composer Alexander Shenshin (see note 55): the latter allegedly demonstrated mathematically determined correlations between Michelangelo's tomb and Franz Liszt's musical composition on the same subject.[83]

Not by chance, Kandinsky's first and most intensive involvement with these questions falls in the critical transitional phase between painting which is still representational and that which is abstract. From his autobiographical writings we see that these were anarchical, agonizing years of searching, doubting and sometimes of despair which he felt to be all too long; in the opinion of most art historians this was the most interesting period of his development. And just at this time his wish 'to change instruments,' as he called it, is expressed with particular frequency. Between 1909 and 1914 all his stage texts, and the greater number of his poems, including the prose-poems entitled *Klänge*, were produced. Schoenberg as well wrote his two first stage works and his 'Aphorisms' between 1908 and 1913, and painted more than two thirds of his pictures during the same period. A general reason for this turning to another art, which moreover also proves true for Oskar Kokoschka, Alfred Kubin, Ernst Barlach, Kazimir Malevich and many others, is the following: the pent-up tension during an arduous period of radical artistic change needs an outlet and, when its own medium becomes too difficult, often seeks its goals in a neighboring sphere. Particularly for such self-critical and strictly ethical artists as Schoenberg and Kandinsky, the 'change of instruments' must have had a liberating effect. In an unaccustomed art they felt less responsibility, were not weighed down by acquired knowledge, did not drag centuries-old tradition around with them, and could therefore experiment in a more unconstrained and playful way.

In addition, the strengthened confidence as a composer or painter which had been built up by that time, the certainty of having accomplished something, and of continuing along the same path, may have served them as a secure basis for somewhat more daring side experiments, which did not even necessarily have to be successful. Without a specific intention, the wish to allow the illuminations and perceptions from the sphere of a neighboring art to react upon their own may have played a part.

Besides his activity in another medium, the *Gesamtkunstwerk*, the *'monumentale Kunst,'* was on Kandinsky's mind. Supplementing his essay 'On Stage Composition' (see p. 111), an additional passage from his earlier book, *On the Spiritual in Art*, may be cited:

> In the impossibility of replacing the essential element of color by words or other means lies the possibility of a monumental art. Here, amidst extremely rich and different combinations, there remains to be discovered one that is based upon the principle just established. I.e. the same inner sound can be rendered at the same moment by different arts. But apart from this general sound, each art will display that extra element which is essential and peculiar to itself, thereby adding to that inner sound which they have in common a richness and power that cannot be attained by one art alone.[84]

That Kandinsky, in particular, dedicated himself enthusiastically to practical as well as theoretical work on the *Gesamtkunstwerk*—even after the October Revolution in Russia, and later at the Bauhaus by his stage-setting of Mussorgsky's *Pictures at an Exhibition* with the play of abstract-geometrical color-forms and lights (performed in 1928 at the Dessau Theater), and up until the last years of his life, when he planned a bacchante ballet together with Hartmann—is also to be understood from the special direction of his gifts. He seems, as far as one can judge from his statements, to have been a true eidetic, who not only could 'copy' a list from memory after he had seen it only once, but obviously came very close to 'color-hearing' as well. Whether G. Wohlgemuth is right that Kandinsky was a genuine synesthetic,[85] or whether, in such a highly sensitive painter, it was simply a matter of emotional synesthesia, in which sense impressions from adjoining spheres merely vibrate sympathetically—like the fine violin which Kandinsky cites as an example, whose other strings vibrate when one of them is touched—cannot be decided with certainty. In any event, this gift was much more strongly developed in him than in Schoenberg, whose paintings are scarcely based on synesthetic effects, and among whose stage works only *Die glückliche Hand* is built on such effects. To be sure, his *Theory of Harmony* and the article 'The Relationship to the Text,' printed in the *Blaue Reiter*, show that

he had also concerned himself theoretically with the differences and interactions of the arts, and in this as well, not too surprisingly, came very close to Kandinsky's ideas. However, such theories never occupied such a central position for him as for Kandinsky.

THE STAGE WORKS

The most important artistic manifestations of the synesthetic interests of Kandinsky and Schoenberg were certainly their stage works, in particular Schoenberg's *Die glückliche Hand* and Kandinsky's *Der gelbe Klang*, which they discussed in several letters. Both began from 1908/9 on (precisely in the great period of awakening to new musical and artistic goals) to concern themselves with the stage. And they did this independently of one another: their two first letters show that before the beginning of 1911 neither one knew anything of the other. The widespread assumption that Schoenberg and Kandinsky had met between 1906 and 1909 has led to the false conclusion that Kandinsky influenced Schoenberg's stage works.[86]

In Schoenberg's case, the beginning of his opera work coincided not only with an artistic, but also with a severe personal crisis, which nevertheless turned out to be creatively fruitful. Not only the String Quartet, Op. 10 (expressly dedicated to his wife Mathilde), but also his first two operas, are partially to be interpreted as the working out and mastering of the following problem: an intimate relationship had developed between Mathilde Schoenberg and the young painter Richard Gerstl;[87] in the summer of 1908 she ran away with him. Schoenberg brooded over thoughts of suicide. Eventually, Mathilde came back. In November 1908 Gerstl took his own life. In the following summer Schoenberg commissioned an opera text and very quickly (from 27 August to 12 September 1909) composed the music to the monodrama *Erwartung*, Op. 17, a representation of the exclusively mental experiences of a woman in love, written in a highly expressive style. In June 1910 he himself wrote the text of the 'drama with music' *Die glückliche Hand* (see p. 91). But, as he complains to Kandinsky on 11 August 1912, he could not make progress with the music. He did not finish the composition until November 1913.[88]

Much has already been written concerning *Die glückliche Hand*, most fully by John Crawford, Jan Maegaard and Karl Wörner.[89] For that reason, a few

152

brief words of explanation, and perhaps of rectification, will suffice here. The first performances, as they are reflected in contemporary criticism, will be treated more extensively, since this interesting data has never been dealt with. Nevertheless, these attempts at interpretation, or capitulations to the unintelligibility of the work, both illuminate it and clarify for us its effect on the stage.

Schoenberg's text consists for the most part of directorial and lighting directions; in the midst of these, a meagerly plotted, heavily symbolic action develops. Framed by a chorus which seems almost antique, it shows first of all the painful encounter of the Man (as the embodiment of the intellectual, creative being) with the other, everyday sphere of life, which is represented by the Woman, the Gentleman and the Workers. Only secondarily and to a much lesser degree is it the image of Schoenberg's personal conflict, the drama of jealousy of a woman between two men.[90] Closely connected to *Erwartung, Die glückliche Hand* is still almost a monodrama, since here as well there is only a single sung role, that of the Man. The other—mute—characters are parts of the outer world, which is reflected through the Man's perceptions and actually remains a backdrop. The title comes from the 'glückliche' (or 'lucky') hand of the Man, with which he spiritually possesses the Woman after a single fleeting touch. 'The Man does not realize that she is gone. To him she is there at his hand, which he gazes at uninterruptedly [. . .] "Now I possess you forever!"' With the same hand he then demonstrates to the Workers with what ease Genius creates a diadem. This interpretation seems to me to be more probable in the light of Schoenberg's frequent comparison of the true artist to the skilled craftsman than Wörner's opinion that Schoenberg's Man had carried out a share of the 'solution of the social question of the abolition of all human toil,' by having freed the Workers from their hard labor.[91]

In addition to the influence of Strindberg on Schoenberg's subsidiary motif of the battle of the sexes, the dependence on Wagner has also been pointed out; the goblet scene from *Tristan*, the anvil scene from *Siegfried*, as well as the use of musical leitmotifs generally.[92] However, it seems to me that the core of the work has not been touched by this.

Schoenberg did not win many friends with the text for *Die glückliche Hand*. Adorno appraises the music as 'perhaps the most significant which he accomplished,' but the text as an 'inadequate makeshift.' All music historians more or less agree with this; I consider it too negative, but will nevertheless quote Adorno's further explanation as correct and fundamental: the text 'cannot be separated from the music. It is precisely the coarse compactness of this text which gives the music its compressed form, and, therewith, its depth and effectiveness. Consequently, the criticism of just this coarseness of the text leads to the very core of Expressionistic music.'[93]

This relationship to Expressionism has also been correctly perceived by later scholars; I will go into it more closely when comparing *Die glückliche Hand* with Kandinsky's *Der gelbe Klang* at the end of the chapter. Regarding the judgement of the text, we must always evaluate it—just as in the case of many Wagner libretti, which seem even more wretched and banal without the music which belongs to them—together with the music and, if possible, on the basis of performances; see also, in this connection, Schoenberg's 'Foreword' (p. 89).

The planned premiere in Dresden was prevented by the First World War. That Schoenberg then had to wait until 1924 for a performance may have resulted from the great difficulties of obtaining a gigantic orchestra for a work lasting scarcely half an hour. From the middle of September to the middle of October 1924, a festival of music and theater was put on in Vienna. The organizer, David Joseph Bach, a friend of Schoenberg for many years, used all his influence to bring about the premiere of *Die glückliche Hand*. In the Volksoper, where there had already been interest in the work in 1910,[94] the orchestra pit had to be especially rebuilt in order to accommodate more than one hundred musicians. Understandably, rehearsals also exceeded the customary limits. On 14 October the work was performed, together with Schubert's *Der häusliche Krieg* ('The Household War') as the festival's conclusion; there were further performances on 17 and 21 October.

From the point of view of the quality of performance, it was an outstanding achievement, as even Schoenberg's adversaries agreed.[95] The four guests from the Vienna State Opera accomplished great things: this was true of Alfred Jerger as the Man, Hedy Pfundmayer as the Woman, and the producer Josef Turnau, who, together with the lighting designer Beck, kept the stage action as 'abstract' as possible, obviously in complete accord with Schoenberg's intentions (to summarize a dozen reviews). Steinhof's stage-settings also conformed to this conception.

The reaction of the critics and public to the music drama itself on the night of the premiere was divided; 'partisans, disciples, zealots and art-revolutionaries have a fortunate hand, when it is a question of forming a claque. Everyone was repeatedly called to the footlights with shouting and clapping; finally Schoenberg appeared several times.'[96] But 'the storm of applause could not move the mute dissenters to react.'[97] Newspaper reviewers as well exhibit every facet of opinion, from the highest praise to complete incomprehension. Robert Konta, for instance, heard

> sounding reflections of a nerve vibration unheard-of in its fine differentiation. The possibility of differentiating with such overpowering strength of expression (without the availability of equipment suitable for

154

VOLKSOPER

Direktion: **Markowsky — Dr. Stiedry**

Telephon 16231 (Direktion), Tageskassen und Billettbestellung: Telephon 16244 (Theatergebäude)
Telephon 77318 (Rotenturmstraße, Basar) „Bienna" Bücherstube, I., Bognergasse 4, Tel. 69524

Anfang ½8 Uhr **Dienstag den 14. Oktober 1924** Anfang ½8 Uhr

Festvorstellung anläßl. des Musik- und Theaterfestes der Stadt Wien

Uraufführung!

Die glückliche Hand

Drama mit Musik von Arnold Schönberg

In Szene gesetzt von Jos. Turnau*) Musikalische Leitung: Fritz Stiedry

Ein Mann Alfred Jerger *) | Ein Herr Josef Hunstiger
Ein Weib Hedy Blundmayer*) |

Sechs Frauen: Ilona Kelmay (Solo) sowie die Damen Brunner, Heinrich Brach, Larisch u. Neumann
Sechs Herren: Karl Fälbl (Solo) sowie die Herren Köchel, Zetsch, Tisch, Kup und Hahn
Dekorationen und Entwürfe von Prof. Steinhof von der Kunstgewerbeschule, ausgeführt im Atelier Kautsky
Beleuchtungstechnische Einrichtung: Inly. Robert Bed*) — Beleuchtungskörper von der Firma Schwabe
& Co. (Ing. Stenger)
*) Von der Staatsoper als Gäste

Zum ersten Male:

Der häusliche Krieg
(Die Verschworenen)

Komische Oper in einem Akt. Text von J. F. Castelli, Musik von **Franz Schubert**, Text und Szene
neu eingerichtet von Dr. Robert Hirschfeld

In Szene gesetzt von Georg Wittmann Musikalische Leitung: Heinz Jalowetz

Leopold Gichwandtner, Major Rudolf Bandler | Kathi, Ferdinand Hinter-
Rudolf Hornbichler, Hauptmann Max Adrian mayers Ehefrau Marie Sciics-Jelmar
Ferdinand Hintermayer, Leut- Marie, Franz Stelzenhubers
nant Lucian Ripper Ehefrau Milada Narenta
Franz Stelzenhuber, Leutnant Wilhelm Tisch Reverl, Stubenmädchen bei
Ein Offizier Hans Hahn Gichwandtners Rosa Wagschal-Ronchetti
Barbara, Leopold Gichwandt- Bastian, Offiziersbursche des
ners Ehefrau Dully Schimon a.G. Majors Gichwandtner . . Paula Bäck
Helene, Rudolf Hornbichlers Eine Dienerin Adele Scheiböck
Ehefrau Ilona Kelmay Offiziere verschiedener Waffengattungen

Die Handlung: Zur Zeit der Befreiungskriege in einem Schlosse von Wien
Während der Ouvertüre und der Akte bleiben die Türen des Zuschauerraumes geschlossen.

Die in diesem Theater verliehenen Operngläser sind von der Firma **Diplom Optiker Karl Kämpf**,
Wien, 9. Bezirk, Spitalgasse 27 in Ordnung gehalten und antiseptisch gereinigt

Kassen-Eröffnung 7 Uhr **Anfang ½8 Uhr** **Ende ¼11 Uhr**

Mittwoch den 15. Oktober. Anfang ½8 Uhr: Der Bettelstudent
Donnerstagden 16. Oktober. Anfang ½8 Uhr: Cavalleria rusticana — Der Bajazzo
Freitag den 17. Oktober. Anfang ½8 Uhr: Die glückliche Hand — Der häusliche Krieg
Samstag den 18. Oktober. Anfang 6 Uhr: Die Meistersinger von Nürnberg
Sonntag den 19. Oktober. Nachmittags ½3 Uhr, bei bedeutend ermäßigten Preisen: Die Zauberflöte
 Abends ½8 Uhr: Der Bettelstudent
Montag den 20. Oktober. Anfang ½8 Uhr: Der fliegende Holländer
Dienstag den 21. Oktober. Anfang ½8 Uhr: Die glückliche Hand — Der häusliche Krieg
Mittwoch den 22. Oktober. Anfang ½8 Uhr: Der Bettelstudent

„Eldemühl", Wien IX.

Poster for the premiere in 1924 at the Vienna Volksoper of *Die glückliche Hand,*
with Schubert's comic opera *Der häusliche Krieg* sharing the bill

its transmission) is only provided by the gigantic orchestra (more than a hundred players) which Schoenberg fully exploits to produce solo and ensemble sounds never heard until now.

However, he immediately concedes that 'apart from Schoenberg's closest intimates and those who share his tendencies, hardly anyone can follow Schoenberg's direction perceptively.' He himself could not follow the work's content; he certainly found the most misguided explanations for the title. At one point he sees the 'glückliche Hand' as that of the Man, as he holds the bloody sword; at another as that of the Gentleman, as he waves the scrap of the Woman's clothing. And in regard to Schoenberg's music, he is capable of following it as far as Op. 10 and not a step further.[98]

Just one quotation at this point out of a large number of completely negative reviews: 'many believe in him, many do not, but he is understood, I vow, by no one at all.' At the end, the critic manages to maintain 'that tones are as unsuitable a means of expression for Schoenberg's purposes as pictures were.'[99] Balduin Bricht's impression in the *Volkszeitung* should be mentioned as well:

an instrumental or vocal piece which is in any way coherent is not present, nowhere a body of sound, nowhere even a line, nothing but color, nothing but colors which chase and crowd each other out, so that, in spite (or perhaps also because) of the exertions of an enormous instrumental body and an extraordinary stage apparatus, no enduring impression is produced. This stage kingdom is not of this world, and he who regrets the absence of the rather daring assertion that this is a work for future generations, only confirms our right to reject it.[100]

Other critics, by contrast, stress the fact that this music is already eleven years old, and therefore much more familiar to the ear, and describe the innovations which are still noteworthy:

the intensity of the musical and scenic events, the constant lighting changes marked in the score, all this seems to me to show clearly that in this case no 'stage work' (such as Schoenberg's *Erwartung* undoubtedly is), but something new, which surpasses the scope of our stage, is put before us— as if the musician had burst open his score, conquering new systems for it. Drawing stage-setting, gesture, light, word into it in a different way, infinitely more strictly and inexorably than anyone had done previously, the piece unfolds in twenty-five minutes which are raised to the highest tension. Where the opera demands plot, Schoenberg provides light as a part of the music, as part of the emotional experience.[101]

A further performance followed in 1928 at the municipal theater of Breslau, a city renowned as a stronghold of artistic reaction. This seems not quite so surprising when one discovers that the director of the theater was the same Josef Turnau who had already produced the work in Vienna. This time too, the staging achievement was unanimously praised.[102] After the first performance, which was greeted with little understanding, Schoenberg delivered his lecture (printed on pp. 102–7); immediately afterwards the piece was played a second time, whereupon the composer and the performers were called before the curtain five times, to be received with equal quantities of lively applause and whistles. The lecture and the repeat performance thus seem to have been useful, since the level of most of the newspaper reviews is higher than in Vienna, and they show more understanding, if not always agreement.[103] Rudolf Bilke, for example, uses Schoenberg's claim to make music with *all* the expressive means of the stage as the basis of his investigation, and maintains finally that this goal has not been reached: 'because everything which the stage can add, can neither theoretically nor practically be so fixed that it functions with the same precision as tones do in the overall musical picture.' This, however, is exactly the reason why Schoenberg wrote down his stage directions with such unprecedented exactitude and detail. He came as close to the precision of musical notation as was possible and perhaps also as close as was necessary. Bilke's criticism shows the helplessness that still prevailed in the judgement of the music. In contrast to the above-quoted criticism, 'nowhere even a line, nothing but color' (see p. 156), he comes to this conclusion: 'it lies in the nature of a tonal-polyphonic music that its thematic material, that is, the melodic, must have higher significance than color.'[104] Stuckenschmidt sees 'preliminary stages of the consequent twelve-tone technique everywhere' in *Die glückliche Hand*.[105]

From performance to performance down to the most recent times, criticisms and the reactions of the public, if not always positive, give evidence of ever greater understanding. Already in 1929, at the large Tonkünstlerfest ('Composers' Festival') in Duisburg, *Die glückliche Hand* had to be repeated by public demand,[106] and the critic Rudolph Serger, who attended, classed the music drama as 'the most mature, modern, thought-provoking piece of the week. [. . .] *Die glückliche Hand*, that, along with all its constructivism and intricacies, forms a model for the greatest possible terseness and precision of expressive form in modern operatic style.'[107]

Kandinsky also began to concern himself with the stage around 1908 and, in his case as well, this happened in the period after a personal crisis which he had suffered in 1907.[108] It was the time when he first became friends with the composer Thomas von Hartmann, in whom he quickly recognized a kindred

157

spirit, and whom he made his musical collaborator. On the other hand, the idea that it was through Hartmann that Kandinsky could first have been brought to the concept of a synesthetic stage work is unlikely. For although Hartmann had already achieved an early success at the Petersburg Opera, Kandinsky, older by about twenty years, was no doubt the dominant partner in every respect (except, of course, in questions of music). In the article quoted above (see p. 141), Hartmann gives information on the years from 1909 on: 'this period was marked by [Kandinsky's] constantly growing interest in music, by his ideas of the teaching of painting with a certain connection to music theory, and by constant dissatisfaction with today's theater (most especially with opera).'

Hartmann's widow still remembers the collaboration between Kandinsky and Hartmann well. As a young married couple, they lived a few houses away from him in Ainmillerstrasse and he was their guest almost every evening, particularly when, as so often happened, Gabriele Münter stayed on in Murnau alone. Hartmann generally sat at the piano and improvised, while Kandinsky narrated the stage action. From a lecture, also unpublished, which Hartmann delivered in New York after Kandinsky's death, we obtain completely authentic information about the collaboration: 'the first thing which we wanted to stage was a fairy tale by Andersen. In a very brief time Kandinsky made an enchanting sketch of a medieval town.'

In Kandinsky's legacy a manuscript with the title 'Paradise Garden' is actually preserved. Though it is still quite conventional, it contains a sentence such as 'Arab with snake—a straight line with a winding one' which already hints at his further development, that is, to the free manipulation of the basic elements of art.

Hartmann continues:

> We began to think of individual scenes and how they could be transformed into ballet. Then we recognized that the existing form of ballet could not furnish what we sought. We wanted something totally different. Just at this time, a gifted young man joined us, who understood our aim. It was Alexander Sakharoff, who later became a famous dancer. We began to occupy ourselves with ancient Greek dance, and Sakharoff to study in the museums. Thus we proceeded from Andersen to *Daphnis and Chloe*. Kandinsky made a sketch for the first stage setting, a marvelous trireme with warriors. It was by no means a realistic picture, but it conveyed an astoundingly strong impression of Daphnis' terror [. . .]
>
> In any case, these endeavors led Kandinsky to his stage work *Der gelbe Klang*, a work which must be considered one of the boldest ventures in this field. The text was printed in *Der Blaue Reiter*. I wrote the music for it, but

only as a sketch, since the final form and the orchestration would depend upon the nature of the theater which accepted the piece.[109]

Kandinsky's work for the theater led by way of the expansion of the warrior motif from *Daphnis and Chloe* to the short stage play *Riesen* ('Giants') that is to be found in a manuscript notebook at the Municipal Gallery, Munich, between 'Stage Composition I *(Der grüne Klang)*' and 'III *(Schwarz und Weiss* ["Black and White"])'. In the next, more developed version, the title *Riesen* is replaced by *Der gelbe Klang;* this (Russian) manuscript is dated 'March 1909' (Nina Kandinsky Archive, Paris). By 1912 Kandinsky had developed the text further and considered it ready for publication. Almost as much has been written about *Der gelbe Klang* as about Schoenberg's *Die glückliche Hand*—and it is scattered, moreover, in monographs and works of theater history.[110]

If *Die glückliche Hand* only had its first performance more than a decade after its completion, it was never granted to Kandinsky, after Hugo Ball's plan to perform it at the Munich Kammerspiel was thwarted by World War I, to see his work on the stage.[111] *Der gelbe Klang* obviously belongs among those avant-garde, difficult works which (according to Kandinsky's own opinion, expressed in his *On the Spiritual in Art*) will only be understood after about two generations. In the most recent times there have been three performances; in New York (1972), in Baume, southern France (1975) and in Paris (1976). None of these three stagings, however, held even approximately to Kandinsky's directions; they were free, relatively inadequate renderings.[112] It is also not possible to assess the total effect without Thomas von Hartmann's partially composed music. We must thus rely only on the text, Kandinsky's theories, and our powers of imagination. The essay 'On Stage Composition' (see p. 111) gives precise and (following some remarks in the book *On the Spiritual in Art*) complete information.

In the light of our knowledge of the preliminary work on and the various versions of *Der gelbe Klang*, it is interesting to observe the development toward abstraction which proceeds parallel to the development in Kandinsky's painting. Even the human being, who in Schoenberg is already deprived of individuality, and functions as a nameless prototype, is more and more reduced to a bearer of color and movement. 'The people resemble marionettes,' says Kandinsky in scene 5. In the last version the wigs and faces are finally the same color as the tights: 'First there appear gray, then black, then white, and finally different-colored people. The movements of each group are different[. . .]. Many of the groups are illuminated from above with stronger or weaker lights of different colors.' The completely 'abstract' play with movements, noises and colored light in the third scene (from the fourth sentence until the meaningless words of the tenor), and much that is in

159

scene 5, Kandinsky did not write until the final version in 1912. This scene 5 is comparable to Schoenberg's third scene, the combined crescendo of the orchestra with lights of changing colors, which, however, according to Schoenberg's words, seems to be brought about by the Man's changing emotions, and thus to that extent still shows, by means of psychology, a last link with reality. Crawford examined Schoenberg's use of colors in the crescendo scene together with Kandinsky's theory of colors in *On the Spiritual in Art* in great detail, because he had accepted Kandinsky's influence as certain.[113] The result, namely Schoenberg's startling 'dependence' on Kandinsky's theory of the optical and psychic effects and the symbolic content of various colors, is of interest to us, even though the dates of the letters show the impossibility of such an influence. Schoenberg, of course, had already published the text of *Die glückliche Hand* in June 1911 and before this had not even seen portions of the manuscript of Kandinsky's *On the Spiritual in Art*.

When Schoenberg compares Kandinsky's stage work with his *Die glückliche Hand* (letter of 19 August 1912), he calls its renunciation of a realistic plot a 'great advantage' and affirms that he had fundamentally wanted the same thing. This is certainly credible, but the contradictions are not easy to resolve. In the third scene, for example, he gives the following direction; 'the entire effect should not imitate nature, but rather be a free combination of colors and forms,' but proves unable to do without detailed descriptions of a realistic stage-setting. Many such crass collisions between purely symbolic action and frankly naturalistic passages, along with similar breaches of style in speech, are the weakest places in the work. Such formal blunders were, together with what is for our taste an all-too-over-burdened symbolism and pathos, the main reasons for the mostly negative evaluation of Schoenberg's text. However, if one looks at it in relationship to other Expressionist dramas, where the same characteristics were particularly frequent, and sometimes even intended, one can hardly interpret this as a weakness. That Schoenberg had had the same purpose as Kandinsky and that 'making music with the media of the stage' was more important to him than the content, we actually discover less from the text than from a letter to Emil Hertzka (see p. 99) which refers to a projected filming of *Die glückliche Hand*. It is not clear, however, whether the letter was written in 1913 or later.

Kandinsky carried out fully what is only to be found sporadically and tentatively in *Die glückliche Hand*. In the context of his striving towards abstraction, he gives up all claim to a plot in the usual sense, and attains— although it still includes human figures, hints of landscape and recognizable objects—what is basically already a random play of color, movement and noise. It may have excited him to add to the elements of color and form, which

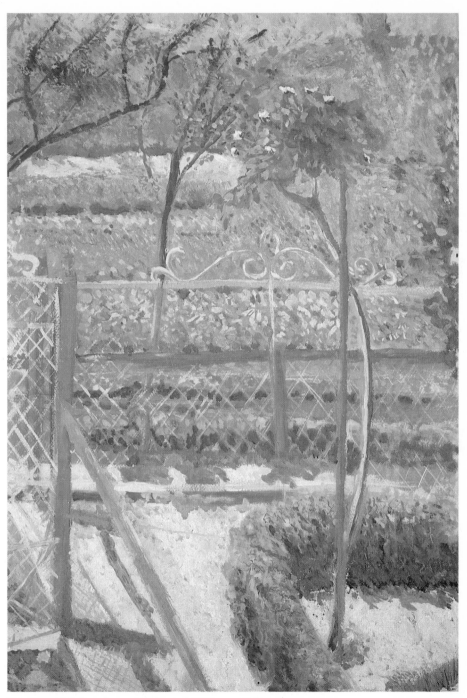

29. Arnold Schoenberg: *Garden in Mödling*, *c*.1908
Oil on pasteboard, 71×49cm. Unsigned and undated. Arnold Schoenberg Institute,
Los Angeles

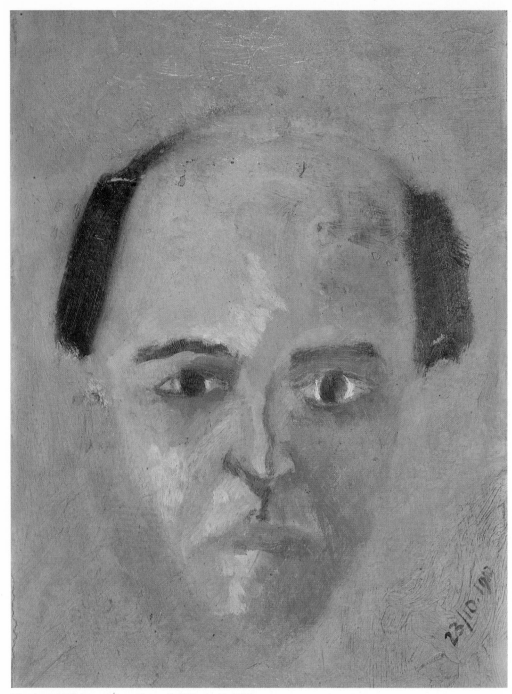

30. Arnold Schoenberg: *Green Self-Portrait*, 1910
 Oil on wood, 33×24cm. Dated at lower right: 23 October 1910. Arnold Schoenberg
 Institute, Los Angeles

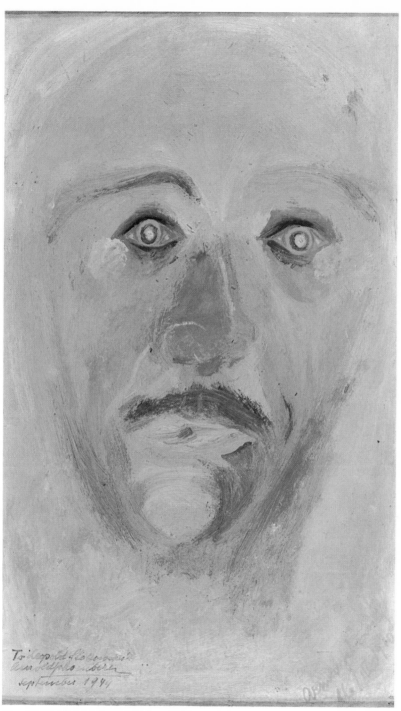

31. Arnold Schoenberg: *Vision*, 1910
Oil on canvas, 32×20cm. Signed and dated at lower right: Arnold
Schoenberg, 16 March 1910. Lower left, 1944 dedication to Leopold
Stokowski. Library of Congress, Washington, D.C.

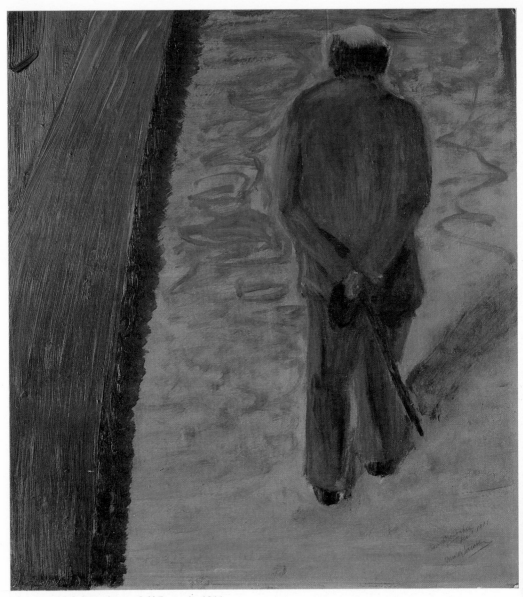

32. Arnold Schoenberg: *Self-Portrait*, 1911
Oil on pasteboard, 48×45cm. Signed and dated lower right. Arnold Schoenberg Institute,
Los Angeles

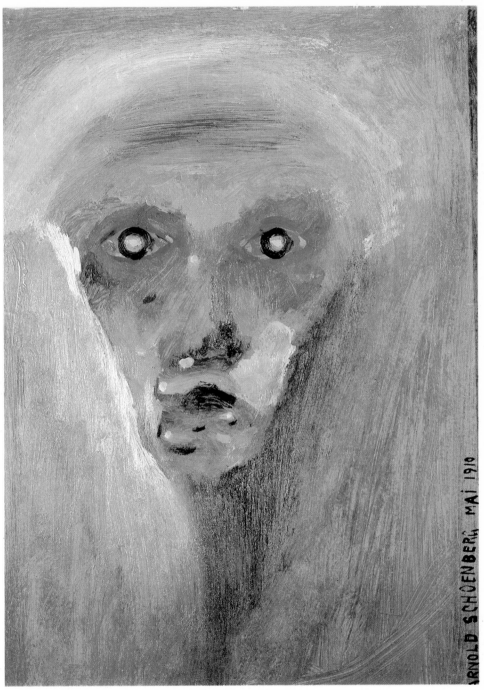

33. Arnold Schoenberg: *Red Gaze*, 1910
 Oil on pasteboard, 32×25cm. Signed and dated at right: Arnold Schoenberg, May 1910.
 Municipal Gallery in the Lenbachhaus, Munich

34. Arnold Schoenberg: *Hands*, 1910
Oil on canvas, 22×33cm. Unsigned and undated. Municipal Gallery in the
Lenbachhaus, Munich (long-term loan from Schoenberg's heirs)

35. Arnold Schoenberg: *Vision*, *c.*1911
 Oil on pasteboard, 25×16cm. Unsigned and undated. Arnold Schoenberg
 Institute, Los Angeles

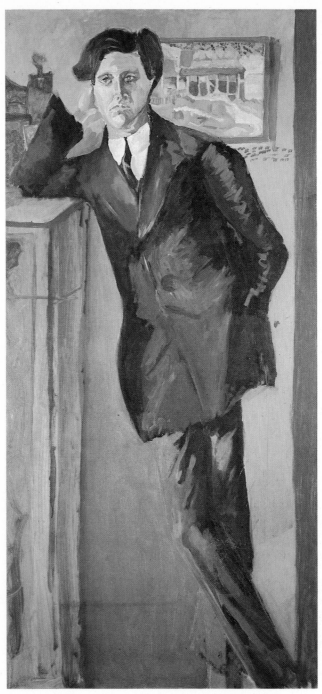

36. Arnold Schoenberg: *Portrait of Alban Berg*, c.1910
Oil on canvas, 175×85cm. Unsigned and undated.
Historical Museum of the City of Vienna

were familiar from painting, the temporal element of music and noise, as well as the likewise temporal element of movement and lighting, both of which could modify form and color—in order, so to speak, to transform his pictures into movement.

The second point of departure was the idea of the *Gesamtkunstwerk* for the stage as a synthesis of equally ranking components which result in something more than, and different from, the sum of the parts—in conscious opposition to the purely additive, effect-heightening agglomeration of artistic means in nineteenth-century opera. In this field Kandinsky's experiments deserve an important place along with those of Richard Wagner, Gordon Craig, Adolphe Appia, Alexander Scriabin and Lothar Schreyer. More consistently than they, he pursues the aim of bringing into play all the media of the stage for their individual values. And since he makes the basic elements of color, movement and music themselves the content, instead of using them to present a plot, he leaves much more to the imagination of the listener than had ever been the case before him. While artistic innovation usually does not abandon a conventional framework, so that even the Theater of the Absurd generally arouses conventional expectations in the listener, in order to then purposely disappoint them, the historical significance of Kandinsky's stage work lies in the fact that here, for the first time in post-naturalistic theater, eschewing the aid of any logical coherence, a synthesis of heterogeneous elements is achieved which is completed in the imagination of the spectator. Kandinsky optimistically considers the spectator to be capable of fully following the complex experience of the artist, allowing himself to be moved by the unfamiliar, absolute play of form purged of all comprehensible 'content,' so that the drama results, and is given final form, only 'from the complex of inner experiences (soul-vibrations) of the spectator' ('On Stage Composition'). Kandinsky thus provided a generic form which may be considered a preliminary stage of German Expressionist drama.

That neither Kandinsky nor Hugo Ball called their stage-plans by the painting term 'Expressionist' did not prevent later scholars from observing more summarily from a greater distance and emphasizing the common elements between differing artistic phenomena. Just as the painting of the Blaue Reiter circle found its place along with Die Brücke under the extended concept of 'Expressionism,' Kandinsky's *Der gelbe Klang*, like Schoenberg's *Die glückliche Hand*, is justifiably dealt with in the context of German Expressionist drama. No objection can be made to this, since there is a wealth of common features. Schoenberg's piece anticipates the typical Expressionist 'Ich-Drama.'[114] Besides the Expressionist music, there is the theme itself, and the general human, not individualized action, the quick, compressed course

of the plot and the concentrated, clipped speech style which fits it, as well as the symbolic use of colors. In regard to the dramatic use of lighting, Schoenberg and Kandinsky made just as abundant use of the stage possibilities which had been further developed since the introduction of electricity—such as moveable spotlights with colored glass and so on—as did most of the Expressionists. However, they were the first to give lighting an independent role in the stage action. In this connection, it would be important to know whether Schoenberg did not perhaps see one of the dramas of Oskar Kokoschka performed in 1908 and 1909; however, there is no evidence to support this, since the Vienna performances were rather 'unofficial.' That Schoenberg names Kokoschka as his first choice for scene designer of his *Die glückliche Hand* may naturally also be explained solely on the basis of his respect for the painter.

The gamut of Expressionist dramas stretches from the lyric-dramatic works—beginning in 1912 with Reinhard Sorge's *Der Bettler* ('The Beggar'), in which youths soliloquize verbosely on the subject of father–son conflicts and other adolescent clashes, on their calling as poets, or on the experience of loneliness—by way of the consciousness of the actual means of the theater, that is to say space, mass and the physical, gestic play of movement, as in Kokoschka—to the other extreme: the negation of any engagement in art, the shift of perspective from subject to object, to extra-human reality, to the cosmic. Included in this style of Expressionist play are the later August Stramm and Lothar Schreyer and, in the most extreme position, Kandinsky as well, while Schoenberg belongs to the first group. In contrast to Schoenberg, it can be asserted in Kandinsky's case that he stands in the most extreme contrast to the typically Expressionist, essentially anthropocentric art of the Brücke painters, just as he does to the dramas from Sternheim to Kaiser, Sorge, and also Barlach and Kokoschka and (to go a step further from moralizing to politicizing) the 'total theater' of Erwin Piscator. Just as the portrait, let alone the self-portrait or the portrayal of human beings, in the sense of the Brücke painters, plays no part in Kandinsky's art, he strives in his stage works to get away from problems of individual psychology, from ideological declarations, and indeed from the portrayal of human beings in general. The human being is now only one element among others. This important differentiation must be made; whether one then considers Kandinsky's dramatic experiments to be 'Cubist Expressionism,' (according to Walter Sokel's distinction), in contrast to the subjective, visionary (and thus the real) Expressionism, or, as would be more correct, to be 'Abstract Expressionism' (if this term had not been taken over in the meantime) is unimportant. The concept 'Cubist Expressionism' is intended to indicate the pre-eminent significance of space, which in any case proves more true of

Kandinsky than the primacy of dialogue, everyday subjects, etc., though not to the degree that it does later with Tairov at the Moscow Chamber Theater. Kandinsky abstracts all unessential transitory characteristics in order to throw into relief the intrinsic, unchangeable shape of things, their true nature. In his conception of the actor, he approaches Craig's 'Übermarionette;' Schoenberg, on the other hand, is closer to Maeterlinck's de-individualized characters who represent something beyond themselves. This tradition was important for German Expressionist drama; Oskar Kokoschka uses masks and costumes in *Sphinx und Strohmann* as material manifestations, as Schwitters and Schlemmer do later and, above all, Lothar Schreyer at the Sturm Theater in Berlin from 1920 on. In many respects, though with a much clearer mystical tendency and also with more interest in what is archetypically human, Schreyer follows Kandinsky more faithfully than anyone else. It is not surprising, therefore, that the most detailed interpretation of *Der gelbe Klang* up to the present comes from him.[115] It shows a sympathetic understanding of the cosmic events which are represented; with regard to the faintly suggested human theme, which is particularly clear in the recitation at the beginning of the piece, the closeness to Schreyer's Sturm Theater is unmistakable; the 'deliverance of captive souls' is the final and deepest meaning of art, 'a meaning which the Expressionist theater also proclaimed, and sought to serve with the burning ardor of the soul of those in captivity to whom the light of freedom shines.' The final theme of *Der gelbe Klang*, the giant who forms a cross, Schreyer interprets as the 'crucifixion of light.' That is correct to the extent that the religious, the mystical and the new genesis are faintly hinted at by the ending. Schreyer's entire interpretation is false to the degree that he interprets the consciously symbolic, ambiguous stage action in too much detail and too one-sidedly according to his own interests, and thereby limits it to only one point of view (even though this point of view is defensible). The rhythmic chanting, which Kandinsky uses in some places, was perfected by Schreyer, Schwitters, Hausmann and Blümner as a dominant stylistic means.

The history of *Die glückliche Hand*'s influence is naturally to be sought in the field of music. It may be said with as little unequivocal certainty as in the case of Kandinsky, that Alban Berg's opera *Lulu* would be unthinkable without *Die glückliche Hand;* further possible influences are cited in the Schoenberg literature.

Munich and particularly Vienna were centers of the incipient Expressionist movement and it is therefore not surprising that Schoenberg and Kandinsky, with their early plays, are included in it. They shared the Expressionists' disgust with the theater of edification, with the socially critical plays of Naturalism and their mistrust of the word in the established sense, and

therefore approached the monosyllabic exclamatory style and gestic, even pantomimic expression. They also shared a fundamental principle, the belief in the powerful possibilities of subjective expression, the artistic shaping of 'inner necessity,' and the task, perceived as a duty, of showing the essence of things, only revealed to the artist in visionary ecstasy, to other human beings as primordial truth, and thereby to sensitize and arouse them to the final goal, the creation of the 'new man.' Like most of the Expressionist dramatists, Schoenberg and Kandinsky also wanted to reveal transcendental forces and relationships, which no longer fit into a pattern of causality; thus the stage is no longer a mirror of the realistic world, but one of 'true being,' beyond the seeming world of material things. Therefore, any realistic plot, constructed according to the laws of logic, must naturally be abolished, something toward which Schoenberg only strives, but Kandinsky carries out consistently and radically.

Schoenberg and Kandinsky—together with Kokoschka and Barlach—must from now on be included in that series of 'dilettantes' who gave to the German Expressionist theater its most significant impetus and, with their own stage works, opened new creative possibilities to the professional theater.

SCHOENBERG'S PAINTING

It is not generally known that Schoenberg painted very intensively for several years and later on still painted occasionally. Altogether over seventy oil paintings and perhaps 160 watercolors have been preserved, for the most part in Schoenberg's legacy in Los Angeles. Schoenberg produced most of the pictures in the years 1906/7 to 1912, thus once again in that decisive period when he carried out his musical revolution and wrote the music drama *Die glückliche Hand*. He even wished to make portrait painting a second profession. At the beginning of January 1910 he asked the director of Universal Edition, Emil Hertzka, to assist him in getting portrait commissions,[116] and in a letter of 16 June 1910 to Carl Moll, the painter and artistic consultant of the Miethke Gallery, he proposed an exhibition sale.[117] Moll, however, did not agree to it. Schoenberg's first and largest exhibition of over forty pictures then took place in October 1910 at the Viennese book and

ARNOLD SCHÖNBERG.
KARRIKATUR VON RUDOLF HERRMANN.

Caricature from *Der Merker. Österreichische Zeitschrift für Musik und Theater*, vol. II, no. 17, June 1911

art shop of Hugo Heller. The critics passed sentence with a lack of understanding similar to that with which they greeted his musical performances, and the saying circulated among orchestra members; 'Schoenberg's music and Schoenberg's pictures—then one must lose both one's hearing and sight at the same time.'[118]

At the end of 1911 Kandinsky was the second to exhibit Schoenberg's pictures; he did not shrink from showing them in the first Blaue Reiter exhibition, together with works by such important professional painters as Franz Marc, Robert Delaunay, Henri Rousseau, and Vladimir and David Burlyuk. His plan to have Schoenberg's pictures taken on to Berlin with the exhibition failed because of the composer's opposition. At the beginning of January 1912 Albert Paris von Gütersloh arranged for a further participation in an exhibition in Budapest, where twenty-three of Schoenberg's pictures hung beside works of Egon Schiele, Anton Kolig and Anton Faistauer.

A major publication about Schoenberg as a painter is planned, following several articles and a 1978 issue of the *Journal of the Arnold Schoenberg Institute* devoted to this subject.[119] I will therefore limit myself here to Schoenberg's own statements and the most essential facts.

Painting was more for Schoenberg than a carefree hobby in addition to his musical work. His necessity for expression was urgent in this medium as well. In an interview with Halsey Stevens (1950), Schoenberg said he could also have imagined a career as a painter, which would have turned out similarly to his career as a musician:

> I planned to tell you what painting meant—means—to me. In fact it was the same to me as making music. To me it was a way of expressing myself, of presenting emotions, ideas [. . .] in the same manner as I did in music. I was never very capable of expressing my feelings or emotions in words [. . .] as a painter I was absolutely an amateur. And I had no theoretical training and only a little esthetic training—this only from general education but not from an education which pertained to painting. In music it was different.[. . .] I always had the opportunity to study the works of the masters[. . .] in quite a professional manner, so that my technical ability grew in the normal manner. This is the difference between my painting and my music.'[120]

Let us listen further to Schoenberg's own statements. In a short handwritten note of 1934, he defends himself against the insinuation—particularly by his early biographers Paul Stefan and Egon Wellesz—that strong influences were displayed in his paintings. He reports briefly on the first contact with Kandinsky and says that by 1911 the greater number of his paintings were finished.

Kandinsky, when he saw them, called them 'Visions,' while I named them 'Gazes.'[. . .] Everything important had been done before Kokoschka *emerged!* I am also not influenced by another painter who, on the contrary, claimed to have learned painting through me (which I really never understood) as my 'Gazes' prove, which are unique in their way. True, I am presumably in some way connected with contemporaries but hardly with these.[121]

A few years later Schoenberg explains in more detail: the fact that he painted *Blicke* ('Gazes') happened from out of his own nature 'and is completely contrary to the nature of a real painter. I never saw *faces* but, because I looked into people's eyes, only their "gazes." This is the reason why I can imitate the gaze of a person. A painter, however, grasps with one look the whole person—I, only his soul.'[122]

In my opinion, Schoenberg is right to defend himself against the assertion that Kandinsky and Kokoschka had influenced his painting. As the letters prove, he did not become acquainted with Kandinsky's paintings before 1911. What Schoenberg says about Kokoschka is also believable; a large number of paintings (twenty-five) were not shown in Vienna until 1911. Previously, in the Internationale Kunstschau (1908 and 1909), only sketches for tapestries and graphic works were shown, then in 1909 some of his first portraits. As Kokoschka himself explained, he saw 'for the first time' in this 1909 exhibit 'that modern painting existed.'[123] Even if a contact through Adolph Loos from 1908 on were conceivable, nothing about it is authenticated.

The painter who maintained that he learned from Schoenberg was Richard Gerstl. In a 1938 note (see note 122), Schoenberg discusses him as well:

However, if one thinks of this certain Mr Gerstl then the matter stands thus. When this person invaded my house he was a student of Lefler for whom he supposedly painted too radically. But it was not quite so radical, for at that time his ideal, his model, was Liebermann. In many conversations about art, music and sundry things I wasted many thoughts on him as on everybody else who wanted to listen. Probably this had confirmed him in his, at that time, rather tame radicalism to such a degree that when he saw some quite miscarried attempts of mine, he took their miserable appearance to be *intentional* and exclaimed: 'Now I have learned from you how one has to paint.' I believe that Webern will be able to confirm this. Immediately afterwards he started to paint 'Modern.' I have today no judgement if these pictures are of any value. I never was very enthusiastic about them.

That Schoenberg was the giving partner in relation to the young Gerstl is beyond doubt. On the other hand, I think that his confession about the unintended 'miserable appearance' of his painting is too modest, and I accept it only for a portion of his works. The other part, which includes the self-portraits and visions (see Plates 30–6), has suffered no loss because of his lack of technical ability, since Schoenberg's purpose lay beyond the boundaries of mechanical dexterity. Fundamentally, the technical side of painting was almost a matter of indifference to him, just as we have already ascertained in relation to the technical aspect of language in *Die glückliche Hand*: he made use of it only in so far as it helped him to attain the expression he desired. Kandinsky immediately discerned this correctly. By his unconcerned attitude to the technical means Schoenberg probably strengthened and influenced Gerstl's struggle toward independence. Unfortunately, Gerstl destroyed his written notes and many of his pictures before his suicide, so that we can no longer obtain precise information.[124]

Even if Schoenberg, following his first attempts at painting in 1905/6, first learned the basic rudiments of painting from Gerstl, the comparison with Gerstl's paintings, just as with those of Kandinsky and Kokoschka, clearly shows Schoenberg's independence. The quality varies greatly. Among the more freely treated portraits and visions there are some (see Plates 30–3) that I would rank with the strongest Expressionistic works of Kokoschka, Kubin and the Brücke painters. What is most extraordinary about Schoenberg's pictures is the strong visionary aspect, which suggests the rendering of a static dream impression or, at times, of a sinister Kubin-like nightmare, rather than impressions from reality. Schoenberg himself speaks of the 'gazes,' which would be 'completely contrary to the nature of a real painter,' as characteristic of his pictures. In many of Schoenberg's paintings we find penetrating eyes, usually directed straight at the viewer, which are so strong in expression and dominating and intensive in their effect, that one can find only little to compare with them in the whole history of art. Neither traditional portraits, nor James Ensor's faces and masks, nor Jawlensky's heads (highly expressive in a completely different manner), nor the wild self-portrait with red eyes by Jawlensky's companion Werefkin, are comparable to them in their intention and result; surely Gerstl's and Kokoschka's portraits are in no way to be compared. Such an exclusive concentration on the gaze would indeed be too restrictive for a painter—this is one interpretation of Schoenberg's explanation. On the other hand, relating it to himself, one could say that to him, 'gazes' were also an important motif outside of painting. For example, we can find it again in the scenes which frame *Die glückliche Hand*, where the chorus are only

present through their eyes and, in the monodrama *Erwartung*, in the frequently repeated motif of the sinister staring eyes which the Woman imagines she perceives in the nocturnal wood.

Schoenberg was not deceived in his own value judgement, which rated his 'Visions' higher than the 'finger exercises' from nature. As early as the middle of 1910 he wrote to Carl Moll that with his nature pieces he did not have the feeling of satisfaction, well-known to him from his music, which told him unmistakably that a work was good, but only with the 'Fantasies and Visions.'[125]

What is remarkable, then, is Kandinsky's greater partiality for these pictures which were more oriented toward reality and truly clumsy. How is it that Kandinsky's judgement—otherwise so trustworthy—diverges from that of most experts? He must surely have discerned in the visionary and abstract pictures a greater proximity to his own endeavors, but he evidently considered that in Schoenberg's case the results were not yet fully mature—it must be in this sense that we should understand his remark that these pictures, 'certainly in their degree of abstraction,' failed to please him—(see letter of 16 November 1911). Schoenberg's choice of subject was foreign to Kandinsky, to whom the subjective, at this indeed primary stage, was never so important as the cosmic, the universally valid vision. Just as half of Schoenberg's work consists of self-portraits and likenesses of others, while Kandinsky, in his much more extensive oeuvre produced only one traditional portrait and a few portrait-like pictures, but never created a self-portrait, so Schoenberg's further development to the 'gazes' and 'visions' is almost diametrically opposed to Kandinsky's direction. In this respect, Schoenberg's work as a painter is closer to that of Kokoschka and the Brücke painters, whose confessional paintings had a more subjective, even a more private character. For this reason Schoenberg possibly understood Kokoschka's painting better and valued it more highly than Kandinsky's (see p. 101). The community between Schoenberg's and Kandinsky's pictures in fact lies only in the sincerity with which both pursued their path. Since Kandinsky had a particularly keen feeling for such artistic authenticity, he would also have discovered in Schoenberg's representational pictures the same sincerity and strength which we perhaps can recognize less clearly. Indeed, Kandinsky always granted an 'inner sound' to the object as well and would have viewed its banishment from painting as a limitation of artistic possibilities.[126]

If we have already ascertained the return to the primitive in Schoenberg's musical development, Albert Paris von Gütersloh saw the same thing in Schoenberg's pictures:

Arnold Schoenberg, the thinker, attempts at long last to recreate for painting that state of psychic primitiveness, a kind of prehistoric earlier life, without which its contemporary existence does not seem to be truly legitimized, and only he could patiently shape these forms which are completely immaterial to the art-lover, because he seems already protected, almost immunized, by an advanced and well-understood art, by his music.[127]

Schoenberg's Artistic Development to 1911

JOHN C. CRAWFORD

ARNOLD SCHÖNBERG

HARMONIELEHRE

[handwritten dedication in German]

Title-page of Kandinsky's copy of *Theory of Harmony* with Schoenberg's handwritten dedication:

[*Theory of Harmony*], 'which almost perhaps leads away from *The Spiritual in Art*, whereas it would really like to lead toward it. But you know the path and also a goal: must your path lead to your goal? Is your goal only to be reached by your path? Isn't the most important thing that *you*, on a *path, are striving toward a goal*? Thus perhaps the *Theory of Harmony* even leads toward *The Spiritual in Art*. We, who both struggle along a path, almost the same path, have already been brought together by it [*Theory of Harmony*] once—but that is our private concern, over which I greatly rejoice.

 With warmest regards, your Arnold Schoenberg
 12 December 1911'

It was the strong impression which Schoenberg's music made on Kandinsky when he heard it in a Munich concert on 1 January 1911 that impelled him to write to the composer, thereby beginning the highly significant relationship between the two men. The two works which Kandinsky heard—the Second String Quartet, Op. 10 and the Three Piano Pieces, Op. 11—were both products of the important stylistic break-through which Schoenberg had achieved around 1908, a break-through which led to his free atonal period (so-called to distinguish it both from the tonal period which preceded it and the twelve-tone period which followed it from about 1921 on). The free atonal works embody a new mode of musical expression which was to be of central significance to the further development of twentieth-century music. In this essay, the various cultural, social and musical forces which influenced Schoenberg toward this new style will be examined.

Arnold Schoenberg was born in Vienna on 13 September 1874, the first child of Samuel Schoenberg and Pauline Nachod Schoenberg. The composer's father has been described as an anarchistic wit and freethinker,[128] while his mother, who came from a very musical Prague family, was pious and conservative. Thus the origins both of the composer's later rebellious argumentativeness and of his strong religious leanings can be seen in his parents' characters. An uncle, Friedrich (Fritz) Nachod, also exercised a strong influence over the boy's development, introducing him to the French language and a love of poetry at an early age.

The family belonged to the lower middle class, and supported itself by means of a shoe store. Although the Schoenbergs had no piano, Arnold learned the violin as a child and, according to his sister, began to compose at ten.[129] His father intended the boy to become an engineer, but early in 1891 the former's death from influenza made it necessary for Arnold to leave the science-oriented Realschule and take a post as a trainee in a bank. He remained in this position until about 1895, when he left it in order to support himself as a musician.

Two friends whom Schoenberg met during his schooldays contributed

importantly to his development. Oskar Adler, with whom the composer played string quartets, and who later became an astrologer and philosopher, influenced Schoenberg musically, poetically and philosophically;[130] D. J. Bach, a good musician who went on to become a socialist philosopher and writer, was later credited by Schoenberg with influencing the development of his character by 'furnishing it with the ethical and moral power needed to withstand vulgarity and commonplace popularity.'[131]

Schoenberg's meeting with the conductor and composer Alexander von Zemlinsky in 1893, which occurred through their mutual involvement in conducting workers' choirs,[132] was of particular importance, since Zemlinsky not only provided Schoenberg with his only real instruction in theory and composition and opened his mind to the influence of Wagner, but also introduced him to the radical intellectual and artistic circles which centered on the Café Griensteidl (nicknamed the 'Café Grössenwahn,' or 'Café Megalomania') until its demolition in 1896. Even at this very early period, the 'wild and energetic' young Schoenberg was known for his 'witty and pert replies' and the 'paradoxes which he tossed about'[133]—a mental liveliness doubtless inherited from his father.

Schoenberg's musical development during his first period (1894–1908) can be understood partly as a gradual departure from the influence of Brahms toward that of Wagner and Strauss, although Schoenberg never took sides in the Brahms-Wagner controversy which existed in the Vienna of his youth, and certainly never completely abandoned Brahms's concepts of contrapuntal texture and of thematic development and transformation. While the D major String Quartet, written in 1897, the year of Brahms's death, still largely reflects his influence, the String Sextet, Op. 4 (Verklärte Nacht), written two years later, is more strongly Wagnerian in its melodic language and chromatic harmony.

Schoenberg's tone poem (which, along with Smetana's String Quartet No. 1 in E minor, 'From My Life,' 1876, is one of the few of the genre to be written as chamber music) was based on a poem from Richard Dehmel's Woman and World (1896). Dehmel's poetry, which was influenced both by Nietzschean ideas and socialism, and shocked the late nineteenth century with its naturalistic treatment of the problems of workers' marriages and free love, was characterized by an ecstatic tone, irregular meters and concise diction. Schoenberg later acknowledged Dehmel's importance to his musical growth:

> [. . .] your poems have had a decisive influence on my develop-
> ment as a composer. They were what first made me try to find a
> new tone in the lyrical mode. Or rather, I found it without even looking,
> simply by reflecting in music what your poems stirred up in me. People

who know my music can bear witness to the fact that my first attempts to compose settings for your poems contain more of what has subsequently developed in my work than there is in many of my later compositions.[134]

The 1899 setting of Dehmel's poem 'Warnung' (Op. 3, no. 3), with its rapid modulations and vehement declamation, is especially prophetic of Schoenberg's later development.

Another influence of a very different sort was that of the Berlin 'Überbrettl,' or literary cabaret, for which Schoenberg served as conductor and arranger in 1901–2, during his first sojourn in the German capital. The basic idea of the literary cabaret was brought from France by Ernst von Wolzogen, the founder of the Überbrettl; Wolzogen was inspired by his visits to Paris cabarets such as Le Chat Noir in Montmartre.[135] The influence of the Überbrettl is most obvious in Schoenberg's *Pierrot Lunaire* (1912), whose text was translated from Albert Giraud's French by Otto Erich Hartleben, a member of Wolzogen's circle. More subtly, the influence of cabaret music, along with that of the thousands of pages of other men's operettas which Schoenberg orchestrated for a living during these years, is to be felt in the many—often submerged—references to Viennese waltz rhythms and melodic patterns in Schoenberg's free atonal and twelve-tone music.

In 1900, Schoenberg began the *Gurre-Lieder*, the largest work of his tonal period, and one which is strongly Wagnerian both in its music and in its text, drawn from poems by Jens Peter Jacobsen based on Nordic legend. However, the work is not completely unified in style, since some of Part III was orchestrated (and perhaps extensively reworked) only in 1910-11, when Schoenberg completed the *Gurre-Lieder* after having set the work aside since 1903.[136] The orchestral writing of Part III takes on a definitely twentieth-century cast, making effective use of xylophone, noise-maker and 'several large chains' in the passage which describes King Waldemar's soldiers rising from their graves and putting on their rusty armour (Part III, Cues 7–11). However, it is in the melodrama 'Des Sommerwindes wilde Jagd' ('The Summer Wind's Wild Hunt'), just before the final chorus, that the clearest evidences of a more advanced musical style occur. Not only does the melodrama contain Schoenberg's first extended use of *Sprechstimme* ('speech-song'—speaking with rhythm and approximate pitch notated), but its *perpetuo mobile* of fleeting motives creates an atmosphere close to French Impressionism. The central portion of the melodrama, with its celesta ostinato, takes the listener into the aural world of Schoenberg's Five Orchestral Pieces, Op. 16 (1909).

Harmonically as well, the melodrama hints at both Impressionism and

175

Schoenberg's free atonal style. No wonder that the composer wrote to his publisher in 1912 that 'this work [the *Gurre-Lieder*] is the key to my whole development [. . .]it explains why everything later had to happen as it did.'[137]

With the completion of the main body of the *Gurre-Lieder* in 1903, Schoenberg had worked through the influence of Wagner for the time being and was ready to go beyond it. Richard Strauss suggested Maeterlinck's *Pelléas et Mélisande* as an opera text and Schoenberg made the play the basis of his symphonic poem *Pelleas und Melisande,* Op. 5, finishing the work in 1903. Here, Schoenberg created a programmatic work whose great contrapuntal complexity is sometimes reminiscent of his contemporary, Max Reger. Harmonically, *Pelleas* introduces whole-tone sonorities, and advances further into the realm of extended tonality.

The Chamber Symphony in E major, Op. 9 (1906), is the final large-scale work of Schoenberg's tonal period. It marks the composer's turn away from the lush, late-Romantic orchestration of *Pelleas und Melisande* and the earlier part of the *Gurre-Lieder,* in favor of a leaner, more astringent and linear texture. Harmonically, chords built on fourths appear prominently, marking an important step in Schoenberg's transition from tonal harmony based on thirds to the free atonal music he was soon to write. Before examining this free atonal music, some of the social, cultural and personal factors which helped to bring it about will be traced.

Arnold Schoenberg was hardly a political man at any stage of his life. According to his late essay, 'My Attitude Toward Politics' (1950),[138] he was introduced to Marxist theories by friends in his early twenties, at the same period when he was conducting workers' choirs under the auspices of the Social Democratic Party. However, before the age of twenty-five he realized that he was a 'bourgeois' and turned away from all political contacts until the outbreak of World War I aroused his Austrian nationalism. He then became a 'monarchist' for 'many years,' though never an active one.

In spite of his comparative aloofness from politics, the young composer must have felt the 'tremors of social and political disintegration'[139] as Austria's Liberals (actually a rather conservative, upper-middle-class group) fell from power in the 1890s, after having played a dominant role for thirty years. Their place was taken by new, more extreme mass movements: on the left, the Social Democrats and on the right, Pan-Germanism and Christian Socialism. All three movements have been called 'post-rational,' since they were in revolt against reason and law.[140] Pan-Germanism and Christian Socialism were both also intensely anti-Semitic.

The growing anti-Semitism of the 1890s must have increased Schoenberg's sense of alienation: in many ways, his feelings must have been similar to those of Gustav Mahler, who became his friend after 1902. Mahler felt himself

'a Bohemian among Austrians, an Austrian among Germans, and a Jew among all the nations of the world.'[141] Like Mahler's conversion to Catholicism in 1897,[142] Schoenberg's turn to Protestantism in 1898[143] may have been caused both by spiritual considerations and by the wish to find acceptance in society increasingly hostile to Jews.

In the artistic sphere, Vienna experienced two waves of revolt against the historicism and naturalism of the *Gründerzeit* (literally 'the time of the founders': the speculative industrial boom and subsequent crash which occurred 1867–73). The first was focused in the founding of the Secession in 1897 by Gustav Klimt and other artists, who were aided ideologically by literary figures from the Jung-Wien movement.[144] The Secession represented *art nouveau* (or *Jugendstil*, as it was called in German-speaking countries); its literary equivalent was the aestheticism of the Jung-Wien *feuilleton* writers and the early Hofmannsthal.

In 1908, a group headed by Klimt split off from the Secession, and organized the summer Internationale Kunstschau exhibition of that year and 1909. It was here that the work of the young artist Oskar Kokoschka (1886–1980) came into prominence. His development and transition from Jugendstil to Expressionism closely parallel Schoenberg's. Though, like Schoenberg, he was largely self-taught, Kokoschka studied at the Vienna School of Applied Arts in 1904. He was drawn into the Kunstschau exhibition by his professor at the school, Franz Cizek, a progressive educator who believed in free creative activity for children, designed to reveal their instinctual artistic power. Kokoschka himself preferred to study primitive art rather than the works of the great masters.[145]

In *Die träumenden Knaben* ('The dreaming boys') (1908), a book for which Kokoschka produced both text and lithographs, the erotic traumas of adolescence are expressed in a highly personal way; the stream-of-consciousness text is paralleled by the lithographs' combination of Jugendstil and sexual symbolism. Kokoschka's play, *Mörder, Hoffnung der Frauen* ('Murderer, Hope of Women'), directed by its author at the outdoor theater of the Kunstschau in 1909, is a much more radical work. Its unnamed central characters and sparse, visionary dialogue have caused it to be widely accepted as the first Expressionist play. The plot takes over the battle of the sexes from Strindberg and Wedekind, and treats it with unprecedented directness and crudity. Kokoschka's illustrations for the play also inaugurated his Expressionism in that medium. Like Kandinsky's *Der gelbe Klang* and Schoenberg's *Die glückliche Hand*, its concept is that of a *Gesamtkunstwerk*.

It is not known whether Schoenberg saw this play, or how well the two creative artists knew each other at this period. However, a later letter from

Schoenberg to Kokoschka recalls that they both had been members of the same intellectual circle which had also included Mahler, Kraus, Webern and Berg.[146] Additional correspondence testifies to their life-long mutual respect.

Other members of the same radical-intellectual circle, to which Schoenberg had been introduced by Zemlinsky in the 1890s (see above, p. 174), were to have a significant influence on the epoch-making changes in his musical style which occurred around 1908. The extreme conservatism of Vienna's cultural and political establishment (Karl Kraus later referred to fin-de-siècle Vienna as 'an isolation cell in which one was allowed to scream'[147]) paradoxically served to draw like-minded members of the avant-garde closer together.

Kraus (1874–1936) was a satirist and polemicist who founded the periodical *Die Fackel* (1899–1936), which was dedicated to publishing scathing criticism of the corruption and stupidity of the Viennese as reflected in the public press. Schoenberg idolized Kraus for his integrity and devotion to truth, as well as for the epigrammatic ruthlessness of his prose, which the composer sought to emulate. Indeed, he wrote on the copy of his *Theory of Harmony* which he presented to Kraus: 'I have learned more from you, perhaps, than a man should learn, if he wants to remain independent.'[148]

The poet and essayist Peter Altenberg (1859–1919) was another writer greatly admired by Schoenberg and his circle. Altenberg's tendency toward aphoristic brevity, which may be observed in the 'picture postcard' poems which Berg set as his Op. 4, may well have influenced Schoenberg, Berg and Webern in their use of extremely short musical forms.[149]

Adolf Loos (1870–1933)—important as an architect who, in reaction to the ornamental emotionalism of the Jugendstil, produced unadorned, functional buildings and interiors—was a friend and patron of both Schoenberg and Kokoschka in their early years. Though it took a more rationalistic form, his revolt against ornamental estheticism closely paralleled theirs.

In her essay, Jelena Hahl-Koch has described the personal crisis which Schoenberg experienced in 1908, owing to his wife's affair with the painter Richard Gerstl, and Gerstl's subsequent suicide (see above, p. 152). Stuckenschmidt suggests that the crisis was even more wide-reaching, and that it began with Mahler's departure from Vienna in 1907. Schoenberg's turn to painting in 1907 may have caused him to seek isolation from the realities of life, bringing about the crisis in his marriage.[150] In the period which followed Mathilde's affair, the composer often contemplated suicide.[151] Schoenberg's spiritual and psychological unrest from 1907 on was probably the underlying force which led him to painting and to increasing literary expression (beginning in 1909),[152] as well as to a radically new musical style.

In spite of its great originality, Schoenberg's new musical Expressionism had important antecedents in the work of other composers. From Wagner, Schoenberg took chromaticism and carried it to its logical extreme in

atonality. The concept of 'musical prose,' a more spontaneous and expressive musical utterance as opposed to symmetry of phrase structure, also came from Wagner,[153] as did the idea that emotion should dominate reason or plot. Wagner had clearly foreshadowed Schoenberg's Expressionism in the highly chromatic and dissonant passages in Act III of *Tristan und Isolde* (1859), which portray Tristan's delirium. In his late work, *Parsifal*, he had consciously cultivated situations of extreme and long-lasting psychological tension, and expressed this tension in harsh, sometimes unresolved dissonance. Rapid changes of musical texture portray the extreme psychological conflicts of Kundry, who is at once a holy messenger and an evil seductress.[154] Like the many unnamed characters of Expressionist opera and drama, Kundry is less an individual than a universal human type; passages of her dialogue anticipate the compressed, fragmented, ungrammatical style of Expressionist poetry, and are markedly similar to the sparse diction of *Die glückliche Hand*.[155] In a 1909 interview, Schoenberg affirmed that 'after I became a Wagnerian—then the further development came rather fast,' and mentions specifically Wagner's 'short motives, with their possibility of changing the composition [*Satz*] as quickly and as often as the least detail of mood requires.'[156] As will be shown below, this latter point is of central significance to an understanding of Schoenberg's free atonal music.

In his operas *Salome* (1905) and *Elektra* (1908), Richard Strauss carried Wagner's nascent Expressionism to greater lengths; their often extreme libretti matched the radical innovations in Strauss's music. These included rapid, often purposefully distorted declamation, bitonality, and unresolved dissonance (as in the famous 'Elektra chord'), and passages which verge on atonality.[157] Strauss's highly differentiated treatment of the orchestra, daring and sometimes even grotesque, reflected every detail of the action and of the changing psychological states of his characters through rapid changes of musical texture. As was soon to be the case with Schoenberg, certain key words are treated as musical symbols (as 'wind' in *Salome*, 'blood' in *Elektra*).

Strauss's pragmatic approach to composition in these operas, his ability to find effective musical expression for even the most extreme parts of his texts, led him to develop a musical style which anticipated most of the features of Schoenberg's Expressionism. However, this same pragmatic approach also led Strauss into stylistic incongruities, as when Chrysothemis's aria celebrating the joys of motherhood, clearly tonal, consonant, and in waltz-like 3/4 time, follows directly upon the high dramatic tension and extreme dissonance of Elektra's opening monologue.

In spite of his important contribution to the new musical language, Strauss lacked the intense need for personal, almost confessional expression which is such an important element in Schoenberg's free atonal music.

This element was present in abundance in the works of Gustav Mahler.

Though Schoenberg was acquainted with Mahler from 1902 on, a performance of Mahler's Third Symphony in 1904 was the catalyst which converted Schoenberg's initial scepticism concerning Mahler's compositions into deep and lasting admiration.[158] Mahler's idealistic and uncompromising character was also venerated by Schoenberg and his circle of students.

The musical influence of Mahler on Schoenberg is somewhat less obvious. In general, Mahler widened the expressive range of music, both in the direction of the transcendental (as in the Rückert song 'Ich bin der Welt abhanden gekommen')[159] and of grotesque irony (the 'Bruder Martin' movement of the First Symphony), and thus prepared the way for the emotional extremes of Schoenberg's free atonal music. Schoenberg must also have been influenced by the many instances in Mahler's music where emotional content overcomes musical form, such as the Finale of the Second Symphony, with its multiple, rapid changes of affect. His 1912 Mahler lecture mentions passages in which 'gigantic structures clash against each other; the architecture crumbles.'[160] In the same lecture, Schoenberg admires the 'unheard-of simplicity' and 'clarity' of Mahler's scores,[161] and it is logical to link the change in his orchestral style in the Chamber Symphony (see above, p. 176) to his increasing knowledge of Mahler's frequently spare and soloistic orchestration.

The idea of perpetual development, as opposed to literal repetition, which is present in Mahler from the Fifth Symphony on, probably influenced Schoenberg, as did the incipient serialism of *Das Lied von der Erde*, in which a three-note motive, used in chordal as well as melodic form, dominates the whole.[162] Portions of the opening Adagio of Mahler's Tenth Symphony (in particular the sustained nine-note chord, bars 203 ff) come so close to the free atonal style of Schoenberg that the question of reciprocal influence has been raised.[163] Mahler's influence on Schoenberg is clearly shown by the introduction of the voice in the last two movements of the Second String Quartet, Op. 10 (1907–8), an innovation (in chamber music) which reflects Mahler's practice in the Second and Third Symphonies. The Second Quartet is a work of particular importance and fascination, since its four movements show the composer at different stages of his development toward the free atonal style of his second period.

The opening movement, written in 1907, is still clearly tonal. The two middle movements were written during the height of the crisis in Schoenberg's marriage,[164] and his upset state of mind is reflected both in the Scherzo's scurrilous black humor (including the introduction of the Viennese street song 'O du lieber Augustin, alles ist hin' ['Oh my dear Augustin, everything's lost']) and in the extreme emotionalism of Stefan George's text and its setting in 'Litanei'. The final movement, written last, is the only one to

be notated without a key signature. Though its tonic is F sharp major, this movement includes long stretches of music which are in fact atonal.

Schoenberg's next work, *Fifteen Poems from 'Das Buch der hängenden Gärten'* by Stefan George, Op. 15 (1908–9), which the composer himself saw as the beginning of a new 'ideal of expression and form,'[165] nevertheless contains strong vestiges of tonality and traditional formal construction. Thus, to examine Schoenberg's musical Expressionism in its purest form, we must turn to the works of the 1909–11 period, since *Pierrot Lunaire* (1912) and *Die glückliche Hand* (1910–13) already show a partial return to strict contrapuntal devices which is in fact the harbinger of the constructivism of twelve-tone technique.

The third of the Three Piano Pieces, Op. 11 (completed on 7 August 1909),[166] which Kandinsky heard at the January 1911 concert he attended in Munich, is an excellent example of Schoenberg's musical Expressionism at its most extreme. Its *ff* opening, at once highly dissonant and densely contrapuntal, culminates in a *fff* chord in bar 3 which contains eight different notes. This density, with which Schoenberg often presents his musical ideas, was perhaps as great a problem for early listeners to his music as his use of dissonance. Following bar 3's explosive chord, no less than three changes of tempo and character ('a little slower'—'much faster'—'much slower') lead to extremely lyrical contrasting material in bar 8 ('a little slower'). Such rapid and often unpredictable changes of character (tempo, texture and dynamics) are a hallmark of Schoenberg's second-period style and often lead to 'free association' forms which 'defeat the natural and expected phrase-motion with breaks in the continuity of thought and with abrupt confrontations and juxtapositions.'[167] Schoenberg himself later wrote that he learned at this period 'to link ideas together without the use of formal connectives, merely by juxtaposition.'[168]

In the rest of Op. 11, no. 3 recurrences of both the violent materials of the opening and the lyrical music of bars 8–10 are important in maintaining the work's coherence. Thus, one cannot completely agree with Webern's statement in a 1912 article that 'Schoenberg gives up motivic work' in this piece[169] though it is true that motives recur here in a much more varied form than in the first two pieces of Op. 11, which were finished somewhat earlier (on 19 and 22 February 1909).[170] Indeed, Schoenberg and his disciples soon found that 'athematic' writing was more problematical in practice than atonality:

As we gradually gave up tonality an idea occurred to us: 'We don't want to repeat, there must constantly be something new!' Obviously this doesn't work, it destroys comprehensibility. At least it's impossible to write long

181

stretches of music in that way. Only after the formation of the Law did it again become possible to write longer pieces.[171]

On 14 July 1909, during the same summer when he composed Op. 11, no. 3, Schoenberg wrote to Richard Strauss describing the score of the orchestral pieces which he was writing (later to be published as Five Orchestral Pieces, Op. 16):

> I expect a great deal from it, especially as regards sound and mood. For it is these that the pieces are about—certainly not symphonic, they are the absolute opposite of this, there is no architecture and no build-up. Just a colorful, uninterrupted variation of colors, rhythms, and moods.[172]

This statement gives some idea of the composer's esthetic stance during the 1909–11 period. In its renunciation of 'architecture,' it is consistent with what Schoenberg writes to Kandinsky in his letter of 24 January 1911, concerning 'the elimination of the conscious will in art' (see above, p. 23) and with the strong position that Schoenberg takes against 'construction,' thus contradicting Kandinsky (see Kandinsky's letters of 18 and 26 January 1911 and 22 August 1912, and Schoenberg's letter of 19 August 1912, as well as the letter quoted above). A part of the great importance of the Schoenberg–Kandinsky correspondence is that it challenges the widely held view that Schoenberg was a 'cerebral' composer. On the contrary, the letters, together with many passages from the *Theory of Harmony* and the essay 'Problems in Teaching Art' (both 1911)[173] show that Schoenberg consistently maintained an Expressionist position in favor of emotion, spontaneity and the suppression of formalism and technique during this period.

Like Op. 11, no. 3, the opening section of the first of the orchestra pieces (entitled 'Vorgefühle' ['Premonitions']) incorporates multiple changes of affect (indicated by tempo, dynamics, instrumentation) which are in themselves a potent symbol of the title's *Angst*. The piece is more clearly thematic than Op. 11, no. 3, since it is based on a three-note motive (the cellos' $e'-f'-a'$) which is developed in inversion and retrograde in a primitive, rather free (and perhaps still unconscious) anticipation of Schoenberg's later serialism.

In the longer second section, the basic motive is developed toward two shattering climaxes over two ostinati, one of which, a pedal chord, is the inversion of the motive itself in vertical form; the other is a melodic variant of the motive. (Ostinato is very frequently used by Schoenberg at this period, perhaps partly to help maintain musical continuity in the unsettled context of free atonality, but also, as in this case, to build excitement, or, alternatively, to

symbolize motionlessness, rest or death.) 'Vorgefühle' ends with the kind of gesture toward open form which is characteristic of Schoenberg's free atonal music: there is no cadence, but both ostinati suddenly and unexpectedly break off, *f* and *ff*.

The second piece, 'Vergangenes' ('The Past') exemplifies Schoenberg's lyric gifts, both in its long-lined, arching opening melody and in its second theme (bars 151 ff), characterized by Webern as 'unendlich zart' ('infinitely tender').[174] This theme is presented in the solistic, highly differentiated orchestration typical of Schoenberg at this period. The theme's multiple, intertwined statements at subtly differing speeds produce an unforgettably dreamlike effect.

To the third piece, Schoenberg later gave the title 'Summer Morning by a Lake,' with the subtitle 'Colors,' proving that Impressionism (not, however, specifically French) coexists along with the predominant Expressionism of his free atonal period. By means of reorchestrations of a slowly changing chord (which are intended to occur imperceptibly), Schoenberg's concept of *Klangfarbenmelodie* ('melody of sound colors') is given material realization.[175]

The stasis of the third piece is contradicted in the fourth, entitled 'Peripetie' ('Peripeteia,' the Greek term for a sudden reversal of circumstances). Like Op. 11, no. 3, 'Peripetie' is based on the repeated, highly dramatic juxtaposition of violent and lyrical sections, though the piece is considerably longer and thematically more worked out.

The last of the five pieces, 'Das obligate Rezitativ' ('The Obbligato Recitative') is characterized by an 'endless melody' which constantly flows from one instrument to another, thus providing another realization of Schoenberg's *Klangfarbenmelodie* concept. In 3/8 time, this piece summons up rhythmic patterns typical of the Viennese waltz. The composer's 1912 diary tells us that here he used 'free form in order to express the inexpressible,'[176] thus providing an early glimpse of the longing for transcendence which became increasingly characteristic of him.

For his next work, the monodrama *Erwartung* ('Expectation') Schoenberg asked for a text from his younger acquaintance, the medical student and poet Marie Pappenheim. If there had been a certain inherent conflict between Stefan George's highly formalized poems and Schoenberg's settings of them in *Das Buch der hängenden Gärten*, Pappenheim was able to provide a libretto for Schoenberg's first stage work which suited his musical style perfectly. The ever-changing thoughts and emotions of the opera's single character, the Woman, as she searches the woods at night for her lover, are expressed in a stream-of-consciousness monolog which often consists of fragmentary and disconnected phrases. Pappenheim's libretto reflects the knowledge of psychology and psychoanalysis which she had gained as a medical student in

the Vienna of Sigmund Freud (her relative, Bertha Pappenheim, was in fact the original of Freud's case-history 'Anna O.'),[177] and *Erwartung* was powerfully influenced by Freud's explorations of the unconscious.

The extreme speed with which Schoenberg wrote the music of *Erwartung* (27 August–4 October 1909, including both sketch and full score)[178] suggests that his approach was quite spontaneous. As in the first and fourth of the Five Orchestral Pieces, sudden changes of musical texture are frequent, often alternating between lyricism and unexpected outbreaks portraying the Woman's returning anxiety. Much free association occurs in both text and music, and certain key words, such as 'night,' 'moon,' and 'blood,' are treated as musical symbols by Schoenberg.[179] In spite of the composer's theoretical statement in the *Theory of Harmony* that art, 'on its highest level [. . .] concerns itself exclusively with inner nature,'[180] outer nature is in fact also reflected impressionistically in *Erwartung* in frequent instances. Even the text's brief mention of 'the crickets, with their love-song' (bars 17–18) motivates a short-lived rhythmic ostinato in celesta and tremolo strings.

Though *Erwartung* is perhaps the work which most fully embodies Schoenberg's Expressionism, it is also the work whose form and technical structure have proved the most difficult to analyze, although large-scale articulations are clearly provided by the work's six major climaxes.[181] Webern, in his 1912 article, writes of the 'giving-up of all thematic work' in *Erwartung*,[182] and describes the work in the following terms:

> the score of this monodrama is an unheard-of-event. In it, all traditional form is broken with; something new always follows according to the rapid change of expression. The same is true of the instrumentation: an uninterrupted succession of sounds never before heard. There is no bar of this score which fails to show a completely new sound-picture [. . .] And so this music flows onward [. . .] giving expression to the most hidden and slightest impulses of the emotions.[183]

Certain more recent writers have found large-scale motivic coherence in the work,[184] while others, like George Perle, see it as '"perpetual variation", [. . .] wherein the thread of continuity is generated by momentary associations. Microcosmic elements are transposed, internally reordered, temporally or spatially contracted, and otherwise revised, in a fluctuating context that constantly transforms the unifying motive itself.'[185] Charles Rosen, in his valuable discussion of *Erwartung*, takes a position between these two extremes: motivic shapes do recur, but are intended to be recognizable only within very short spans of approximately thirty seconds.[186]

During the following two years, Schoenberg composed two works which are the most aphoristic in his entire output: Three Pieces for Chamber

Orchestra (1910; the third piece is unfinished) and Six Little Piano Pieces, Op. 19 (1911). These works come the closest to a realization of the ideal of non-repetition (see the Webern quotation above, p. 181). We must assume that Schoenberg found both extreme brevity and non-repetition to be unsatisfactory to his expressive needs, since he never again returned to the aphoristic style.

Since Schoenberg's following works (*Die glückliche Hand* and *Pierrot Lunaire*) show a partial return to closed forms, recognizable thematic development and strict contrapuntal techniques, the works of the 1909–11 period which have been discussed present a rather well-defined stylistic phase. The response to emotional impulses–mirrored in multiple, frequent changes of musical texture—is a key element in all of Schoenberg's music at this period. Other important characteristics are asymmetrical melody (often including wide and jagged intervals), the avoidance of tonal references, the structural use of ostinato and the tendency toward athematic writing (which, like Kandinsky's elimination of objective references in painting, was not completely carried out in this period). Formal devices like repetition and sectionalism are indeed present, but are often not clearly recognizable, for this would be in conflict with the 'spiritual attitude of Expressionism,' which is 'to a large extent an adventure into the subconscious.'[187]

In his article for the *Blaue Reiter*, 'The Relationship to the Text' (1912), Schoenberg makes a statement which seems to be in conflict with his highly differentiated response to the details of the text in works like *Das Buch der hängenden Gärten* and *Erwartung*:

> intoxicated by the first words of the text, I had composed many of my songs straight through to the end without troubling myself in the slightest about the continuation of the poetic events, without even grasping them in the ecstasy of composing, and [. . .] only days later I thought of looking back to see just what was the real poetic content of my song. It turned out, to my greatest astonishment, that I had never done greater justice to the poet than when, guided by my first direct contact with the sound at the beginning, I had divined everything that obviously had to follow this first sound with inevitability.[188]

This passage, like the one from Schoenberg's 24 January 1911 letter to Kandinsky concerning 'the elimination of the conscious will in art,' is best understood as a consequence of the composer's extreme Expressionist stance during this period: the emphasis on the composer's inner emotions is so strong that there is no room left either for impressions of nature or for the emotions of others present in the text. Schoenberg later admitted, however, that his turn away from music as expression of the text was largely theoretical:

185

'in my essay "The Relationship to the Text" in *Der blaue Reiter*, 1912, I was perhaps the first to turn away from expressive music—theoretically, for the time being—very soon after my first steps in a new territory where I had still been using expression to its fullest extent, even if unconsciously.'[189] In an article written toward the end of his life, Schoenberg was even more specific in acknowledging the decisive influence of the text upon the works of his Expressionist period:

> A little later [i.e. after 1908] I discovered how to construct larger forms by following a text or a poem. The differences in size and shape of its parts and the change in character and mood were mirrored in the shape and size of the composition, in its dynamics and tempo, figuration and accentuation, instrumentation and orchestration. Thus the parts were differentiated as clearly as they had formerly been by the tonal and structural functions of harmony.[190]

The conflict between the expression of inner emotions and of those present in the text is only one of many present in Schoenberg's music as a whole: the composer's strong will to communicate vies with the complexity of his style, which hinders communication; love of tradition struggles with radical innovation; and, most of all, strong emotional intuition competes with a bent towards intellectual constructivism. In the works written between 1909 and 1911, this final, most crucial conflict is largely resolved in favor of intuition and Schoenberg is able to venture into his own creative subconscious in order to produce a series of works which must be ranked among his finest—works which are in fact unequalled in freedom, audacity and the sensitivity with which the human psyche is expressed in sound.

NOTES

Full bibliographical details are given only for those works
not listed in the Select Bibliography.

THE SCHOENBERG-KANDINSKY CORRESPONDENCE

1 The reference is to the advance publication of 'On Parallel Octaves and Fifths'
 from Schoenberg's *Theory of Harmony* in *Die Musik,* October 1910, pp. 97–105.

2 VLADIMIR ALEKSEEVICH IZDEBSKII (b. Kiev, 1882—d. New York, 1965),
 Russian sculptor and organizer of important exhibitions; studied sculpture first
 in Odessa, and from 1903 on with Wilhelm von Rümann at the Academy of Art
 in Munich. Here he met Kandinsky; that they were already acquainted from
 Odessa, where Kandinsky lived until 1885 with his family, and also visited
 frequently later, is possible, but not certain. In 1905 Izdebskii fought against the
 pogroms and was for that reason exiled from the country in 1907, following a
 prison term. He went to Paris and continued his studies at the École des Beaux
 Arts. From 1909 on he was again in Odessa and in December organized an
 international exhibition, with almost 800 works by Russian painters, including
 those living in Munich, such as Kandinsky, Jawlensky and Werefkin; in addition
 works by Balla, Gleizes, Matisse, Rousseau, Kubin, Münter and many other
 Western Europeans. After Odessa the exhibition was also shown in Kiev and St
 Petersburg. In his second exhibition (1910–11), out of 440 pictures shown, 53
 were by Kandinsky, again along with those of his colleagues from the Neue
 Künstlervereinigung of Munich, as were works of the younger Russian avant-
 garde—the brothers D. and V. Burlyuk, M. Larionov, N. Goncharova, V. Tatlin,
 A. Ekster and others. Kandinsky asked Schoenberg, immediately after he had
 received from him an album with photographs of his pictures, if he did not also
 wish to send some pictures to the exhibition (see letter of 6 February 1911). This
 did not take place, but Schoenberg's advance excerpt from the *Theory of Harmony*
 'On Parallel Octaves and Fifths,' was printed in the exhibition's catalog at
 Kandinsky's request (see p. 129 of this book). As Kandinsky writes further in his
 letter to Schoenberg, the catalog contains numerous interesting articles:
 'Content and Form' by Kandinsky, 'The City of the Future' by V. Izdebskii,
 aphorisms on art by Nikolai Kul'bin, 'Harmony in Painting and Music,' a very
 detailed comparative study by Henri Rovel, 'On the Philosophy of Con-
 temporary Art' by A. Grinbaum, a poem by Leonid Grossman and more. In its
 claim to go beyond the specialized questions of pictorial art, this catalog could
 have been a stimulus toward the *Blaue Reiter* almanac for Kandinsky. Like
 Kandinsky and Schoenberg, Izdebskii was also interested in theater problems;
 from 1911 to 1913 he even appeared as an actor. From 1913 he lived again in Paris,

from 1918 in St Petersburg, from 1920 in Paris and from 1941 on in New York, where he worked as a sculptor until his death in 1965.

3 *Über das Geistige in der Kunst* ('On the Spiritual in Art'), published by Piper Verlag, Munich, at the end of 1911 (but dated 1912).

4 GABRIELE MÜNTER (b. Berlin, 1877—d. Murnau, 1962), German painter, from 1902 on student at Kandinsky's painting school Phalanx in Munich. From 1904 to 1914 Kandinsky's companion. In the first years they traveled frequently; in 1909, in addition to their joint residence in Munich, they bought a house in Murnau, where they lived mostly in the summer. After her separation from Kandinsky, Münter lived in Sweden and Denmark; from 1932 to her death (1962) she lived once again in the house in Murnau.

5 FRANZ MARC (b. Munich, 1880—killed in action near Verdun, 1916), German painter and graphic artist. After initially studying philosophy and theology, he attended the Munich Academy of Art and became a painter. After seeing the second exhibition of the Neue Künstlervereinigung of Munich in September 1910, he joined it on 6 February 1911 and soon made friends with Kandinsky. At the end of 1911 he procured the publication of Kandinsky's principal theoretical work, *On the Spiritual in Art*, by the publisher Reinhard Piper. Marc resigned from the Neue Künstlervereinigung out of solidarity with Kandinsky and, together with him, organized the Blaue Reiter exhibitions, and the almanac of the same name that was published (also by Piper) in 1912.

6 Schoenberg had very probably sent Kandinsky two copies of the number of the Viennese periodical *Der Merker* mainly devoted to him (*Der Merker: Österreichische Zeitschrift für Musik und Theater*, ed. R. Batka and R. Specht, vol. II, no. 17, June 1911). It contains, along with two musical supplements, reproductions of seven of his pictures (two portraits, one landscape, the self-portrait from behind, and three 'fantasies and visions'), the first printing of the text of *Die glückliche Hand*, an advance excerpt from the *Theory of Harmony* ('Esthetic Evaluation of Sounds with Six or More Tones'), as well as essays on Schoenberg by Karl Linke, Paul Stefan, the periodical's editor Richard Specht, and Rudolf Réti.

7 With this remark of September 1911, 'I will not visit Strauss this time,' the question in H. H. Stuckenschmidt's Schoenberg biography (*Arnold Schoenberg: His Life, World and Work*, p. 72) is answered, as to whether Schoenberg followed Strauss's invitation to visit him in Garmisch between 2 and 6 September. Richard Strauss, (b. Munich, 1864—d. Garmisch, 1949), 'progressive' composer of tone poems and operas, among them *Salome* and *Elektra*, became acquainted with the young Schoenberg around 1901, during his first stay in Berlin, and obtained a scholarship and a teaching position at the Stern Conservatory for him. Schoenberg is also indebted to him for the stimulus to his 1903 symphonic poem *Pelleas und Melisande*, Op. 5, based on the drama by Maurice Maeterlinck. In his *Theory of Harmony*, Schoenberg still names Strauss the most frequently, along with Mahler, as a 'great master of our time;' but on Strauss's side the relationship began to deteriorate markedly from 1909 (paralleling Schoenberg's elimination of tonality). He refused to conduct the Five Orchestral Pieces, Op. 16 (1909), finding them too daring, and would not accept Schoenberg's explanation that it was only a question of sound and mood, absolutely not symphonic, in fact the exact opposite, no architecture, no structure, nothing but eternally changing, uninterrupted successions of moods; '*his* [Schoenberg's]*music more*

and more approaches the principles of modern painting!' Strauss is later said to have remarked about Schoenberg that he could now only be helped by psychiatric means, and that he would be better employed shovelling snow rather than filling up sheets of music paper with scribbling. Alma Mahler secretly informed Schoenberg of this remark, and thereby destroyed once and for all the relationship between the two composers.

8 MARIA MARC, wife of Franz Marc (see note 5). AUGUST MACKE (b. Meschede/ Ruhr, 1887—killed in action, 1914), painter friend of Marc and Kandinsky, collaborator on the *Blaue Reiter*. ELISABETH MACKE, his wife.

9 The article from the *Pocketbook* was probably 'Probleme des Kunstunterrichts' ('Problems in Teaching Art'), *Musikalisches Taschenbuch, illustrierter Kalender für Musikstudierende*, vol. II (Vienna: Stern & Steiner, 1911), pp. 22–27 (see illus., p. 33). English trans. in A. Schoenberg, *Style and Idea*, ed. Leonard Stein, p. 365.

10 OSKAR KOKOSCHKA (b. Pöchlarn, 1886—d. Villeneuve, 1980), one of the founders of Expressionism in painting and dramatic art. Lived first in Vienna, where his pictures and the performances of his plays caused scandals from 1907 on. Schoenberg valued him highly (see p. 101 of this book, and the entry in his Berlin diaries for 2 February 1912: 'Kokoschka is genuine'—Arnold Schoenberg, *Berliner Tagebuch*, ed. Josef Rufer, p. 15).

11 ALBAN BERG (b. Vienna, 1885—d. there, 1935), Austrian composer, Schoenberg's pupil from 1904 to 1910 and one of his most faithful friends. He organized and edited the Festschrift *Arnold Schönberg* in 1912. Along with Schoenberg, Berg is considered the most significant representative of atonal and twelve-tone music. His best-known works are the operas *Wozzeck* (1921) and *Lulu*, dedicated to Schoenberg (left unfinished at Berg's death in 1935). See further W. Reich, *The Life and Work of Alban Berg*, trans. Cornelius Cardew (London: Thames & Hudson, 1965/New York: Vienna House, 1971).

12 ARNOLD ROSÉ (b. Jassy, Rumania, 1863—d. London, 1946) was from 1881 on for fifty-seven years leader of the Vienna Philharmonic, founded the quartet bearing his name in 1883, and sided consistently with contemporary music, particularly that of Schoenberg who liked to work with him. Thus Rosé played his string quartets on 12 October 1910, at the Heller art gallery, on the occasion of the first exhibition of Schoenberg's pictures (see P. Stefan, 'Schoenberg-Abend,' *Der Merker*, vol. II, no. 2, 1910, p. 79), and he had already played in the premiere of the Second String Quartet, Op. 10, in Vienna, and at the Schoenberg concert which Kandinsky heard in Munich in January 1911. How highly Schoenberg valued Rosé's accurate, polished interpretations is clear from his letters to him (Pierpont Morgan Library, New York).

13 This letter has already been printed in J. Rufer, *The Works of Arnold Schoenberg*, trans. Dika Newlin, p. 185. Rufer could not decipher the name 'Le Fauconnier,' and wrote 'Le Fanesmil [?].' The French painter LE FAUCONNIER (1881–1946) had exhibited, together with Kandinsky, with Izdebskii in Odessa in 1910 (see note 2). From that time on, Kandinsky stood in a friendly, collegial relationship to him, inviting him, for example, to the second exhibition of the Neue Künstlervereinigung in Munich, and having him write one of the introductions in the catalog. In the preparatory work for the *Blaue Reiter* almanac he made him the representative for France, as is clear from Le Fauconnier's letters to Kandinsky (Kandinsky Legacy, G. Münter and J. Eichner Bequest, Munich). Literature: J. Romains, *Le Fauconnier*, (Paris: Seheur, 1927); exhibition catalog *Le*

Fauconnier (Antwerp: Koninklijke Academie voor Schone Kunsten, 1959).

14 The planned article by the Russian musicologist Nadežda Brjusova (Brüssowa), 'Musicology, its Historic Path and Present State,' was finally not accepted by the *Blaue Reiter*. A galley proof and the translation into German by Thomas von Hartmann (see note 24) are to be found in Kandinsky's Legacy (G. Münter and J. Eichner Bequest, Munich).

15 The exhibition catalog of the Neue Secession Berlin e. V., 4th Exhibition, Paintings (17 November 1911—31 January 1912) names four paintings by Kandinsky: 'Composition IV' (see p. 206 of this book), 'Nude,' 'Romantic Landscape' (p. 208 of this book) and 'Improvisation No. 18.'

16 A short, unsigned review appeared on p. 3 of the newspaper *Münchener Neueste Nachrichten* on 12 December 1911, concerning a concert of works by Schoenberg, Mandl and Sekles: 'An evening of new works by the excellent Rebner Quartet brought to Leipzigers the D minor String Quartet, Op. 4 [Op. 7 is meant; Op. 4 is the String Sextet, *Verklärte Nacht*], by the controversial 'Young-Viennese' Arnold Schoenberg. Schoenberg's work excited the greatest interest by its extremely daring harmony and counterpoint, combined with beauty of sound, although this overflowing fantasy in one movement lasts for more than half an hour without interruption.'

17 EMIL NOLDE (= E. Hansen, b. in the Tondern district, 1867—d. Seebüll, 1956; both in North Schleswig), German Expressionist painter, known for his strongly colored watercolors and oil paintings. Studied 1899 with A. Hölzel in Dachau near Munich; 1906/7 member of Die Brücke; in 1910 co-founder of the Neue Secession Berlin. After 1918 lived alternatively in Berlin and Seebüll. Forbidden to paint after 1933. Literature: Emil Nolde, *Das eigene Leben* (Berlin: Rembrandt, 1931); *Jahre der Kämpfe* (Berlin: Rembrandt, 1934); *Briefe aus den Jahren 1894–1926*, ed. M. Sauerlandt (Berlin: Furche-Kunstverlag, 1927).

18 BOHUMIL KUBIŠTA (b. Vlčkovice, 1884—d. Prague, 1918), Czech painter and graphic artist, at first influenced by Impressionism, studied Munch and Cézanne, worked in a cubist and futuristic style. Was prominent also as a theorist and driving force among Prague artists. Literature: F. Kubišta, *Bohumil Kubišta,* (Brno: Kubišta, 1940); Hlaváček, *Životni Drama Bohumil Kubišta* (Prague: Mladá Fronta, 1968).

19 Doubtless Picasso, who produced a whole series of circus pictures in 1905 (for example, 'The Mountebanks' and 'Harlequin with Family'). He was still fond of using this motif later as well.

20 ALBERT PARIS VON GÜTERSLOH (= Albert Konrad Kiehtreiber, b. Vienna, 1887—d. Bad Ischl, 1973), Austrian writer and painter, previously an actor (with Reinhardt in Berlin, among others). In January 1912 he arranged for twenty-three of Schoenberg's pictures to be sent to an exhibition in Budapest, where pictures by Schiele, Kolig and Faistauer were also shown. Gütersloh wrote an essay for the Festschrift *Arnold Schönberg*, ed. Alban Berg *et al.* Literature: *Albert Paris von Gütersloh zum 75. Geburtstag. Autor und Werk* (Munich: Piper, 1962); Albertina catalogue: A. P. Gütersloh, ed. H. Hutter (Vienna, 1970) (with extensive bibliography).

21 ADOLF LOOS (b. Brno, 1870—d. Vienna, 1933), important Austrian architect in the transition from the *Jugendstil* to the International Style; belonged to the Viennese avant-garde, was a friend of Karl Kraus and Oskar Kokoschka. With his renunciation of decorative accessories used to conceal construction (article

'Ornament und Verbrechen,' 1908), he was close to the points of view of Kandinsky and Schoenberg. He met Schoenberg in 1895, and was his friend from about 1905 until his death in 1933. Schoenberg wrote an article for the Festschrift for Loos's sixtieth birthday. Literature: Franz Glück, 'Briefe von A. Schönberg an A. Loos,' *Österreichische Musikzeitschrift*, vol. XVI, no. 1, January 1961, pp. 8–20; A. Loos, *Sämtliche Schriften*, ed. F. Glück (Vienna/Munich: Herold,1962), Vol. I.

22 Kandinsky meant the second exhibition (1912) of the *Bubnovjy valet* ('Knave of Diamonds') in Moscow, one of the most important international exhibitions of the Russian avant-garde.

23 HEINRICH THANNHAUSER, Munich art dealer and gallery owner. In his Moderne Galerie on Theatinerstrasse the first exhibition of the Neue Künstlervereinigung of Munich took place in December 1909, the second in September 1910 and, in December 1911 and January 1912, the first Blaue Reiter exhibition.

24 THOMAS VON HARTMANN (b. Choruževka, Ukraine, 1885—d. Princeton, 1956), Russian composer, studied with Taneiev and Arensky, graduated from the Moscow Conservatory, and attained early fame as composer of the ballet *The Purple Flower* at the Court Theater in St Petersburg. From 1908 he studied with Felix Mottl in Munich; there he met Kandinsky, made friends with him, and experimented along with him from 1908 until 1911/12 on the *Bühnengesamtkunstwerk* ('total work of art for the stage'). He composed the music to Kandinsky's stage work *Der gelbe Klang*. His spiritual closeness to Kandinsky, and indeed his partial dependence on him, is evident from his article on anarchy in music in the *Blaue Reiter*. In particular, they shared mystical and theosophical interests, in which Hartmann went much further and attached himself for his entire life to the strict Sufi sect of the Armenian Gurdjieff. This may have hindered his career as a composer, for in the community for working and living (from 1922 on in Fontainebleau near Paris) one had to devote oneself primarily to concentration and bodily exercises, handicrafts and horticulture, and in order to earn money for the community he wrote film music under a pseudonym (see Thomas von Hartmann, *Our Life with Mr Gurdjieff*, Baltimore: Penguin, 1964). In 1919 Hartmann became director of the conservatory at Tiflis; from 1922 he lived near Paris, and was close to Kandinsky until his death in 1944. In 1950 he moved to New York and died in 1956 in Princeton. As a composer of chamber music, symphonies, operas and ballets (published by Boosey & Hawkes: London, New York and Paris) he became only moderately known.

25 ARS: a progressive art alliance founded in spring 1911 in St Petersburg, consisting of eight independent sections (Music, led by A. Drozdov; Painting and Sculpture, under N. Kul'bin; Stage, under Evreinov; Choreography, under Fokine, etc.) with the aim of a rapprochement and ultimately a synthesis of the arts. Since this alliance scarcely got beyond the beginning stage, it is mentioned nowhere in the scholarly literature. Knowledge of it comes from the unpublished writings of Kul'bin. On 10 October 1911 Kul'bin wrote to Kandinsky that the musicians suggested by him (primarily Schoenberg) were invited to become members of ARS and that he had informed Drozdov and Karatygin.

26 SERGEI ALEXANDROVICH KOUSSEVITSKY (b. Tver, 1874—d. Boston, 1951), Russian conductor, music publisher and composer. From 1905 on he settled in

Berlin, where he founded a Russian music publishing house in 1909. He acquired the rights for Scriabin, then Stravinsky, Prokofiev and Rachmaninov. From 1909 on he lived again in Moscow and founded the orchestra bearing his name, with which he gave, for example, the first performance of Scriabin's *Prometheus*. He left Russia in 1921 and later lived in Boston, where he became the conductor of the Boston Symphony Orchestra.

27 FERRUCCIO BUSONI (b. Empoli, Florence, 1866—d. Berlin, 1924), Italian composer and pianist; 1907/8 director of a master class in piano at the Vienna Conservatory. 1920 to 1922 head of one of the three master classes for composition at the Academy of Arts in Berlin, which was taken over by Schoenberg in 1925. The work of Busoni's which is mentioned is the book *Entwurf einer neuen Ästhetik der Tonkunst* (repr. with Schoenberg's annotations, Frankfurt; Suhrkamp, 1974. English translation by T. Baker, *Sketch of a New Esthetic of Music* (New York: Schirmer, 1911)). Busoni's 'Selbstrezension' ('Self-critique') appeared in the periodical *Pan*, vol. II, 1 February 1912, pp. 327 ff. Cf. Jutta Theurich, 'Der Briefwechsel zwischen Arnold Schönberg und Ferruccio Busoni,' p. 55.

28 REINHARD PIPER (b. Penzlin, 1879—d. Munich, 1953), founder of the publishing house of Piper & Co., Munich. At the end of 1911 he printed Kandinsky's *On the Spiritual in Art*, in 1912 the almanac *Der blaue Reiter* and the omnibus volume *Arnold Schönberg*, and in 1913 Kandinsky's volume of prose poems, *Klänge*.

29 The date is illegible, but in all probability the telegram was sent to Prague on 29 February 1912, where Schoenberg, in addition to Mozart's G minor symphony and a Bach–Mahler suite, was conducting his *Pelleas und Melisande*. As Alban Berg writes to Kandinsky on 19 February 1912, Schoenberg was to be surprised on this occasion with his Festschrift; could not Kandinsky also come? 'I know that Schoenberg would be overjoyed if you came' (letter in the G. Münter and J. Eichner Bequest, Munich). On 25 February Kandinsky answers that he wishes to send his congratulations by telegraph and asks Berg for Schoenberg's address in Prague (letter in the Berg Legacy, Music Collection of the National Library, Vienna).

30 On Saturday 2 March 1912, a short report appeared in the *Münchener Neueste Nachrichten* under the heading 'Theater and Music,' p. 3: 'As a telegram from our correspondent reports, Arnold Schoenberg's symphonic poem *Pelleas und Melisande* had extraordinary success in Prague. The composer was often called back to the stage. A few hisses were smothered by tumultuous applause.'

31 HERWARTH WALDEN (= Georg Lewin, b. Berlin, 1878—d. in a Stalinist prison in Russia, 1941), musician, writer, but above all the gifted and courageous promoter of young, unofficial, forward-looking art, literature and theater. In 1910 he created with his periodical *Der Sturm* (from 1912 on also an art gallery) a forum for the new movement (the Expressionists, Italian and Russian Futurists, and others). Several undated letters from Schoenberg to Walden are to be found in the Preussische Staatsbibliothek in Berlin, also numerous letters from Kandinsky, whose pictures were exhibited at the Sturm, and whose album *Kandinsky 1910–1913*, along with 'Rückblicke' ('Reminiscences'), were published by Sturm-Verlag in 1913.

32 The then well-known Berlin journalist and music critic Leopold Schmidt (1860–1927) published a review of Schoenberg's 4 February concert in the *Berliner*

Tagblatt, vol. XLI, no. 67, 6 February 1912, evening edition, p. 1, under the title 'Der Wert des Unmodernen' ('The Value of the Unmodern'). He begins by speaking of the overestimation of new music which has become customary and says that there should also be concerts which one would not only have to judge, but could also enjoy, such as, for example, a recent performance of Romantic music. 'The pleasurable atmosphere of this, if you will, reactionary concert, could only be rightly appreciated by one who does not neglect to seek out the newer and the newest and, in so far as possible, to come to terms with them. To be sure, he sometimes comes up against manifestations which make agreement impossible even for the most patient and goodwilled. Arnold Schoenberg has already proved that he is a gifted, a very gifted, musician; but his tendency is more and more to follow strange paths. There is an originality that is very cheap. On Sunday morning a small group of people, here and there smiling, sat in the Harmoniumsaal and listened while Egon Petri tapped around on the piano, and Frau Winternitz-Dorda, in a kind of psalmodic tone, dreamed aloud to herself alleged 'songs' (on texts by Stefan George, Maeterlinck and others). One like the other. We do not mean to speak here of the ruthless daring of the sound combinations. The most audacious harmony would not bother me, if it expressed anything at all. But until now I have never heard anything so boring and lacking in invention. One does not need to fight against this music; it will destroy itself.' Schoenberg answered on 22 February 1912, with an equally sharp counter-criticism, 'Schlafwandler' ('Sleepwalkers') in the Berlin weekly *Pan* (ed. P. Cassirer; vol. II, no. 14, p. 432), and in no. 15 of the same journal (29 February 1912, p. 460) 'Der Musikkritiker.' For further detail on this quarrel see *Pan,* vol. II, no. 16 (9 March 1912), p. 489, and Arnold Schoenberg, *Berliner Tagebuch,* p. 21.

33 Schoenberg's tone poem based on Maeterlinck's drama *Pelleas und Melisande* was performed in Berlin in October 1910, at the Gesellschaft für Musikfreunde. On this occasion Herwarth Walden (see note 31), under the pseudonym 'Trust,' published the following sarcastic commentary in his periodical *Der Sturm,* no. 37, 10 October 1910, p. 295, which Schoenberg condemns as a 'coarse review': 'Arnold Schoenberg—not only "geniuses" come from Vienna. Arnold Schoenberg is boundlessly overestimated there. A good musician, no artist. (He lacks the ability to create, he is no personality, but rather an homunculus out of Wagner, Mahler and Debussy. His parentage can be traced limb by limb. His symphony has nothing to do with *Pelleas und Melisande.* Music without structure, pasted-together, picturesque Baroque.) The press behaved helplessly. Some rejoiced. Those who do not want to "misunderstand." Others fumed about "disharmonies." Therefore about the *purely* musical, in which Schoenberg is above the average. Laymen and critics continually confuse handicraft and art. (Have even created "Art in Handicraft.") To make it completely clear: the perfect craftsman will never become an artist. In him the manual, even in intellectual matters, is a presupposition. Art cannot be "understood" and explained. He who does not carry it within him will never understand it. So: hands off!' (I wish to thank Eva Ziesche of the Staatsbibliothek Preussischer Kulturbesitz, Berlin, for this reference.)

34 GUSTAV MAHLER (b. Kalischt, Czechoslovakia, 1860—d. Vienna, 1911), Austrian composer and conductor. Schoenberg met him through Arnold Rosé (see note 12), who was married to Mahler's sister. In the Prague speech which is mentioned (printed in Schoenberg's *Style and Idea,* p. 449), Schoenberg referred

to Mahler as one of the greatest men and artists. Mahler, in his turn, esteemed Schoenberg; see the undated letter of recommendation (1910) printed in the catalog *Arnold Schönberg Gedenkausstellung 1974*, ed. Ernst Hilmar, p. 224.

35 FRANZ STADLER (1877—1959), art historian and professor at the University of Zürich for many decades. We owe this information to the anonymous reviewer of this book (German edition) in the *Neue Zürcher Zeitung* of 25 September 1980.

36 JOSEPH AUGUST LUX (1871—1947), a writer and journalist who was born in Vienna and later lived in Munich; wrote novels, travel guides, books on art and, from the 1920s on, on music as well. Kandinsky later became disappointed in Lux; on 3 February 1914, he wrote to Walden that he wished to have no more to do with him (Staatsbibliothek Preussischer Kulturbesitz).

37 HANS GOLTZ, proprietor of a Munich art gallery with publishing house and exhibition rooms; in March 1912 put on the second exhibition of the Blaue Reiter.

38 Festschrift volume *Arnold Schönberg*, ed. A. Berg *et al*.

39 Schoenberg finally changed the order of the names.

40 J. A. LUX (see note 36). Which of his books Kandinsky sent to Schoenberg can only be guessed at; out of those which appeared before 1912 the following would be possible: *The Political Economy of Talent: Fundamentals of a Political Economy of Art* (1906); *Taste in Everyday Life* (1908); *The New Arts and Crafts* (1908). Less likely would be *The Art of Amateur Photography* (1910), or the edifying work *The Will to Happiness* (1909).

41 ALEXANDER SCRIABIN (b. Moscow, 1872—d. there, 1915), Russian composer and virtuoso pianist. At the same time as Kandinsky and Schoenberg he was working on a *Gesamtkunstwerk;* the beginning of it was a *Prometheus* Symphony with chorus and color organ (1909—10); his 'Mysteries,' planned later, were to incorporate, along with music and the other arts, the rustling of trees, sunrises and sunsets, aromas, etc., as well, and last several days. Nothing of this was realized. Kandinsky was interested in Scriabin and printed an article by his biographer Leonid Sabaneiev in the *Blaue Reiter*.

42 'Vosstante' ('Voss-auntie') was a frequently-used nickname for the *Vossische Zeitung*, 'Royally Privileged Berlin Newspaper for State and Scholarly Matters.'

43 FRANZ SCHREKER (b. Monaco, 1878—d. Berlin, 1934), Austrian composer; from 1912 on composition teacher at the Academy of Music in Vienna, where, for instance, he performed Schoenberg's *Gurre-Lieder* with great success. The first performance of the opera *Der ferne Klang* ('The Distant Sound'), written to his own libretto, took place the same year. From 1920 on he was the director of the College of Music in Berlin and taught composition. On his relationship with Schoenberg, see *Arnold Schönberg/Franz Schreker, Briefwechsel* ed. F.C. Heller (Tutzing: Schneider, 1974).

44 VITĚZSLAV NOVÁK (b. Kamenice, 1870—d. Skuteč, 1949), Czech composer; in 1920 Rector of the Prague Conservatory.

45 Here a half sentence is missing, as the bottom edge of the page is torn off.

46 ALBERTINE ZEHME (1857—1946), Viennese actress, from 1893 on a singer, after she had had herself trained by Cosima Wagner in Bayreuth, and theorist: she wrote *Grundlagen des künstlerischen Sprechens und Singens* ['Basic Principles of Artistic Singing and Speaking'] (Leipzig: Carl Merseburger, 1920). Schoenberg met her in 1912, when she commissioned him to write *Pierrot Lunaire*. She was not only an excellent interpreter of his work, but also a kind of patron of Scoenberg. See further in H. H. Stuckenschmidt, *Arnold Schoenberg: His Life, World and Work*.

47 NICOLAI KUL'BIN (b. St Petersburg, 1868—d. there, 1941), medical officer and important personality in Russian artistic life around 1910, less as the painter of symbolistic-impressionistic pictures and striking portrait drawings, than as a theorist of art and music (on the synthesis of the arts, and, as early as 1909, half- and quarter-tones, and the direct effect on the human subconscious, not registered by the brain, of dissonances made by the putting together of closely adjacent tones of the scale). However, Kul'bin's principal merit was that, as an older friend, more established in society, of the 'Russian *Fauves*' (see D. Burlyuk's article in the *Blaue Reiter*), he championed the Cubofuturists; beginning with the omnibus volume *Studio impressionistov* ed. Nikolai Kul'bin (St Petersburg: 1909), and continuing through exhibitions, lectures, etc. Through this activity he met Kandinsky, and found basic points of contact with the latter's views on art. Kandinsky printed a condensed version of Kul'bin's article 'Freie Musik' ('Free Music') in the *Blaue Reiter*, and felt it was important that Kul'bin and Schoenberg should meet, as is apparent from his letters to Kul'bin. Schoenberg's trip to St Petersburg, when he conducted his symphonic poem *Pelleas und Melisande* on 21 December 1912, was thus initiated not only through Alexander Siloti (see Stuckenschmidt, *Schoenberg*, pp. 178 ff), but also through Kandinsky (see also note 25).

48 N. DOBYČINA, progressive Petersburg gallery-owner and publisher. In 1913 she planned a large exhibition of Kandinsky's work and the publication of his 'Reminiscences.' This did not take place; not until 1917 did she exhibit pictures by Kandinsky.

49 Schoenberg's article 'Problems in Teaching Art' had already appeared in *Musikalisches Taschenbuch*, vol. II (see note 9).

50 FRITZ SOOT (b. Wellersweiler, Saar, 1878—d. Berlin 1965), Court Singer (Heldentenor) and teacher of stagecraft. From 1908 on with the Dresden State Opera, after World War I in Stuttgart, and from 1921 to 1944 at the Berlin State Opera Unter den Linden. Appears in the *Deutsches Bühnenjahrbuch* from 1931 on, most extensively 1964, p. 81, and 1966, p. 122.

51 Felix Müller, better known by his *nom d'artiste* CONRAD FELIXMÜLLER (b. Dresden, 1897—d. Berlin, 1977). This astoundingly precocious graphic artist and painter (from 1909 on musical training, from 1911 on training in art), heard a performance of Schoenberg's *Pierrot Lunaire* in autumn 1912, in Dresden, which inspired him to ten expressive, reductive, two-dimensional woodcuts (Schoenberg Institute, Los Angeles); there also a handwritten covering letter, in which he mentions the war, and suggests that his woodcuts be sent to Else Lasker-Schüler; this shows that the letter was not written before autumn 1914. The *Pierrot Lunaire* woodcuts, which were produced in 1913, and the portrait of Schoenberg of 1914 (Exhibition catalog *Felixmüller*, Museum am Ostwall, Dortmund, 1978, p. 52), works by the 16- to 17-year old, show his knowledge of the Brücke painters, and foretell his future development to Expressionism, by way of E. Lasker-Schüler's *Hebräische Balladen* (Berlin: Meyer, 1914). At the age of 18 he had already finished at the Dresden Academy of Arts, became in the same year a collaborator of *Der Sturm*, from 1916 on of *Die Aktion*, from 1917 on of the Expressionistische Arbeitsgemeinschaft Dresden. In 1919 he founded the Dresden Secession and joined the German Communist Party. In 1933 his pictures were outlawed as 'degenerate.' In 1949 he obtained a professorship in Halle; in 1961 he moved to Berlin, where he died in 1977.

52 Kandinsky was a regular reader of the great Moscow musical weekly, edited by V.V. Derzanovsky. In 1913 he himself had an item printed in it.

53 The BAUHAUS, the school of architecture founded by Walter Gropius in Weimar in 1919, which attempted 'to unite all the applied arts in a new architecture,' but transcended in every respect a specialized school of architecture and developed into a distinguished intellectual center.' Instruction also included painting (Kandinsky taught there from 1922), theater arts (under O. Schlemmer), weaving (under G. Muche) and much more.

54 After the October Revolution, in the first, very experimental years until 1921, Kandinsky took an active part in Russian cultural politics as organizer, museum founder, teacher and theorist. (See J. Hahl-Koch, 'Kandinsky's Role in the Russian Avant-garde,' in the exhibition catalog *The Russian Avant-garde, 1910–1925,* Los Angeles County Museum, 1980.)

55 ALEXANDER SHENSHIN (b. Moscow, 1890—d. there, 1944), Russian composer, conductor, and museum lecturer. He initially studied philology, then took instruction in music from Grechaninov and Glière, and taught music theory at the People's Music School from 1919 to 1922, during the same period when Kandinsky worked in Moscow. Literature: V. Beljaev, *A. Šenšin* (Moscow, 1929) (in Russian and German).

56 During a summer stay in Mattsee, Schoenberg was given to understand that Jews were unwelcome there. For details, see the catalog of the 1974 Vienna *Gedenkausstellung,* p. 291, no. 336, and J. Rufer, 'Hommage à Schönberg,' in A. Schönberg, *Berliner Tagebuch,* pp. 54 ff.

57 Probably Louis Danz, who wrote the article 'Schoenberg the inevitable' in the Festschrift *Arnold Schoenberg,* ed. M. Armitage.

58 GALKA (actually EMMY) SCHEYER (b. Braunschweig, 1889—d. Los Angeles, 1941), art amateur and patron. She met Jawlensky in 1916 and was so impressed by his art that she gave up her own attempts, became his portrait model, and dedicated herself to the furthering of his art. From 1924 on she organized sales exhibitions for the *Blaue Vier* ('the Blue Four': Jawlensky, Kandinsky, Klee and Feininger) in the USA, and had some success in making them known. For further details, see the exhibition catalog *The Blue Four: Galka Scheyer Collection* (Pasadena: Norton Simon Museum of Art, 1976).

KANDINSKY AND SCHOENBERG, by Jelena Hahl-Koch

59 MARIANNE WEREFKIN (Marianna Verevkina; b. Tula, 1860—d. Ascona, 1938), Russian painter. Studied first in St Petersburg, moved to Munich in 1896 together with Jawlensky. In 1909, founding member of the Neue Künstlervereinigung of Munich. From 1913 on, exhibited with the Blaue Reiter group. Her art shows Expressionist elements, while at the same time stressing Symbolist themes.

60 Information from Adi Erbslöh, widow of Adolf Erbslöh, a founding member of the Neue Künstlervereinigung (conversation on 17 March 1970, in Irschenhausen), and Olga von Hartmann (see note 24; conversation on 4 April 1973, in Garches). Kandinsky's widow Nina recounted in a conversation of 11 June 1978, in Paris, that he enjoyed playing the piano four-handed with her.

61 Nina Kandinsky Archive, Paris. The manuscript music will be published together with the theater pieces in Vol. IV of Kandinsky's *Gesammelte Schriften,* ed. H.K. Röthel and Jelena Hahl-Koch.

62 'My Evolution' ('Rückblick') in Arnold Schoenberg, *Style and Idea*, p. 79. At the premiere in Vienna (December 1908) a terrible scandal occurred, which was repeated in weaker form in Munich two years later.

63 H. Pfitzner, 'Die neue Ästhetik der musikalischen Impotenz,' in *Ges. Schriften*, vol. II (Augsburg: Filsern, 1926), p. 115.

64 August Macke/Franz Marc, *Briefwechsel*, ed. Wolfgang Macke (Cologne: Du Mont Schauberg, 1964), pp. 40 ff and 46 ff.

65 The former opinion is that of H.H. Stuckenschmidt, 'Kandinsky et la musique,' p. 25. Moreover, Stuckenschmidt was wrong about the location of Rottach-Egern; it is not on the Starnberger See but on the Tegernsee. In his large Schoenberg monograph, he reports the meeting between Schoenberg and Kandinsky correctly. The latter opinion is that of W. Haftmann in 'Über die Funktion des Musikalischen in der Malerei des 20. Jahrhunderts,' in Lucius Grisebach (ed.), *Hommage à Schönberg*, p. 9. W. Hofmann also names 1906 as the beginning of the acquaintance in his article 'Beziehungen zwischen Malerei und Musik'.

66 Nina Kandinsky, *Kandinsky und Ich*, p. 196.

67 Ibid., p. 193.

68 Ibid., p. 195 ff.

69 Kandinsky's letters to Galka Scheyer (see note 58) and copies of her own letters with Lette Valeska in Los Angeles, whom I thank cordially for the permission to study all the letters of Scheyer and the *Blaue Vier*.

70 'I do not attach so much importance to being a musical bogy-man as to being the natural continuer of properly understood good old tradition!' (E. Stein (ed.), *Arnold Schoenberg Letters*, p. 100.)

71 W. Hofmann, 'Beziehungen zwischen Malerei und Musik,' *Schönberg, Webern, Berg* catalog.

72 H.H. Stuckenschmidt, *Arnold Schoenberg*; J. Rufer, 'Schönberg–Kandinsky. Zur Funktion der Farbe in Musik und Malerei,' in Lucius Grisebach (ed.), *Hommage à Schönberg*; in the same book also appeared W. Haftmann's 'Über die Funktion des Musikalischen in der Malerei des 20. Jahrhunderts', see also K. Kropfinger, 'Schönberg und Kandinsky,' *Schönberg* catalog of the Akademie der Künste, Berlin (Berlin: Festspiele GmbH, 1974); R. Waissenberger, 'Der Bereich Malerei in Arnold Schönbergs Leben,' in Ernst Hilmar (ed.), *Arnold Schönberg Gedenkausstellung 1974*.

73 M. Hansen and C. Müller (eds), *Arbeitsheft 24. Forum: Musik in der DDR. Arnold Schönberg 1874 bis 1951. Zum 25. Todestag des Komponisten*.

74 Letter to Richard Dehmel, 13 December 1912 (*Arnold Schoenberg Letters*, pp. 35 ff). The complete edition of Strindberg's works is to be found in Schoenberg's legacy.

75 Foreword to the catalog of the second exhibition of the Neue Künstlervereinigung München (1910–11), p. 7.

76 Schoenberg, *Style and Idea*, p. 365.

77 Introduction to the performance of the *Gurre-Lieder*, the George songs, and the piano pieces of 1909, cited by Egon Wellesz, *Arnold Schönberg*, p. 27.

78 Frank Schneider, '"Kunst kommt . . . von Müssen." Zu A. Schönbergs Position in der bürgerlichen Gesellschaft,' *Arbeitsheft 24. Forum*. . . (see note 73 above), p. 16.

79 Kandinsky's first encounter with the element of time in painting probably occurred

in front of Rembrandt's paintings, which, on account of the contrasts of light and dark, this 'mighty chord,' immediately reminded him of Wagner's trumpets. He found that these paintings lasted 'a long time' because he had to take in first the light portion, then the dark ('Reminiscences,' in Kenneth C. Lindsay and Peter Vergo (eds), *Kandinsky: Complete Writings on Art*, Vol. I, p. 366, pp. 17 ff).

80 Ibid., pp. 360, 364.

81 ALEXANDER SAKHAROFF (b. Marinpol, Sea of Azov, 1886—d. Siena, 1963), Russian dancer. First studied painting with Bougereau in Paris from 1903 to 1905; then he decided, because of the strong impression made on him by the actress Sarah Bernhardt, to become a dancer. He moved to Munich and came into the circle around Jawlensky/Werefkin, and there met Kandinsky as well. In similar spirit, and probably also under the influence of the painter, who was about twenty years older, he eliminated all that was decorative and unessential, and attempted with great earnestness to press forward toward the nature and origin of the dance. From the beginning, he saw no possibility for this in the ballet, and developed his own type of expressive dance. Sakharoff was to have danced the principal role in Kandinsky's *Der gelbe Klang*. From 1913 on he appeared together with Clothilde von Derp; they married in 1919 and became known worldwide. From 1950 on they dedicated themselves to dance teaching, following upon a theoretical concern with his art which Sakharoff had already shown earlier. It would be welcomed if a publisher could undertake the publication of his manuscripts and the reprinting of his two short books.

82 In 'Speech by the Painter Kandinsky,' *Vestnik rabotnikov iskusstv*, no. 4–5, Moscow, 1921, pp. 74 ff.

83 Ibid., p. 73.

84 Lindsay and Vergo (eds), *Kandinsky: Complete Writings on Art*, Vol. I, p. 191.

85 In *Arbeitsheft 24. Forum. . .*, pp. 157 ff.

86 Even John Crawford, in his otherwise excellent dissertation on Schoenberg ('The Relationship of Text and Music in the Vocal Works of Schoenberg, 1908—1924,' pp. 167, 169), considers Kandinsky's influence on Schoenberg to be proven. In his 1974 article he still speaks of this influence, although Kandinsky's letters had been accessible to him in the meantime, and he dates the beginning of the relationship correctly as January 1911 ('*Die glückliche Hand:* Schoenberg's *Gesamtkunstwerk,*' pp. 583, 590). M. MacDonald, in *Schoenberg*, p. 188, is also of this opinion. (Translator's note: Even though the influence of Kandinsky on Schoenberg's text for *Die glückliche Hand* is a chronological impossibility, the synesthetic ideas of the two men regarding equivalent colors, instrumental timbres and emotions are so similar as to suggest that both were influenced by a common, earlier source.)

87 RICHARD GERSTL (b. Vienna, 1883—d. there, 1908). This multi-gifted, highly sensitive young man was a pupil of Heinrich Lefler at the Academy of Art for a short time in 1903, then continued his work independently. In 1906, he was very impressed by the Vienna van Gogh exhibition. His interest in music brought him into contact with Schoenberg by 1907 at the latest. A year later he rented a studio in the house in which the Schoenbergs lived, and spent time with Schoenberg and his wife Mathilde for the purpose of painting together. After the unhappy affair with Mathilde, the 25-year-old Gerstl took his own life. Today he is considered to be the first 'Fauve' painter in Vienna, at a time when the *Jugendstil* still predominated.

88 This would answer Crawford's question as to whether the dramatic or musical composition came first (*Musical Quarterly*, see note 86).

89 John Crawford, see note 86; Jan Maegaard, *Studien zur Entwicklung des dodekaphonen Satzes bei Arnold Schönberg*; Karl Wörner, '*Die glückliche Hand*,' p. 274, and *Die Musik in der Geistesgeschichte* (Bonn: Bouvier, 1970), pp. 73–91.

90 Wörner's interpretation of *Die glückliche Hand* as a battle of the sexes in imitation of Strindberg, which Egon Wellesz had already stated in more general form in his 1921 book on Schoenberg, seems to me to make this one secondary aspect absolute ('*Die glückliche Hand*,' see note 89). Peter Epstein reproduces Erwin Stein's quotation of Schoenberg's own words concerning the content of *Die glückliche Hand* as follows: 'A man who has been defeated by misfortune pulls himself together. Fortune smiles on him once more. He is able to carry out accomplishments as in earlier times. However, once more everything proves to be a delusion, and, struck by new blows of destiny, he breaks down' ('A. Schönbergs *Die glückliche Hand*', p. 198). Even if Schoenberg said this in such a way, this description of the outward events does not contradict the interpretation adopted here and in the other essays on the work.

91 Wörner, '*Die glückliche Hand*', p. 279.

92 On the first point, see note 90; on the other, see J. Crawford, '*Die glückliche Hand. . .*' p. 589.

93 T.W. Adorno, *Philosophy of Modern Music*, p. 43.

94 Stuckenschmidt, *Arnold Schoenberg*, p. 124.

95 'Direktor Stiedry conducted the complicated score of this pointillistic music with consummate mastery [. . .] an analyst [. . .] who succeeds in performing the unperformable, and one is moreover astonished at what he is making out of the Volksoper: a theater of premieres, of experiment, of literature, in short a metropolitan theater which—still dragging its name with it, but only as an empty sound—intends to supplement the Staatsoper' (E. Decsey in the *Neues Wiener Tagblatt*, 16 October 1924). Shortly thereafter the success of the Volksoper was also honored officially by higher governmental subsidies.

96 B. Bricht in the *Volkszeitung*, Vienna, 17 October 1924.

97 E. Bienenfeld in the *Wiener Journal*, October 1924.

98 R. Konta in the *Illustriertes Wiener Extrablatt*, October 1924. See also his review 'Schönbergs *Die glückliche Hand*,' *Auftakt*, vol. IV, no. 10, 1924, pp. 287 ff. An anonymous double-column criticism in the *Reichspost* (16 October 1924) was less favorable: 'We experience a drama with music, the title of which, *Die glückliche Hand*, I find inexplicable, since a "glückliche Hand" is never mentioned, or even hinted at. Mysterious things have taken place on the stage, concerning which a person of normal intelligence would scarcely be in a position to unveil the mystery. In the orchestra it sounds as if the instruments had come alive and begun to blow their noses, to clear their throats and cough, to whimper, to slurp noisily, and to bawl. In short, I find the entire performance completely incomprehensible.'

99 *Wiener allgemeine Zeitung*, 15 October 1924.

100 B. Bricht in the *Volkszeitung*, 17 October 1924.

101 Dr H.H. in *Der Augenblick*, M. Gladbach, no. 8, 30 October 1924, p. 46.

102 For example A. Einstein in the *Berliner Tagblatt*, 26 March 1928.

103 Peter Epstein, in *Melos*, vol. VII, no. 4, 1928, p. 200, writes the most understanding and comprehensive report about the Breslau performance and

concludes as follows: 'The repetition of the work served to prove emphatically the unity of this performance; it also revealed the inexorable inner laws of Schoenberg's work.' On the other hand, 'P. P.' in the *Breslauer Zeitung* of 26 March 1928: 'The repetition had the drawback of underlining the dramatic bloodlessness of plot and music even more sharply.' Dr H. Matzke, in the *Schlesische Tagespost*, 27 March 1928, also wrote a negative review.

104 Rudolf Bilke, in the *Breslauer neueste Nachrichten*, 26 March 1928.

105 H.H. Stuckenschmidt, 'Schönbergs "Glückliche Hand" in Breslau,' p. 98.

106 *Deutsche Zeitung*, Berlin, 12 July 1929.

107 *Berlin am Morgen*, 11 July 1929.

108 Kandinsky's biographer Will Grohmann, who also knew him well personally, reports concerning Kandinsky's stay in Paris from May 1906 to June 1907; 'In Paris, he had come close to a severe nervous breakdown. The first thing he did on his return was to go for a rest cure to Reichenhall, where he recovered' (*Wassily Kandinsky*, trans. Norbert Guterman, p. 52).

109 English manuscript of the lecture in possession of the composer's widow, Olga von Hartmann (New York).

110 Will Grohmann, *Wassily Kandinsky*, pp. 55 ff and 98 ff; Horst Denkler, 'Das Drama des Expressionismus in Zusammenhang mit den expressionistischen Programmen und Theaterformen' (PhD diss., Münster, 1963); W.H. Römstock, 'Die antinaturalistische Bewegung in der Szenengestaltung des expressionistischen Theaters zwischen 1890 und 1930' (PhD diss., Munich, 1954).

111 Hugo Ball, *Flucht aus der Zeit* (Lucerne: Stocker, 1946), pp. 147 ff, and *Briefe*, ed. A. Schütt-Hennings (Einsiedeln/Cologne: Benziger, 1957), pp. 33 ff. Letter to Maria Hildebrand-Ball.

112 About these performances, as also about Kandinsky's work for the theater in general, a detailed discussion will appear within the framework of his *Gesammelte Schriften*, ed. H.K. Röthel and J. Hahl-Koch.

113 Crawford, *'Die glückliche Hand . . . ,'* pp.586 ff; 'The relationship . . . ,' pp. 203 ff.

114 Crawford, *'Die glückliche Hand . . .'*, pp. 583 and 600.

115 Lothar Schreyer, *Expressionistisches Theater* (Hamburg: Toth, 1948), pp. 80 ff.

116 Letter cited in E. Freitag, *Arnold Schönberg*, pp. 61 ff.

117 Pierpont Morgan Library, New York.

118 Freitag, op. cit., p. 56; J. Rufer, 'Schönberg als Maler. Grenzen und Konvergenzen der Künste,' R. Waissenberger, 'Der Bereich Malerei in Arnold Schönbergs Leben' in Ernst Hilmar (ed.), *Gedenkausstellung* catalog, p. 100.

119 E. Freitag, 'Expressionism and Schoenberg's Self-Portraits' and G. Eisler, 'Observations on Schoenberg as Painter,' *Journal of the Arnold Schoenberg Institute*, vol. II, no. 3, June 1978.

120 English text of the interview, repr. in the *Gedenkausstellung* catalog, Vienna, 1974, p. 109.

121 Note dated 5 August 1934, attached to Marion Bauer's book *Twentieth-Century Music* (New York: Putnam, 1933), p. 211, at the passage where the influence of Kandinsky on Schoenberg is discussed. Reproduced in *Journal of the Arnold Schoenberg Institute*, vol. II, no. 3, June 1978, p. 236.

122 Handwritten memorandum 'Malerische Einflüsse', 11 February 1938. Reproduced in *Journal of the Arnold Schoenberg Insitute* (see note 121), p. 234.

123 O. Kokoschka, *Mein Leben*, p. 73.
124 See Werner Hofmann, 'Der Wiener Maler Richard Gerstl,' *Kunstwerk*, vol. X, 1956/57, p. 99.
125 Schoenberg *Gedenkausstellung* catalog, pp. 205-6. Letter dated 16 June 1910.
126 *On the Spiritual in Art*, in Kenneth C. Lindsay and Peter Vergo (eds), *Kandinsky: Complete Writings on Art*, vol. I, p. 191.
127 'Der Maler Schönberg,' in Alban Berg *et al.* (eds), *Arnold Schönberg*.

SCHOENBERG'S ARTISTIC DEVELOPMENT TO 1911, by John Crawford

128 Stuckenschmidt, *Schoenberg*, pp. 16, 18.
129 Ibid., p. 28.
130 Schoenberg *Gedenkausstellung* catalog, pp. 158–9, no. 12.
131 'My Evolution,' *Style and Idea*, p. 80.
132 Stuckenschmidt, *Schoenberg*, pp. 31, 33.
133 Ibid., p. 31, and Max Graf, 'Das Wiener Café Grössenwahn.'
134 Letter to Dehmel dated 13 December 1912, in *Arnold Schoenberg Letters*, p. 35.
135 Stuckenschmidt, *Schoenberg*, p. 48.
136 Cf. the author's record review of the *Gurre-Lieder*, *Musical Quarterly*, vol. LXII, no. 1, January 1976, pp. 147–8.
137 Unpublished letter to Emil Hertzka, Universal Edition, dated 19 August 1912.
138 *Style and Idea*, p. 505.
139 Carl E. Schorske, *Fin-de-siècle Vienna: Politics and Culture* (New York: Knopf, 1980), p. xviii.
140 Ibid., pp. 119–20.
141 Kurt Blaukopf, *Gustav Mahler*, trans. Inge Goodwin (New York: Praeger, 1973), p. 18.
142 Henry-Louis de La Grange, *Mahler* (Garden City, N.J.: Doubleday, 1973), Vol. I, p. 411.
143 Stuckenschmidt, *Schoenberg*, p. 34.
144 Schorske, *Fin-de-siècle Vienna*, p. 214.
145 Ibid., pp. 327-8.
146 Unpublished letter from Schoenberg to Kokoschka, dated 3 July 1946 (Library of Congress, Washington, D.C.).
147 Quoted in Alessandra Comini, *Gustav Klimt* (New York: G. Braziller, 1975), p. 13.
148 Allan Janik and Stephen Toulmin, *Wittgenstein's Vienna* (New York: Simon & Schuster/London: Weidenfield & Nicolson, 1973), p. 102.
149 As suggested by Schoenberg's son-in-law Felix Greissle in a lecture at Princeton University, 20 August 1959.
150 Stuckenschmidt, *Schoenberg*, p. 94.
151 Robert Waissenberg, 'Der Bereich Malerei in Arnold Schönberg's Leben,' in Schoenberg *Gedenkausstellung* catalog, p. 101. Suicides were frequent among Viennese intellectuals during the early 1900s, including Otto Weininger, the poet Georg Trakl, and three of Ludwig Wittgenstein's older brothers.
152 See Schoenberg, *Style and Idea*, pp. 12–13, 185 ff.
153 Cf. 'The Destiny of Opera,' in *Richard Wagner's Prose Works*, trans. William Ashton Ellis, (New York: Bronde Bros., 1966), vol. V, pp. 149–50.
154 See particularly the climax of Parsifal's confrontation with Kundry in Act II

(Richard Wagner, *Parsifal,* piano-vocal score (Mainz: Schott, 1910), pp. 212–42).
155 Ibid., pp. 125–6.
156 Interview with Schoenberg by Paul Wilhelm, first printed *Neues Wiener Journal,* 10 January 1909. Reprinted in Ivan Vojtěch (ed.), *Arnold Schönberg Gesammelte Schriften,* vol. I, p. 157.
157 Richard Strauss, *Elektra,* piano-vocal score (Berlin: Fürstner [*c.* 1908]), 144a–146a, for instance (Elektra's recognition of Orestes).
158 Stuckenschmidt, *Schoenberg,* p. 103.
159 Gustav Mahler, *Sieben Lieder,* Philharmonia no. 253, Vienna, n.d., p. 71.
160 *Style and Idea,* p. 463.
161 Ibid., p. 459.
162 Cf. Dika Newlin, *Bruckner–Mahler–Schoenberg,* rev. pp. 198–9.
163 Jack Diether, 'Mahler and Atonality,' *Music Review,* vol. XVII, no. 2, May 1956, p. 130.
164 The third movement ('Litanei') was finished 11 July 1908, the second (Scherzo) 27 July 1908.
165 Wellesz, *Arnold Schönberg,* p. 26.
166 Rufer, *The Works of Arnold Schoenberg,* p. 30.
167 Eric Salzman, *Twentieth-Century Music: an Introduction* 2nd edn. (Englewood Cliffs: Prentice-Hall, 1974), p. 11.
168 'My Evolution' (1948), *Style and Idea,* p. 79.
169 Anton von Webern, 'Schönbergs Musik,' in the 1912 Festschrift *Arnold Schönberg,* p. 41.
170 Rufer, *The Works of Arnold Schoenberg,* p. 30.
171 Anton von Webern, 'The Path to Twelve-Note Composition,' in his *The Path to the New Music,* p. 55.
172 Stuckenschmidt, *Schoenberg,* p. 70.
173 *Harmonielehre,* pp. 364–66 and 442–62, and 'Problems in Teaching Art,' in *Style and Idea,* p. 365.
174 Webern, 'Schönbergs Musik,' p. 43.
175 See *Theory of Harmony,* pp. 421 ff.
176 Schoenberg, *Berliner Tagebuch,* p. 11.
177 *Gedenkausstellung* catalog, p. 203, no. 129.
178 Rufer, *The Works of Arnold Schoenberg,* pp. 34–5.
179 See J. Crawford's 'The Relationship of Text and Music in the Vocal Works of Arnold Schoenberg, 1908–1924,' pp. 128–40.
180 *Harmonielehre,* p. 15.
181 Climaxes: (1) bars 110–12; (2) bars 153–7; (3) bars 190–4; (4) bars 347–8; (5) bars 415–16; (6) bar 424. See the author's dissertation, pp. 103–4.
182 Webern, 'Schönbergs Musik,' p. 43.
183 Ibid., pp. 45–6.
184 Walter and Alexander Goehr, 'Arnold Schoenberg's Development towards the Twelve-Tone System,' in *European Music in the Twentieth Century,* pp. 89–90; Stuckenschmidt, *Schoenberg,* pp. 120–1; and Crawford, 'The Relationship. . .,' pp. 104–28.
185 George Perle, *Serial Composition and Atonality,* p. 19.
186 Charles Rosen, *Schoenberg,* pp. 49–50.
187 Jan Maegaard, 'Some Formal Devices in Expressionistic Works,' *Dansk Aarbog for Musik Forsning,* 1961, p. 75.

188 This essay is printed in *Style and Idea*, p. 141, in slightly revised form (trans. Dika Newlin). For a translation of the original text, see Klaus Lankheit (ed.), *The Blaue Reiter Almanac*, p. 90.

189 Schoenberg, 'Opinion or Insight?' (1926), *Style and Idea*, p. 260.

190 Schoenberg, *Style and Idea*, pp. 217–18.

CAPTIONS TO
KANDINSKY COLOR PLATES
(*between pages 64 and 65*)

12. *Grüngasse in Murnau*, 1909

Kandinsky painted the sun-drenched Green Lane in Murnau, the village in the foothills of the Alps where he was fond of staying, beginning in 1908, and where he acquired a house in 1909. With his fellow painters, particularly Münter, Jawlensky and Werefkin, he painted outdoors almost daily in Murnau and its vicinity throughout many summers. Here, close to Kandinsky, Schoenberg spent the summer of 1914.

The picture 'Grüngasse' points the way to future developments: perspective is still observed almost completely, and the houses and plants behind the garden walls are still clearly recognizable. The subjective shaping of impressions from nature is, however, indicated by the very strong colors.

13. *Study for Composition II*, 1910

'Composition II' was destroyed in World War II. On the basis of the black and white reproduction in the *Sturm-Album* (Berlin: Sturm-Verlag, 1913), p. 48, one can ascertain a great similarity of all structural elements to the 'Study', which must, however—as so frequently with Kandinsky's studies—be accepted as a painting in its own right. In the upper left quarter, a yellow fringe with outstretched arms is reminiscent of the last Yellow Giant in the final scene of *The Yellow Sound* (see p. 117).

In the Russian version of 'Reminiscences' (1918), Kandinsky gives in a supplement, which was not contained in the German version of 1913, the following clues to an understanding of the picture: 'In indistinct dreams, something indeterminate occasionally stood out before me in intangible fragments, and frightened me at times with its daring. Sometimes harmonious pictures appeared to me in dreams, which after my awakening left behind only confused traces of unessential details. Once, in the midst of typhoid fever, I saw a whole picture with great clarity, which nevertheless somehow fell to pieces in my mind as soon as I became well. Then after several years I painted 'The Arrival of the Merchants', later 'Motley Life', and finally, after many years, I succeeded, in 'Composition II', in expressing the essentials of this fever vision, though I only realized this a short while ago. From the very beginning the word 'composition' sounded for me like a prayer. It filled my soul with awe. And even today, I am pained when I see how frivolously people often deal with it.' (*Stupeni. Tekst chudožnika* (Moscow, 1918), p. 25.)

An extended analysis of the various pictorial components is found in H. K. Röthel, *Kandinsky*, p. 72. However, I do not agree with Röthel's interpretation of the central

motif, the two riders in the lower middle ground. His opinion is that they are both galloping into the background of the picture. But since Kandinsky himself, in his comparison of 'Compositions II' and 'IV', speaks of the battle motif, and the position of the horses as they rear up against each other is certainly clearly recognizable, I consider 'fighting riders' more likely; the inference from 'Composition IV' supports this interpretation (see Plate 14).

14. *Composition IV*, 1911

Schoenberg saw this picture in Herwarth Walden's Sturm exhibition in 1912. Kandinsky's own observations, published in Walden's *Sturm-Album* (Berlin: Sturm-Verlag, 1913) are of interest:

'COMPOSITION IV
Subsequent Interpretation
1. Masses (weight masses):
 Color: lower middle—blue (gives a cold tone to the whole)
 upper right—separated blue, red and yellow
 Line: upper left—black outlines of tangled horses
 lower right—elongated lines of a horizontal form
2. Contrasts
 of mass to line,
 of the precise to the indistinct,
 of tangled lines to tangled colors and the *main* contrast:
 pointed, sharp movement (battle) to bright-cold-fresh colors.
3. Overflows
 of color over the outlines.
 The complete outlining (of the fortress *only*) is weakened
 by the flowing of the sky over the outline.
4. Two focal points:
 1. tangled lines,
 2. molded summit of the blue
 these are separated from each other by two vertical black lines (spears).
 'The whole composition is intended to be very bright, with many fresh colors which often flow into each other (dissolutions). Even the yellow is cold. This bright-fresh-cold to the sharp-agitated (War) is the principal contrast of the picture. Here, it seems to me this contrast is even stronger (compared to 'Composition II'), but correspondingly even more severe (spiritually), clearer, which has the advantage of producing a more precise impression, and the disadvantage of a too great clarity arising from this precision.

 'Here the following elements are basic:
1. The harmony of *peaceful* masses with each other.
2. *Peaceful* movement of the components, principally toward the right and upward.
3. Principally *sharp* movement toward the left and upward.
4. The *opposition* in both directions (in the direction toward the right smaller forms go to the left and so on).
5. *Harmony* of the masses with the lines which merely lie.
6. Contrasts of the indistinct forms to the contoured ones (thus line as line (5) and as contour, where it also functions as a line).

206

7. The *flowing* of color *over* the boundaries of the form.
8. The *preponderance* of the color-sonority over the form-sonority.
9. Dissolutions.
 March 1911'

The comparison with 'Composition II' (see above), which Kandinsky himself draws, in that he calls the contrast between the battle motif and the peaceful right side of the picture sharper and more obvious here, demonstrates that in 'Composition IV' he again takes up the motifs of the middle and lower right sections of 'Composition II', above all the reclining white pair at the right, and the pair of riders fighting each other in the center of the picture, of which remain in 'Composition IV' (upper left) the shorthand strokes of the horses scurrying against each other, their legs, heads and the rider.

15. *Impression 3 (Concert)*, 1911

Possibly this is Kandinsky's working out of the strong impression that the Schoenberg concert in January 1911 made on him. In any event, the concert caused him to begin a correspondence with the composer.

The picture was probably painted soon after the concert: Kandinsky entered it as the third of thirty-three works for the year 1911 in his personal catalog (Nina Kandinsky Archive, Paris).

The large black blot suggests a grand piano, the instrument of the Three Piano Pieces, Op. 11. Concerning the two large contrasting color areas of black and yellow we have the following observations from Kandinsky's book *On the Spiritual in Art:* 'A picture painted in yellow gives out a spiritual warmth' (Lindsay and Vergo (eds), *Kandinsky: Complete Writings on Art*, Vol. 1, p. 183). As the movement inherent in yellow he names the 'striving *toward* the spectator . . . its secondary movement, which causes it to leap over its boundaries, dissipating its strength upon its surroundings . . . yellow, when directly observed . . . is disquieting to the spectator, pricking him, stimulating him, revealing the nature of the power expressed in this color, which has an effect upon our sensibilities at once impudent and importunate.' As examples of glaring and shrillness he names letter-boxes,* lemons and canaries. 'This characteristic of yellow, a color that inclines considerably toward the brighter tones, can be raised to a pitch of intensity unbearable to the eye and to the spirit. Upon such intensification, it affects us like the shrill sound of a trumpet being played louder and louder, or the sound of a high-pitched fanfare. Yellow is the typical earthly color' (pp. 180-1).

'Black has an inner sound of nothingness bereft of possibilities, a dead nothingness as if the sun had become extinct, an eternal silence without future, without hope. Musically, it is represented by a general pause. . . Black is externally the most toneless color, against which all other colors, even the weakest, sound stronger and more precise' (p. 185).

By its title 'Impression', the picture belongs to one of the three categories established by Kandinsky: 'The direct impression from "external nature," expressed in linear-painterly form. I call these pictures *Impressions.*' They are without exception the simplest and clearest of Kandinsky's pictures, as is well exemplified by 'Concert.' The pictures arising from 'events of an inner character' he calls *Improvisations*, and

* Translator's note: Letter-boxes are painted yellow in Germany.

207

those which develop most slowly, perfected after many preliminary sketches, he calls *Compositions* (p. 218).

16. *Romantic Landscape*, 1911

Schoenberg saw this picture in Berlin in 1912 and wrote to Kandinsky how much it pleased him.

Around 1930, Kandinsky told his biographer Will Grohmann: 'In 1910 I painted a 'Romantic Landscape' that had nothing to do with earlier romanticism. Someday I intend using such a designation again [. . .] the coming romanticism is actually profound, full of meaning; it is a piece of ice, in which a flame burns': Karl Gutbrod (ed.), *Künstler schreiben an Will Grohmann* (Cologne: DuMont Schauberg, 1968), p. 50.

In this picture, three riders, the sun, and, in the foreground, perhaps a thick, dark fir-tree are still clearly recognizable, while the elements of a winter (?) landscape are already beginning to dissolve and become ambiguous.

17. *Picture With White Border*, 1913

Schoenberg saw this picture in Berlin at the *First German Autumn Salon* in 1913. In his *Sturm-Album* p. xxxix, Kandinsky gives information on the picture's origin:

'For this picture I made many sketches, designs and drawings. I made the first sketch very soon after my return from Moscow in 1912: it was the result of my most recent (and, as usual, very powerful) experiences in Moscow, or, more accurately, *of Moscow* itself. The first sketch was very terse and compact. In the second, I already brought about the "dissolution" of the color- and form-events in the right lower corner. The troika motif, which had already been a part of me for a very long time, and which I had used in various drawings, stood at the upper left. This left corner had to be particularly simple, that is, the impression it made had to be produced directly and unhindered by the form. In the far corner are white peaks, which express a feeling that I cannot give in words. Perhaps they excite a feeling of hindrance, which, however, cannot hold back the troika in the long run [. . .]

'Thus, *clarity* and *simplicity* at the upper left, blurred *dissolution* with gloomy little disintegrations at the lower right. As so often with me, two centers [. . .]

'At the lower left there is *battle* in black and white, which is separated by Naples Yellow from the dramatic clarity of the upper left corner. The way in which the black, indistinct spots welter in the white, I call *"inner seething in unclear form."*

'The upper right corner opposite is similar, but it already belongs to the white border.

'It went very slowly with this white border. All sketches were of little use to me; that is, the individual forms finally became clear to me—but I still could not make up my mind to paint the picture. It tormented me. For weeks I viewed the sketches again and again, and each time felt once more that I was unready. Only with the years have I learned to show patience, and not to try to act impetuously in regard to such a problem.

'And it was thus only after almost five months that I sat in the dusk before the second, larger sketch and suddenly saw with complete clarity what was still missing—it was the white border. . .

'I brought about this white border just as capriciously as it presented itself to me: abyss at the lower left, a white wave mounting out of it, which suddenly falls, then

208

flows round the right side of the picture in lazy, meandering form, forms a lake at the upper right (where the black seething begins) and disappears to the left upper corner, in order to appear in the picture for the last time and definitively as white peaks.

'Since this white border was the picture's solution, I named the whole picture after it.

May 1913.'

Kandinsky's personal catalog confirms his statement. The first two sketches stand at the beginning of the year 1913 as nos. 162 and 163, while the picture itself is only registered as no. 173, after 'Picture With White Shapes', 'Red Spots', 'Composition VI', and many others.

18. *Picture With White Shapes*, 1913

Schoenberg saw this picture at the *First German Autumn Salon* in Berlin in 1913. Herwarth Walden acquired it himself, and had it in his possession until 1924.

In Kandinsky's personal catalog it follows, accompanied by a sketch, the sketches for the 'Picture With White Border;' only 'Improvisation 31' lies in between. It is closely related to the 'Picture With White Border,' for Kandinsky, still impressed by his lack of progress, worked out many of its motifs in this second picture. Here the white shape has a similar function to the white border in the other picture, and it may have guided him to the solution of the problem with the white border.

Here the vestiges of landscape are still further dissolved, and even fewer shorthand motifs are recognizable, such as for instance the rider with the white lance (St George) hurrying toward the left in the center of the 'Picture With White Border,' a motif as striking to any expert as the troika-motif at the upper left mentioned by Kandinsky himself. In the 'Picture With White Forms' the independence of the constructive pictorial vocabulary even from the slightest illusion of reality is clearly to be observed; it is, like several of Kandinsky's oil paintings from 1911 on, an autonomous creation made from pure, contentless colors and forms.

19. *Within the Black Square*, 1923

This is a typical example of Kandinsky's Bauhaus style, as his language of form changed from its 'anarchistic' phase around 1911 to a more restrained expression in clear, geometrical, primary forms. His colors are also less effervescent and often are limited to primary colors. The new reductions and objectivism, which is to be observed beginning in 1921, has its counterpart in Schoenberg's twelve-tone technique, which was developed at the same time.

Certainly, vestiges of the old motifs may still be surmised occasionally in Kandinsky's work, but it is now even more superfluous to search after them than in the earlier abstract pictures. Nevertheless, the type of perception which Kandinsky himself suggests in 'Composition IV' (see p. 206), also continues in the Bauhaus pictures. The special characteristic of the composition of this picture is the insertion of a trapezoid into an approximately square black form.

SOURCES OF TEXTS

Arnold Schoenberg's letters up to 1914: Gabriele Münter and Johannes Eichner Bequest, Munich; the letter copies from 1922 on and all Kandinsky and Münter letters, Library of Congress, Washington, D.C.; the following letters already published in *Arnold Schoenberg Letters*, ed. Erwin Stein, trans. Eithne Wilkins and Ernst Kaiser: Schoenberg to Kandinsky, 20 July 1922; Schoenberg to Kandinsky, 19 April 1923; Schoenberg to Kandinsky, 4 May 1923; Schoenberg to Emil Hertzka (*c.* autumn 1913) and Schoenberg to Ernst Legal, 14 April 1930. Portions of Kandinsky's letters of 16 November 1911 and 13 January 1912, published in Josef Rufer's *Das Werk Arnold Schönbergs* (for details of English translation, see Bibliography); Arnold Schoenberg's *Die glückliche Hand*, trans. David Johnson, in booklet distributed with *The Music of Arnold Schoenberg*, Columbia Records, 1963, vol. I; Arnold Schoenberg, Breslau lecture in I. Vojtěch (ed.), *Arnold Schönberg, Gesammelte Schriften*, vol. I; Wassily Kandinsky, 'On Stage Composition,' *The Yellow Sound* and 'The Pictures' in his *Complete Writings on Art*, vol. I, ed. Kenneth C. Lindsay and Peter Vergo.

SOURCES OF ILLUSTRATIONS

Plate 1, Gabriele Münter and Johannes Eichner Bequest, Munich; 2,3: Arnold Schoenberg Institute, Los Angeles; 4,5: Municipal Gallery in the Lenbachhaus, Munich; 6, Gabriele Münter and Johannes Eichner Bequest, Munich; 7, Universal Edition, Vienna; 8, Gabriele Münter and Johannes Eichner Bequest, Munich; 9,10: Universal Edition, Vienna; 11, Nina Kandinsky, Paris; p.20, Library of Congress, Washington, D.C.; p.22, Gabriele Münter and Johannes Eichner Bequest, Munich; p.24, Gabriele Münter and Johannes Eichner Bequest, Munich; p.33, Vienna City Library, Printed Materials Collection; p.37, Municipal Gallery in the Lenbachhaus, Munich; 12, Municipal Gallery in Lenbachhaus, Munich; 13, Solomon R. Guggenheim Museum, New York; 14, Nordrhein-Westfalen Art Collection, Düsseldorf; 15, Municipal Gallery in the Lenbachhaus, Munich; 16, Municipal Gallery in the Lenbachhaus, Munich; 17,18,19: Solomon R. Guggenheim Museum, New York; p.63, Gabriele Münter and Johannes Eichner Bequest, Munich; 20–28, Arnold Schoenberg Institute, Los Angeles; p.103, Universal Edition, Vienna; p.124, Municipal Gallery in the Lenbachhaus, Munich; 29, 30: Arnold Schoenberg Institute, Los Angeles; 31, Library of Congress, Washington, D.C.; 32, Arnold Schoenberg Institute, Los Angeles; 33,34: Municipal Gallery in the Lenbachhaus, Munich; 35,

SOURCES OF ILLUSTRATIONS

Arnold Schoenberg Institute, Los Angeles; 36, Historical Museum of the City of Vienna; p.155, Vienna City Library, Printed Materials Collection; p.165, illustration from *Der Merker: Österreichische Zeitschrift für Musik und Theater*, Vol. II, no. 17, June 1911; p.172, private collection, Munich.

The publishers and the Arnold Schoenberg Institute would like to thank Herr Walter Dräyer of Zurich for color photography of eleven pictures and sketches by the composer.

SELECT BIBLIOGRAPHY

An extensive bibliography of Kandinsky's writings can be found in Kenneth C. Lindsay and Peter Vergo (eds), *Kandinsky: Complete Writings on Art;* Josef Rufer's *The Works of Arnold Schoenberg* is an annotated catalog of Schoenberg's compositions, writings and paintings.

T.W. Adorno, *Die Philosophie der neuen Musik* (Tübingen: Mohr, 1949). English translation by Anne G. Mitchell and Wesley V. Blomster: *Philosophy of Modern Music* (New York: Seabury Press, 1973).

M. Armitage (ed.), *Arnold Schoenberg* (New York: Schirmer, 1937).

Alban Berg et al., *Arnold Schönberg* (Munich: Piper, 1912).

John Crawford, 'The Relationship of Text and Music in the Vocal Works of Schoenberg, 1908–1924,' unpublished diss., Harvard (1963).

——'*Die glückliche Hand*: Schoenberg's *Gesamtkunstwerk*,' *Musical Quarterly*, vol. LX, no. 4, October 1974.

Louis Danz, 'Schoenberg the inevitable,' in M. Armitage (ed.), *Arnold Schoenberg*.

G. Eisler 'Observations on Schoenberg as painter,' *Journal of the Arnold Schoenberg Institute*, Vol. II, no. 3, June 1978.

Peter Epstein, 'A. Schönbergs *Die glückliche Hand*,' *Melos*, vol. VII, no. 4, 1928, p. 198.

E. Freitag, *Arnold Schönberg* (Reinbek: Rowohlt, 1973).

——'Expressionism and Schoenberg's self-portraits,' *Journal of the Arnold Schoenberg Institute*, vol. II, no. 3, June 1978.

Walter and Alexander Goehr, 'Arnold Schoenberg's development towards the twelve-tone system,' in Howard Hartog (ed.), *European Music in the Twentieth Century* (London: Routledge & Kegan Paul, 1965).

Max Graf, 'Das Wiener Café Grössenwahn', *Neues Österreich*, 11 February 1951.

Lucius Grisebach (ed.), *Hommage à Schönberg* (Berlin: Nationalgalerie, 1974).

Will Grohmann, *Wassily Kandinsky*, 2nd edn (Cologne: Du Mont, 1966). English translation by Norbert Guterman: *Wassily Kandinsky: Life and Work* (New York: Abrams, 1958).

W. Haftmann, 'Über die Funktion des Musikalischen in der Malerei des 20. Jahrhunderts,' in Lucius Grisebach (ed.), *Hommage à Schönberg*.

M. Hansen and C. Müller (eds), *Arbeitsheft 24. Forum: Musik in der DDR. Arnold Schönberg 1874 bis 1951. Zum 25. Todestag des Komponisten* (Berlin: Deutsche Akademie der Künste, 1976).

Ernst Hilmar (ed.), *Arnold Schönberg Gedenkausstellung 1974* (Vienna: Universal Edition, 1974).

Werner Hofmann, 'Beziehungen zwischen Malerei und Kunst,' in Werner Hofmann (ed.), *Schönberg, Webern, Berg*, exhibition catalog, ed. W. Hofmann (Vienna: Brüder Rosenbaum/The Hague: Gemeentemuseum, 1969), pp. 103–13.

Nina Kandinsky, *Kandinsky und Ich* (Munich: Kindler, 1976).

SELECT BIBLIOGRAPHY

Wassily Kandinsky, *Über das Geistige in der Kunst* (Munich: Piper, 1912).
—*Rückblicke* (Baden-Baden: Klein, 1955).
Oskar Kokoschka, *Mein Leben* (Munich: Bruckmann, 1971).
Klaus Lankheit (ed.), *Der blaue Reiter* (orig. eds Wassily Kandinsky and Franz Marc) (Munich: Piper, 1965). English translation by Henning Falkenstein, Manug Terzian and Gertrude Hinderlie: *The Blaue Reiter Almanac* (London: Thames & Hudson/New York: Viking, 1974).
Kenneth C. Lindsay and Peter Vergo (eds), *Kandinsky: Complete Writings on Art*, 2 vols (London: Faber/Boston: Hall, 1982).
M. MacDonald, *Schoenberg* (London: Dent, 1976).
Jan Maegaard, *Studien zur Entwicklung des Dodekaphonen Satzes bei Arnold Schönberg* (Copenhagen: Wilhelm Hansen, 1972).
Dika Newlin, *Bruckner–Mahler–Schoenberg*, 2nd rev. edn (New York: Norton, 1978).
George Perle, *Serial Composition and Atonality*, 2nd edn (London: Faber/Berkeley and Los Angeles: University of California Press, 1968).
Sixten Ringbom, *The Sounding Cosmos* (Abo: Akademi, 1970).
Charles Rosen, *Schoenberg* (London: Marion Boyars/Fontana, 1976).
H.K. Röthel, *Kandinsky* (New York: Hudson Hills Press, 1979).
Josef Rufer, *Das Werk Arnold Schönbergs* (Kassel: Bärenreiter, 1959). English translation by Dika Newlin: *The Works of Arnold Schoenberg* (London: Faber, 1962).
—Schönberg als Maler, Grenzen und Konvergenzen der Künste,' in W. Burde (ed.), *Aspekte der neuen Musik: Festschrift für Prof. H.H. Stuckenschmidt zum 65. Geburtstag* (Kassel: Bärenreiter, 1968).
—'Schönberg–Kandinsky. Zur Funktion der Farbe in Musik und Malerei,' in Lucius Grisebach (ed.), *Hommage à Schönberg*.
Arnold Schoenberg, *Harmonielehre* (Vienna: Universal Edition, 1911). English translation of 3rd (1922) edn by Roy E. Carter: *Theory of Harmony* (London: Faber/Berkeley: University of California Press, 1978).
—*Texte* (Vienna/New York: Universal Edition, 1926).
—*Berliner Tagebuch*, ed. Josef Rufer (Berlin: Propyläen, 1974).
—*Style and Idea*, ed. Leonard Stein (London: Faber/New York: St Martin's Press, 1975).
Erwin Stein (ed.), *Arnold Schönberg: Ausgewählte Briefe* (Mainz: Schott, 1958). English translation by Eithne Wilkins and Ernst Kaiser: *Arnold Schoenberg Letters* (London: Faber/New York: St Martin's Press, 1964).
H.H. Stuckenschmidt, *Schönberg: Leben, Umwelt, Werk* (Zurich: Atlantis, 1974). English translation by Humphrey Searle: *Arnold Schoenberg: His Life, World and Work* (London: Calder/New York: Schirmer, 1978).
—'Kandinsky et la musique,' *XX siècle*, 1966.
—'Schönbergs "Glückliche Hand" in Breslau,' *Der Auftakt*, vol. VIII, no. 4, 1928, p. 97.
Jutta Theurich, 'Der Briefwechsel zwischen Arnold Schönberg und Ferruccio Busoni,' in M. Hansen and C. Müller (eds), *Arbeitsheft 24. Forum: Musik in der DDR. Arnold Schönberg 1874 bis 1951.*
Ivan Vojtěch (ed.), *Arnold Schönberg Gesammelte Schriften*, vol. I (Frankfurt: Fischer, 1976–).
Anton von Webern, 'Schönberg's Musik,' in Alban Berg *et al.*, *Arnold Schönberg*.
—*The Path to the New Music*, ed. by Willi Reich, translated by Leo Black (London: Universal Edition, 1975).

Egon Wellesz, *Arnold Schönberg*, translated by W.H. Kerridge (London: Dent, 1925/ New York: Da Capo, 1969).

Karl Wörner, 'Die glückliche Hand,' *Schweizerische Musikzeitschrift*, vol. CIV, no. 5, September/October 1964, p. 274.

Index

217